Studies in Renaissance Literature

Volume 43

PICTURING DIVINITY IN JOHN DONNE'S WRITINGS

Studies in Renaissance Literature

ISSN 1465-6310

General Editors
Brooke Conti
Jane Grogan
Ramona Wray

Studies in Renaissance Literature offers investigations of topics in English literature focussed in the sixteenth and seventeenth centuries; its scope extends from early Tudor writing, including works reflecting medieval concerns, to the Restoration period. Studies exploring the interplay between the literature of the English Renaissance and its cultural history are particularly welcomed.

Proposals or queries should be sent in the first instance to the editors, or to the publisher, at the addresses given below; all submissions receive prompt and informed consideration.

Professor Brooke Conti, Cleveland State University, English Department, Rhodes Tower, Cleveland, OH 44115, USA

Professor Jane Grogan, University College Dublin, School of English, Drama and Film, Newman Building, Belfield, Dublin 4, Ireland

Professor Ramona Wray, Queen's University Belfast, School of Arts, English and Languages, University Square, Belfast, BT7 1NN

Boydell & Brewer Limited, PO Box 9, Woodbridge, Suffolk, IP12 3DF

Previously published volumes in this series are listed at the back of this volume

Picturing Divinity in John Donne's Writings

Kirsten Stirling

D. S. BREWER

The prepress stage of this publication was supported by the Swiss National Science Foundation.

© Kirsten Stirling 2024

Some rights reserved. Without limiting the rights under copyright reserved above, any part of this book may be reproduced, stored in or introduced into a retrieval system, or transmitted, in any form or by any means (electronic, mechanical, photocopying, recording or otherwise)

The right of Kirsten Stirling to be identified as
the author of this work has been asserted in accordance with
sections 77 and 78 of the Copyright, Designs and Patents Act 1988

First published 2024
D. S. Brewer, Cambridge

ISBN 978-1-84384-707-6

This book is available under the Open Access license CC BY-NC-ND

D. S. Brewer is an imprint of Boydell & Brewer Ltd
PO Box 9, Woodbridge, Suffolk IP12 3DF, UK
and of Boydell & Brewer Inc.
668 Mt Hope Avenue, Rochester, NY 14620-2731, USA
website: www.boydellandbrewer.com

A catalogue record for this title is available
from the British Library

The publisher has no responsibility for the continued existence or accuracy of URLs for external or third-party internet websites referred to in this book, and does not guarantee that any content on such websites is, or will remain, accurate or appropriate

For Ian

CONTENTS

List of Illustrations ix
Acknowledgements xi

Introduction: Verbal and visual art 1
 Making and breaking images 1
 Donne's knowledge of art 6
 Dr Donne's art gallery 10
 Iconoclasm and anxiety in Donne's poetry 13

1. Shadows 23
 Portraits of Donne 24
 "His Picture" 30
 The picture in the heart 38
 Likeness 42

2. Art and the apophatic 51
 The "well-made and well-placed picture" 52
 The sculptor and the statue 57
 The *red glasse* 61
 The "curious masterpeece" and the *Imago Dei* 68

3. Annunciation: Representing the unrepresentable 77
 "In little roome": the circumscription of the divine 81
 Circumscription 86
 The Incarnate Word 88
 Swerving away from ekphrasis 90
 "A circle… whose first and last concurre" 94

4. Crucifixion 107
 Negative theology and "The Crosse" 108
 The *Deus Absconditus* and the Cross in Donne's Good Friday poem 115
 The "Picture of Christ crucified" 122
 This beauteous forme 130

5. Judgement — 135
 Resurrection. Imperfect. — 141
 The face of God in the Holy Sonnets — 146
 Imagined corners — 148
 Vision and revision — 150
 Ut pictura poesis — 153

Conclusion — 159

Bibliography — 163

Index — 173

ILLUSTRATIONS

Cover: Rogier van der Weyden (c. 1400–1464), Netherlandish, *Saint Luke Drawing the Virgin* (detail), c. 1435–1440. Oil and tempera on panel. Museum of Fine Arts, Boston, gift of Mr. and Mrs. Henry Lee Higginson, 93.153. Photograph © 2024 Museum of Fine Arts, Boston.

Image gallery follows p. 100.

1. John Donne, by Unknown English Artist. ("The Lothian Portrait") c. 1595. Oil on Panel. NPG 6790, © National Portrait Gallery, London.

2. Portrait of Dr. Donne, by William Marshall. Print used as frontispiece to various editions of his poems, 1635–1650. D25490, © National Portrait Gallery, London.

3. Annunciation Triptych (Merode Altarpiece). Workshop of Robert Campin. c. 1427–1432. Oil on oak. The Cloisters Collection, Metropolitan Museum of Art, New York.

4. Doom painting in St. Peter's Church, Wenhaston, Suffolk, England. Image © Simon Knott and reprinted by permission of the photographer.

5. *The Resurrection of Christ and the Women at the Tomb*, by Fra Angelico. c. 1439–1443. Fresco. Ministero per i Beni e le Attività Culturali, Polo Museale della Toscana, Museo di San Marco, Firenze.

6. *The Last Judgement*, by Joos van Cleve. c. 1525–1530. Oil on wood. Metropolitan Museum of Art, New York.

The author and publisher are grateful to all the institutions and individuals listed for permission to reproduce the materials in which they hold copyright. Every effort has been made to trace the copyright holders; apologies are offered for any omission, and the publisher will be pleased to add any necessary acknowledgement in subsequent editions.

ACKNOWLEDGEMENTS

This book has been a long time in the making, and a lot of things have happened since the first germ of an idea came to me in an undergraduate seminar on John Donne at the University of Lausanne in 2001. I would like to thank the students in that long-ago class and all my Donne students since who invariably help me to have ideas and let me test them out.

Earlier versions of parts of this book have been published in the *John Donne Journal*, *Word and Image*, *Études de Lettres*, and Russell Hillier and Robert Reeder's volume *Comparative Essays on the Poetry and Prose of John Donne and George Herbert*.

Much of the book was written in the context of the project "Space, Place and Image in the Poetry and Prose of John Donne", funded by the Swiss National Science Foundation from 2014–2018. Warm thanks to the SNSF for funding both this project and the Open Access publication of this book. I would like to thank my two doctoral students in that project, Kader Hegedüs and Sonia Saunier, for all their work, including their invaluable help in organising two international conferences and bringing the John Donne Society to Lausanne, but above all for developing and refining my ideas on Donne with their own scholarly work, as my current doctoral student, Ezra Benisty, continues to do.

The John Donne Society's conference is a bright spark in my year. I am immensely grateful for the feedback and encouragement I've received when presenting my work there, and for the many friends I've made who have read drafts and/or generally supported me, including but not only Greg Kneidel, Sean McDowell, Maria Salenius, Jeanne Shami, Achsah Guibbory, Brent Nelson, Kimberly Johnson, Jeff Johnson, Laura Yoder and Heather Dubrow.

The English Department of the University of Lausanne has been my academic home for twenty-five years; I would like to thank all my colleagues, past and present, who have made it such a congenial place to teach and research over the years, and a particular thank you to Neil Forsyth, without whom I would not have arrived here. I have presented work in this book at the conferences of both the Swiss Association for University Teachers of English and the Swiss Association of Medieval and Early Modern English Studies, and salute the lively scholarly community of English studies in

Switzerland. Another source of scholarly exchange and support is my participation in the SNSF-funded project "Poetry in Notions" – thanks to my project colleagues in English, French, German and Hispanophone poetry in Lausanne, Fribourg and Cergy Paris. Thanks to my colleagues in the Décanat of the Faculté des Lettres from 2021–2024 who have shown me that administrative responsibilities can be mixed with laughter and good will, and even leave a sliver of time for research. Thanks also to the earlier Décanat and Direction of the University who granted me a sabbatical leave in 2015 as well as two teaching load reductions, all of which contributed to the completion of this book.

It has been a real pleasure to work with Elizabeth McDonald at Boydell & Brewer. Her enthusiasm for the book and her care and attention to detail made the final furlong much easier than it might have been. Thanks also to the anonymous reader particularly for their helpful suggestions regarding structure. The image on the cover is thanks to a suggestion from Antoinina Bevan Zlatar.

Thanks to my mother, Moira Burgess and my brother, Peter Stirling, and to Lucy Perry for the haven of Friday nights. And thanks to Ian MacKenzie who has been there all through the long writing of this book, thanks for sharing in the epiphanies in many European and American art galleries and above all thanks for the painstaking reading and re-reading of every word!

INTRODUCTION: VISUAL AND VERBAL ART

> To adore, or scorn an image, or protest,
> May all be bad; doubt wisely; in strange way
> To stand inquiring right, is not to stray;
> To sleep, or run wrong, is. On a huge hill,
> Cragged and steep, Truth stands, and he that will
> Reach her, about must and about must go,
> And what the hill's suddenness resists, win so.
>
> John Donne, "Satyre 3", ll. 76–82[1]

This book proposes a new approach to the visual arts in the work of John Donne. While many other discussions of Donne and the visual arts concentrate on his knowledge of painting and the material visual culture of his time, this study argues that even Donne's explicit references to pictures are metaphorical and conceptual rather than material. Although his interest in and knowledge of visual art is clearly reflected in his writing, and the currents of Reformation iconoclasm feed into his expressed unease regarding images, Donne seldom if ever treats the visual artwork as an object in itself. Rather, the artwork is a metaphor, a way of approaching the immaterial or ineffable, a tool with which to test the limits of representation and particularly the representation of the divine. Donne's use of visual art goes beyond the reformers' debates about images in worship and can be traced to pre-Reformation theological treatises where the metaphor of a painting or a sculpture is employed to illustrate the nature of God or the relationship between human and divine.

MAKING AND BREAKING IMAGES

In *Iconoclasm and Poetry in the English Reformation*, Ernest Gilman wrote that "the making and breaking of images becomes Donne's figure for registering the deepest conflicts of his imagination".[2] The tension implied in that statement can be found in just about every reference Donne makes to visual

[1] "Satyre 3", Gary Stringer *et al.*, eds., *The Variorum Edition of the Poetry of John Donne. Volume 3: The Satyres* (Bloomington and Indianapolis: Indiana University Press, 2016), pp. 91–93 (p. 92).
[2] Ernest Gilman, *Iconoclasm and Poetry in the English Reformation: Down Went Dagon* (Chicago and London: University of Chicago Press, 1986), p. 135.

art in his writing. Every "image" that he evokes is made problematic in some way – broken, erased, or otherwise called into question. Donne's phrase "pictures made, and marrd", from the poem "Witchcraft by a Picture" (l. 6), sums up for Gilman the way that the visual is both conjured up and withheld in his poetry. The line is an apt description of the way material images are treated in Donne's work, and well describes the many contradictory impulses to be found in the criticism on the topic. To engage with the question of Donne and visual art is to enter into a convoluted discussion that is reminiscent of the "huge hill" of truth in "Satyre 3". I originally set out, naïvely and optimistically, to compare John Donne's religious poetry with visual art. After many turns around the hill, the book has ended up being more about the impossibility of comparing his writing to visual art.

But the path critics have taken in pursuit of Donne and the visual arts is both well-trodden and tortuous. While Annabel Patterson describes Donne's work as "larded with reference to painting in general and portraits in particular", Ann Hollinshead Hurley opens her study on Donne and visual culture with the statement that his verse "does not allude directly to specific paintings, pieces of sculpture, or similar artifacts".[3] These apparently opposed versions of the relationship between Donne's writing and the visual arts can serve as bookends for the widely differing ways in which critics have seen some visual influence in his work. The speaker of the Holy Sonnet "What if this present were the world's last night" imagines "the picture of Christ crucified" projected in his heart, and for R. V. Young this "suggest[s] a Spanish baroque painting". He goes on to find a contemporary "visual analogue" for the sonnet in Velázquez's *Christ on the Cross* (1599–1600).[4] Donne's sonnet sequence "La Corona", focusing on moments from the life of Christ, has similarly inspired visual parallels: Helen Gardner compares the sequence to a series of stained glass windows while Patterson reads it as an ekphrasis of an identifiable illustrated rosary manual.[5] Without identifying a specific artwork, Louis Martz seems to be responding to a similar quality in Donne's religious poetry when he describes the "graphically imaged openings" characteristic of his verse, "where the moment of death, or the Passion of Christ, or the Day of Doom is there, now, before the eyes of the

[3] Annabel Patterson, "Donne in Shadows: Pictures and Politics", *John Donne Journal* 16 (1997): 1–35 (p. 12); Ann Hollinshead Hurley, *John Donne's Poetry and Early Modern Visual Culture* (Selinsgrove, Susquehanna University Press, 2005), p. 13.

[4] R. V. Young, *Doctrine and Devotion in Seventeenth-century Poetry: Studies in Donne, Herbert, Crashaw, and Vaughan* (Cambridge: Boydell and Brewer, 2000), pp. 24–25.

[5] Helen Gardner, ed., *John Donne. The Divine Poems* (Oxford: Clarendon Press, 1952), pp. xxii–xxiii; Annabel Patterson, "Donne's Re-formed *La Corona*", *John Donne Journal* 23 (2004): 69–93 (p. 85).

writer, brought home to the soul by vivid 'similitudes'".[6] Joseph Lederer, and other critics following him, describes a "correspondence" between Donne's imagery and the emblem books of his time, with Donne either "lifting" his images directly from an emblematic source or simply using an image with an "emblematic cast".[7] Barbara Lewalski too picks up on Donne's use of the term "emblem" in "Upon the Annunciation and the Passion" and the "Hymne to Christ" as indicative of his "emblematic habit of mind", and identifies several emblems that may lie behind particular lines in the Holy Sonnets: the adamant heart of "Thou hast made me" and, particularly, the siege of the heart in "Batter my heart".[8] This collection of visual responses to Donne's poetry begins to illustrate the different ways in which verbal-visual parallels can be generated, and the different angles that word-and-image interpretations of his poetry can take.

Norman Farmer categorically states that Donne is not "a pictorialist writer in the sense that Sidney and Spenser are", while Patterson highlights his "frequent recourse to pictorialism".[9] These apparently contradictory claims may at least partly be explained by their different understandings of the term. Farmer is sticking closely to Jean H. Hagstrum's definition of "pictorialism" in *The Sister Arts*, where he claims that "in order to be called 'pictorial' a description or an image must be, in its essentials, capable of translation into painting or some other visual art ... must be imaginable as a painting or a sculpture".[10] Patterson seems rather to use the term to indicate any reference to a picture, without insisting on the descriptive quality or visualising function. These two different understandings of the term underlie much of the tension in the critical understanding of Donne as a "visual poet". A poet – notably Donne – may display great interest in pictures as objects, or in the function of painting, without engaging in the "pictorial" in Hagstrum's sense of the word, which would involve some sort of potential translation of literary content into visual art, or vice versa. While Donne's interest in and knowledge about works of visual art as

[6] Louis Martz, *The Poetry of Meditation: A Study in English Religious Literature of the Seventeenth Century* (New Haven: Yale University Press, 1954) (rev. ed. 1962), p. 31.

[7] Josef Lederer, "John Donne and the Emblematic Practice", *The Review of English Studies*, 22 (1946): 182–200 (p. 185). See also Mary Cole Sloane, *The Visual in Metaphysical Poetry* (Atlantic Highlands, NJ: Humanities Press, 1981).

[8] Barbara Kiefer Lewalski, *Protestant Poetics and the Seventeenth-Century Religious Lyric* (Princeton, NJ: Princeton University Press, 1979), p. 196; p. 202.

[9] Norman K. Farmer, Jr., *Poets and the Visual Arts in Renaissance England* (Austin: University of Texas Press, 1984), p. 19; Patterson, "Donne in Shadows", p. 14.

[10] Jean H. Hagstrum, *The Sister Arts: The Tradition of Literary Pictorialism and English Poetry from Dryden to Gray* (Chicago and London: University of Chicago Press, 1958), pp. xxi–xii.

material objects can be demonstrated fairly conclusively through biographical evidence and his own writing, attempts to read his poems as ekphrastic or "pictorial" tend to become over-general or far-fetched. While there are parallels to be made, Donne's engagement with the question of visual representation in these poems is much more complex, more intellectual and more problematising. "Seeing" for Donne is seldom simple, and his poems often resist "pictorial" visualisation in the manner of Hagstrum. This distance between Donne's demonstrable interest in visual art and how it filters into his poetry produces these divergent interpretations, and reflects, I would argue, Donne's own anxiety about the possibility of representation in both visual and verbal art. Yet at the moments where Donne's subject matter overlaps with a subject widely treated in visual art, the search for a "visual analogue" is sparked.

"Visual analogue" is a broad category, of course, and a useful catch-all for a number of kinds of comparison between literary texts and artworks. While literary ekphrasis is a recognised genre it is hard, despite the claims of some critics, to go very far in identifying any ekphrases of actual works of art, direct or indirect, in Donne's work.[11] Donne makes no explicit references to known paintings in his poetry, though his more general or "notional" ekphrases demonstrate a knowledge of the field.[12] But "visual analogues" may be based on a comparable use of subject matter, as in Young's comparison of Donne's "picture of Christ crucified" and Velázquez's painting cited above, or on a perceived structural parallel between literary or artistic techniques.

One of the most critically influential examples of this kind of attempt to find structural and stylistic parallels between Donne and the visual arts – though it extends well beyond Donne's poetry alone – is the approach found in Wylie Sypher's 1955 *Four Stages of Renaissance Style* and the work of Mario Praz, particularly his *Mnemosyne*.[13] The interart approach shared by Sypher and Praz relies on the notion of the *Zeitgeist*, proposing a direct parallel between visual and verbal art of approximately the same

[11] For a comprehensive discussion of literary ekphrasis see James A. W. Heffernan, *The Museum of Words: The Poetics of Ekphrasis from Homer to Ashbery* (Chicago: Chicago University Press, 2004).

[12] The phrase "notional ekphrasis" to describe literary representations of imagined works of visual art was coined by John Hollander, "A Poetics of Ekphrasis", *Word and Image* 4:1 (1988): 209–219 (p. 209).

[13] Wylie Sypher, *Four Stages of Renaissance Style: Transformations in Art and Literature 1400–1700* (Garden City, NY: Doubleday, 1955); Mario Praz, *Mnemosyne: The Parallel Between Literature and the Visual Arts* (Princeton: Princeton University Press, 1970). See also A. D. Cousins, "The Coming of Mannerism: The Later Ralegh and the Early Donne", *English Literary Renaissance* 9.1 (1979): 86–107.

period, and applying art history terminology as a basis for describing and interpreting literary texts. According to this logic Donne's poetry can be described as "mannerist" because of an "instability" in his style and his subject matter, a "troubled" sensibility that is also to be identified in Shakespeare's *Troilus and Cressida, Hamlet* and *Measure for Measure*, and which may be compared to the "skeletal forms" of Tintoretto and El Greco, and the "nervous complexity" and "opposing movements" of Parmigianino's "strange art".[14] Such "disquieting arrangements in literature and the visual arts" are a result of the "reversal of classical usage" typical of mannerist aesthetics.[15]

The trouble with this kind of analogy, as various critics have pointed out, is not only its subjectivity but the way it necessarily remains on the level of casual observations of general similarities.[16] Such interpretations can only provide partial readings of the poems because they are unable to get too close and see the moment that the visual analogy breaks down. As David Evett cautions, such an approach "needs to be careful of easy analogies".[17] Attempts to move closer in for sustained analysis of literary passages inevitably founder and end up sounding either ridiculous or banal, like Praz's comparison of the cupola, "the crowning feature of a church" with the "crowning effect of the tercets" in an Italian sonnet.[18] With reference to Donne's poetry particularly, Sypher finds in Parmigianino's *Self Portrait in a Convex Mirror* (1524) a "device for self-contemplation [that] is dramatically immediate, but preposterously contrived, like some of the self-regarding poems of Donne". Mario Praz, meanwhile, identifying the *linea serpentinata* as the "recurrent pattern of so much mannerist art", finds "Donne's tortuous line of reasoning [which] frequently takes the form of a statement, reversed at a given point by a 'but' at the beginning of a line" to be iconically paralleled by the "twisted motions" of a painting such as Salviati's *Bathsheba Betaking Herself to David* (1552–1554).[19]

[14] Sypher, *Four Stages*, pp. 101-104; pp. 110-111.
[15] Praz, *Mnemosyne*, pp. 90-91.
[16] Alastair Fowler, "Periodization and Interart Analogies", *NLH* 3:3, Literary and Art History (Spring, 1972): 487–509.
[17] David Evett, *Literature and the Visual Arts in Tudor England* (Athens and London: University of Georgia Press, 1990), p. 250.
[18] Praz, *Mnemosyne*, p. 87.
[19] Sypher, *Four Stages*, p. 112; Praz, *Mnemosyne*, p. 97; pp. 92-93.

DONNE'S KNOWLEDGE OF ART

For both Praz and Sypher, the serpentine line becomes a particularly apt motif for the mannerist tension they identify in Donne's poetry.[20] Sypher quotes, suggestively, in the opening pages of his chapter on Mannerism, the passage from Donne's "First Anniversary: An Anatomy of the World", in which "new Philosophy calls all in doubt", and where Donne uses the word "serpentine" to describe the assumed elliptical path of the sun, "cousening" or deceptive in more ways than one:

> … nor can the Sunne
> Perfit a Circle, or maintaine his way
> One inche direct; but where he rose to day
> He comes no more, but with a cousening line,
> Steales by that point, and so is Serpentine
>
> (The First Anniversary: An Anatomy of the World, ll. 268–272)[21]

The "cousening line" and disfigured proportion of this passage chime thematically with Mannerism's experimentation with techniques of disproportion and disturbed balance. Donne's use of the very word "serpentine" at one level seems to invite precisely this kind of parallel with the visual arts. Curiously though, despite both Sypher and Praz's focus on the serpentine line in their discussion of Donne, neither of them cites the sermon in which Donne uses the term "serpentine" in an undeniably painterly sense. In this sermon preached on the Penitential Psalms in the early 1620s Donne elaborates on a sinner's supplication to God:

> …it is a religious insinuation, and a circumvention that God loves, when a sinner husbands his graces so well, as to grow rich under him, and to make his thanks for one blessing, a reason, and an occasion of another; so to gather upon God by a rolling Trench, and by a winding staire, as *Abraham* gained upon God, in the behalfe of Sodome; for this is an act of the wisedome of the Serpent, which our Saviour recommends unto us, in such a Serpentine line, (as the Artists call it) to get up to God, and get into God by such degrees, as *David* does here… (5: 347)[22]

[20] Praz, *Mnemosyne*, pp. 79–105 (see p. 92); Sypher, *Four Stages*, pp. 156–159.
[21] Sypher, p. 101. "The First Anniversary: An Anatomy of the World", Stringer *et al.*, eds., *Variorum* 6, Anniversaries p. 13.
[22] George R. Potter and Evelyn M. Simpson, eds., *The Sermons of John Donne* 10 vols. (Berkeley and Los Angeles: University of California Press, 1952-1963). Hereafter cited in the text as *Sermons*.

Introduction: Visual and verbal art

As Liam Semler comments in his *The English Mannerist Poets and the Visual Arts*, Donne here "is undoubtedly referring to the *linea serpentinata* of mannerist art theory. He plainly acknowledges that it is a current technical term", as his parenthetical comment "(as the Artists call it)" makes clear. Semler speculates that the source of Donne's knowledge of the term may be Richard Haydocke's 1598 English translation of Giovanni Paolo Lomazzo's 1584 *Trattato dell'arte della pittura*.[23]

What is interesting here when considered against the interart comparison proposed by Sypher and Praz, is that this occurrence of the serpentine line in Donne's writing is not the product of an indeterminate collective *Zeitgeist* but rather a deliberate and signalled reference to the technical vocabulary of a field of the visual arts, which explicitly invokes the metaphors offered by interart comparison. Alastair Fowler observes, commenting on the application of art historical terminology to literature, "every interart comparison, even between two visual arts, involves a metaphor ... This is far from invalidating it, however, so long as the metaphor is sound".[24] Semler's attempts to outline a "mannerist poetic", unlike those of his predecessors, are grounded in a discussion of his subjects' demonstrable knowledge of visual art, establishing Donne's participation in a culture that was actively interested in and influenced by visual art.[25]

In many ways, Semler's chapter sets the scene for the most extensive study of this kind to date, Hurley's *John Donne's Poetry and Early Modern Visual Culture* (2005). Declaring it essential to take into account the influence of visual culture on literary production, Hurley describes Donne as a particularly "intriguing instance of a poet operating under the influence of the visual aspects of his culture, and one who was quite sophisticated in both his awareness and in his responses, even modifications, of that influence".[26] Both Semler and Hurley are keen to establish what works Donne may have read and seen and to trace his known personal relationships to painters and their associates, suggesting for example that he was probably familiar with recent treatises on art, such as Haydocke's translation of Lomazzo's 1598 treatise, and Nicholas Hilliard's *The Art of Limning* (1598–1603).[27] For both Semler and Hurley, some of Donne's comments on visual art, particularly in

[23] L. E. Semler, *The English Mannerist Poets and the Visual Arts* (Madison and Teaneck: Fairleigh Dickinson University Press and London: Associated University Press, 1998), p. 51.
[24] Fowler, "Periodization", p. 499.
[25] Semler, *English Mannerist Poets*, pp. 46–55. Besides Donne, Semler's book discusses Robert Herrick, Thomas Carew, Richard Lovelace and Andrew Marvell.
[26] Hurley, *John Donne's Poetry*, p. 13.
[27] Hurley, *John Donne's Poetry*, p. 30; Semler, p. 47.

the sermons, are reminiscent of these contemporary treatises, even though he cites neither of them directly.[28]

As Semler points out, Donne's passing reference to "Durers rules" to describe the symmetry of the body in Satyre 4 (l. 204) suggests at least an awareness of some of Albrecht Dürer's writings on geometry and human proportion.[29] The most compelling reference to the world of visual art in his poetry, though, must be his mention of Nicholas Hilliard in the opening lines of the verse letter "The Storme", to Christopher Brooke:

> a hand, or eye
> By Hilliard drawne, is worth an historie
> By a worse painter made; And without pride,
> When by thy iudgment they are dignified,
> My lines are such; (ll. 3–7)[30]

The direct reference to Hilliard shows, at the very least, that Donne was aware of the work of a contemporary artist; it is one of the key moments often cited to establish Donne's credentials in matters of visual art.[31] It has been somewhat tenuously proposed that the earliest known portrait of Donne himself, the engraving by William Marshall dated 1591 that appears as a frontispiece to the revised 1635 edition of Donne's *Poems*, was based on an original portrait miniature by Nicholas Hilliard, and the poem is often cited in conjunction with this claim, despite the fact that very little evidence supports it.[32] If Donne had sat for Hilliard, Semler argues, this strengthens the assumption that he might have had access to treatises such as Haydocke's translation of Lomazzo.[33] But even without the tantalising possibility of a

[28] Semler, *English Mannerist Poets*, pp. 48–49; Hurley, *John Donne's Poetry*, pp. 174–6.

[29] Semler, *English Mannerist Poets*, p. 47. Albrecht Dürer, *Elementa geometrica* (Paris, 1532); *De symmetria partium humanorum corporum* (Nuremberg, 1528); *Quatuor libri geometriae … De symmetria* (Paris, 1535). See Lucy Gent, *Picture and Poetry 1560-1620* (Leamington Spa: James Hall, 1981), p. 83 and n. on known copies of Dürer's writings in English collections.

[30] Jeffrey S. Johnson *et al.*, eds., *The Variorum Edition of the Poetry of John Donne. Volume 5: The Verse Letters* (Bloomington and Indianapolis: Indiana University Press, 2019), p. 5.

[31] Hurley, *John Donne's Poetry*, 15; Martin Elsky, "John Donne's La Corona: Spatiality and Mannerist Painting". *Modern Language Studies* 13.2 (1983): 3–11 (p. 11 n.2).

[32] This theory seems to have originated with the poet and art historian Laurence Binyon, is mentioned by Grierson in *The Poems of John Donne* (Oxford: Clarendon Press, 1912, vol. 2, 134), and has developed into a bit of a biographical commonplace: see John Bryson, "Lost Portrait of Donne", *The Times*. (London) October 13, 1959: p. 15; Helen Gardner, ed., *The Elegies and The Songs and Sonnets* (Oxford: Clarendon Press, 1965), p. 143; p. 266.

[33] Semler, *English Mannerist Poets*, p. 49.

Hilliard portrait of him, in these lines Donne seems, in Hurley's words, to be "explicitly thinking about portraiture as opposed to historical painting", suggesting a certain knowledge about hierarchies of painting.[34] All of this reinforces the impression that Donne was aware of contemporary practice and theory in visual art, but most interestingly these lines show him comparing his own "lines" to the "hand or eye" drawn by Hilliard.

Donne's Hilliard comparison, in fact, is in harmony with the Renaissance celebration of Horace's simile *ut pictura poesis* from his *Ars Poetica*, but more on the side of theory than of practice.[35] Rather than writing poems that enact the principle of poetry resembling painting, Donne participates rhetorically in the dissemination of the idea, just as Sidney does in his *Apology for Poetry* when he describes poetry as "a speaking picture".[36] As with his reference to the "serpentine line (as the Artists call it)", Donne deliberately invokes visual art – and particularly, the action of the painter – as a metaphor. He seems less interested in the finished artwork itself than in the process of its production, an idea supported by another painterly metaphor in the love elegy "The Expostulation", where the speaker compares the process of courting a woman to "Painters that doe take / Delight, not in made worke, but whiles they make."[37] As Hurley also observes, "in his sermons, his letters, his poetry, Donne refers to painting atypically for his time, that is with attention to the craft of the artist or to the handling of painting's material properties, in a fashion that sets him apart it is not an end in itself".[38]

The serpentine line and the Hilliard hand or eye are two of Donne's most explicit allusions to visual art, and yet they are far from what Hagstrum would term "pictorial" – the description that is "imaginable as a painting". While "pictorial" may be the wrong word, Donne's references here could perhaps be described as "painterly", because his metaphor relies on a detail

[34] Hurley, *John Donne's Poetry*, p. 36. Peter De Sa Wiggins suggests that the lines may imply that Donne is aware of the hierarchy of painting outlined in Alberti's *De Pittura* (1441). Peter De Sa Wiggins, "Giovanni Paolo Lomazzo's *Trattato dell'Arte Della Pittura, Scultura et Architettura* and John Donne's Poetics : 'The Flea' and 'Aire and Angels' as Portrait Miniatures in the Style of Nicholas Hilliard", *Studies in Iconography* 7–8 (1981-1982): 269–288 (p. 270). Cited by Semler, *English Mannerist Poets*, p. 56.
[35] On the doctrine of *ut pictura poesis*, see Rensselaer W. Lee, *Ut Pictura Poesis: The Humanistic Theory of Painting* (New York: Norton, 1967).
[36] Philip Sidney, *The Defence of Poesy*, in *Sidney's 'The Defence of Poesy' and Selected Renaissance Literary Criticism*, ed. by Gavin Alexander (London: Penguin, 2004), p. 16.
[37] "Elegy 16: The Expostulation", ll. 57–58. Stringer *et al.*, eds., *Variorum 2 Elegies*, p. 370.
[38] Hurley, *John Donne's Poetry*, p. 163.

that acknowledges the craft and the skill of the painter. Hagstrum himself indeed goes on to observe that Donne himself "very seldom uses images from painting or sculpture... Donne appears less interested in portraits as works of art than in the way they appear to stare at you from wherever you stand."[39] This recurrent image from the *Sermons* of a "a well-made, and well-plac'd picture, [which] looks always upon him that looks upon it"[40] will be discussed in detail in Chapter 2; it does indeed seem to have "caught Donne's fancy"[41] although it does not originate with him. Hagstrum's observation pinpoints the fact that when Donne refers explicitly to visual art, he does so by referring to how the work of art is made, and/or how it functions when it is seen; he tends not to describe its subject matter. While there are very few actual descriptions of paintings in Donne's poetry or sermons, references to the frames and functions of visual art are more common.

DR DONNE'S ART GALLERY

Donne's metaphor of the "well-made, and well-plac'd picture, [which] looks always upon him that looks upon it" depends upon the viewer's engagement with the artwork, the dynamic between the viewer and the artwork. Although any discussion of Donne's actual appreciation of visual art during his lifetime must remain speculative, bequests in his will, and bequests made to him in the wills of others, allow the reconstruction of "Dr Donne's art gallery", to use the title of Wesley Milgate's article which does just that.[42] Donne's own will makes mention of twenty paintings, eighteen of which are named or described. These include some of the portraits of Donne himself, as well as a number of paintings with religious subject matter, such as the "Picture of the blessed Virgin Marye which hanges in the little Dynynge Chamber... the picture of Adam and Eve which hanges in the great Chamber"; "the Picture of the B: Virgin and Joseph which hanges in my Studdy" and "the fower large Pictures of the fower greate Prophettes which hange in the Hall".[43] Milgate's article leaves us with the impression of Donne in the Deanery of St Paul's surrounded by pictures; in Gilman's words, "[his collection] was surely large enough to have filled nearly every corner of Donne's little world with imagery".[44] Not only does Milgate's article

[39] Hagstrum, *Sister Arts*, p. 113; citing Milton Alan Rugoff, *Donne's Imagery* (New York: Russell and Russell, 1962), p. 109.
[40] *Sermons*, 2: 237; Cf. *Sermons* 4: 130; 5: 299; 9: 368.
[41] Rugoff, *Donne's Imagery*, p. 109.
[42] Wesley Milgate, "Dr Donne's Art Gallery", *Notes and Queries* (1949): 318–319.
[43] "Donne's Will", R. C. Bald, *John Donne: A Life* (Oxford: Clarendon Press, 1970), Appendix D.II; p. 563; p. 564.
[44] Gilman, *Iconoclasm*, pp. 120–121.

reconstruct Donne's visual world, but it also reconstructs, to some extent, Donne's place in a network of friends who were connoisseurs of painting. Christopher Brooke, the addressee of the verse letter "The Storme" with its mention of Hilliard, bequeaths to Donne in his will "a peece of Apollo and the Muses – being an originall of an Italian master's hand as I have bin made to believe".[45] And more tantalisingly still, Milgate proposes that the painting Donne bequeathed to James Hay, Earl of Carlisle, "the Picture of the blessed Virgin Marye which hanges in the little Dynynge Chamber", was the same one listed in Abraham van der Doort's catalogue of Charles I's collection as "done by Titian; being our Lady, and Christ, and St John [...] given heretofore to his Majesty by my Lord of Carlisle, who had it of Dr Donn, painted upon the right light".[46] Efforts to track down this possible Titian, which was redistributed with the rest of Charles I's collection after the Revolution, have so far not yielded any concrete results.[47] Without the painting itself this attribution cannot be confirmed. Nevertheless, the possibility that Donne owned a Titian allows Hurley to identify him as a "connoisseur" of art.[48]

In reconstructing, as far as possible, Donne's "art gallery" as a background to exploring his treatment of visual art in his writing, we may run the risk of assuming that we know how he looked at the paintings he saw and projecting anachronistic assumptions about attitudes to and perceptions of visual art onto the seventeenth century. In an article attempting to qualify the many attempts to find visual sources (primarily Italian) for Milton's *Paradise Lost*, Michael O'Connell has argued that we should be wary of such easy parallels, arguing that Milton, as an English Protestant, would have seen visual art, particularly that with a religious theme, in a very different way from either his Italian Catholic contemporaries or his twentieth-century readers.[49] Milton himself makes no comment at all on the visual art he encountered, and O'Connell points out that English travellers of the period in general have very little to say about the artworks they saw and the artists who made them. He attributes this not only to "Protestant wariness of idolatry" but also to the fact that, partly due to Reformation iconoclasm, the English were "untrained in habits of perception, not only of

[45] Milgate, "Dr Donne", p. 318.
[46] Milgate, "Dr Donne", pp. 318–319.
[47] The story so far has been reconstructed by Dennis Flynn, "John Donne's Titian: What was it, how did he get it, and what does it mean for us?" Many thanks to Dennis Flynn for sharing this unpublished article with me.
[48] Hurley, *John Donne's Poetry*, p. 163.
[49] Michael O'Connell, "Milton and the Art of Italy: A Revisionist View", in Mario A. Di Cesare, *Milton in Italy: Contexts, Images, Contradictions* (Binghamton, NY: Medieval and Renaissance Texts and Studies, 1991), pp. 215–236.

its iconology but also of the complexities of mannerist and baroque styles".[50] Lucy Gent similarly urges caution in making too many assumptions about the knowledge and appreciation of art of Donne's contemporaries, commenting that "the desperate shortage in sixteenth-century English of terms to do with art is a clear index of a lack of contact with works of art being produced, or recently produced, in Italy or France".[51] The same caution should apply to any claims we make regarding Donne and the visual culture of his time. Although, unlike Milton, Donne's Catholic upbringing may well have given him a different perspective on devotional art, the biographical journey bridging his Catholic youth and his Protestant ministry cannot be assumed to mean that his attitude to images was any simpler or more easily described – rather, the contrary. As with his attitude to visual art generally, it is hard to pin Donne down to any clear stance regarding the iconoclasm linked to the Reformation that spread through England in the 1530s and 1540s, and on the debates that continued during his lifetime.[52]

The risk of assuming simple equivalences between how people see visual art in different cultures and different periods is another reason to be wary of the interart *Zeitgeist* comparison proposed by Mario Praz and Wylie Sypher. The verbal-visual parallels identified by Sypher, Praz and later critics tend to be between English literature and Italian Renaissance art. The mannerist instability and doubt that they identify in poetry and painting alike is said to reflect a loss of Renaissance certainty that affects Catholic and Protestant sensibilities equally, and Sypher indeed refers grandly to "the mannerist God of Donne and Calvin and the Jesuits [who] imposes his will by fiat, and [whose] justice is despotic, inexplicable, perhaps equivocal".[53] But even if this was not the primary intention of Sypher and Praz's project, the fact that the visual analogues evoked are all (perhaps inevitably) Continental, Counter-Reformation works, skews their argument towards a Catholic interpretation of Donne, particularly when his religious poems are under consideration.

This is made explicit in Murray Roston's *The Soul of Wit*, which situates Donne's poetry within a Counter-Reformation philosophy and aesthetic by placing Sypher and Praz's interart approach alongside the theory developed in the 1950s by Gardner and Martz, that Donne's Holy Sonnets in general

[50] O'Connell, "Milton", p. 223.
[51] Gent, *Picture and Poetry*, p. 16.
[52] See Margaret Aston, *England's Iconoclasts. Volume 1: Laws Against Images* (Oxford: Clarendon, 1988) and *Broken Idols of the English Reformation* (Cambridge: Cambridge University Press, 2016); John Phillips, *The Reformation of Images: Destruction of Art in England 1535–1660* (Berkeley, Los Angeles and London: University of California Press, 1973).
[53] Sypher, *Four Stages*, pp. 132–133.

follow the pattern of meditation prescribed in the *Spiritual Exercises* of St Ignatius of Loyola (1548).[54] Comparing Donne's poetry with paintings by artists such as Tintoretto and El Greco, Roston argues that the destabilising techniques of mannerist art, such as "the unexpected angle of vision, the convulsed figures… the inversion of perspective, or the shocking hues" are "remarkably close to those developed in Donne's verse".[55]

Perhaps this is what we can take away from Sypher and Praz's interart comparison. Leaving aside the over-generalised analogies, and the elision of historical and cultural differences between England and Italy, their intuition that there is a visual aspect to Donne's poetry remains worth pursuing. What they identify is a disquieting, destabilising visual quality that, finally, is not a million miles away from Gilman's observations regarding "the crosscurrents of attraction and repulsion flowing through Donne's preaching on the image", and through his poetry. Gilman locates the unsettling visual quality in Donne's poetry firmly in the context of the iconoclastic controversy in England: "a man split between the Roman and the Reformed church, Donne would seem to have absorbed both sides of the iconoclastic controversy into the language of his little world, where their antagonism remains fully charged".[56]

ICONOCLASM AND ANXIETY IN DONNE'S POETRY

The sermon most consistently cited in discussions of Donne and iconoclasm was one preached at Paul's Cross in 1627 in which he addresses the iconoclastic controversy directly. As Patterson points out, this is Donne's "only definitive statement" on the subject. As a public sermon, it cannot be interpreted as offering any insight into Donne's private, personal views on the matter, and indeed, as Patterson demonstrates, it has to be read in the context of the shifting political climate of 1626–1627.[57] Making direct reference to Calvin's *Institutes* and the Elizabethan *Injunctions* of 1559, Donne outlines the objections to holy images but turns the arguments against images around to make the case that they are "indifferent" objects. This sermon echoes what we have already observed, that Donne seems much

[54] Martz, *Poetry of Meditation*, pp. 43–53; Gardner, "Introduction", *Divine Poems*, pp. l–lv.
[55] Murray Roston, *The Soul of Wit: A Study of John Donne* (Oxford: Clarendon, 1974), p. 166; p. 160. Cf. Martin Elsky, "John Donne's *La Corona*", pp. 3–11; Louis Martz "English Renaissance Poetry: From Renaissance to Baroque", in *From Renaissance to Baroque: Essays on Literature and Art* (Columbia: University of Missouri Press, 1991), pp. 3–38.
[56] Gilman, *Iconoclasm*, p. 135.
[57] Patterson, "Donne in Shadows", p. 20; pp. 22–26.

more interested in the frames and functions of images – both their material composition and the use that is made of them – than their actual content:

> since, by being taught the right use of these pictures, in our preaching, no man amongst us, is any more enclined, or endangered to worship a picture in a Wall or Window of the Church, then if he saw it in a Gallery, were it onely for a reverent adorning of the place, they may be retained here, as they are in the greatest part of the Reformed Church, and in all that, that is *properly Protestant*. (7: 432)

As a marginal note, "1 Eliz. 1599", indicates, here Donne is picking up on the language of the 1559 *Injunctions* which dictates the removal of "pictures, paintings, and all other monuments of feigned miracles, pilgrimages, idolatry, and superstition, so that there remain no memory of the same in walls, glass windows, or elsewhere within their churches and houses".[58] But as both Patterson and Gilman point out, Donne "inverts" the position taken by the Elizabethan *Injunctions* on religious images in the home. Where the injunction states that religious images should not be moved from church to the home, Donne represents this as stating that anything acceptable in a home is also acceptable in a church: "that Injunction ... forbids nothing in the Church, that might be retained in the home" (432). He also takes "astonishing liberties" with Calvin in citing him as an authority for his statement that "where there is a frequent preaching, there is *no necessity* of pictures", which he immediately follows up with his own observation that "if the true use of Pictures be preached unto them, there is *no danger* of an abuse" (432).[59]

Donne's balanced defence of images in the sermon concludes with this often-quoted, apparently even-handed take on the matter:

> *Væ Idolalatris*, woe to such advancers of Images, as would throw down Christ, rather then his Image: But *Væ Iconoclastis* too, woe to such peremptory abhorrers of Pictures, and to such uncharitable condemners of all those who admit any use of them, as had rather throw down a Church, than let a Picture stand. (7: 433)

The rhetorical balance between idolaters and iconoclasts here leaves the sermon passage open to a variety of interpretations. For Evelyn Simpson, Donne here "springs eagerly to the defence of pictures in church, whether in glass or on a wall, as aids to devotion or instructors of the ignorant", commenting also that Donne "never at any time showed any sympathy with

[58] "The Injunctions of 1559", Henry Gee and W. H. Hardy, eds., *Documents Illustrative of English Church History* (New York, 1896), pp. 417–442.
[59] Patterson, "Donne in Shadows", p. 24.

the Puritan attack on ceremonies, pictures and 'masses.'"⁶⁰ Her quotation though, starting only with "*Væ Iconoclastis...* " somewhat misrepresents Donne's position. Jeffrey Johnson observes that "strictly speaking, Donne relegates the use of external pictures and images as a formal element of worship to the category of 'things indifferent.'"⁶¹ But rather than placing him definitively on the spectrum of opinion on the iconoclastic controversy, the sermon passage is perhaps revealing for our understanding of Donne's attitude to images because it is poised between image and iconoclasm. Both Gilman and Patterson highlight the ways in which Donne undoes iconoclastic pronouncements in this sermon. But through its juxtaposition and balancing of the "advancers" and the "abhorrers" of images, rhetorically this passage both "throws down" images and "lets them stand". In doing so it reproduces the inherent contradiction of many iconoclastic acts. As Alexandra Walsham has observed, in many of the "acts of ritual destruction" undertaken by the iconoclasts, there is a marked tension between the desire to "extinguish sacred sites and structures...completely" and the "instinct to preserve mutilated residues of the vanquished past as enduring evidence of Protestantism's glorious triumph".⁶² The "broken idols" themselves, she argues, also have a memorialising function.

In his *The Reformation of the Image*, Joseph Leo Koerner addresses such contradictions and tensions in iconoclasm through a study of Lutheran art of the early Reformation, in particular Lucas Cranach's altarpiece in Wittenberg. Much of his detailed analysis of Cranach's art, and the dynamics of Reformation images more generally, resonates with the doubleness we observe in Donne's references to visual art. Koerner makes the point that not only is there a contradictory impulse towards preservation inherent in iconoclasm, there is also a sense in which "the Christian image was iconoclastic from the start ... meant to train our eyes to see beyond the image, to cross it out without having to do something so undialectic as actually destroying it".⁶³ The dialectics of Luther's own stance on visual art is an important context for Donne's approach to the image question, and Luther's anti-iconoclastic treatise *Wider die himmlischen Propheten, von den Bildern*

60 Evelyn M. Simpson, "The Biographical Value of Donne's Sermons", *The Review of English Studies*, 2.8 (1951): 339–357 (p. 347).
61 Jeffrey Johnson, *The Theology of John Donne* (Cambridge: D. S. Brewer, 1999), p. 64; p. 66.
62 Alexandra Walsham, "Sacred Topography and Social Memory: Religious Change and the Landscape in Early Modern Britain and Ireland", *Journal of Religious History* 36.1 (2012): 31–51 (p. 41). See also Margaret Aston, "Public Worship and Iconoclasm", in *The Archaeology of Reformation 1480–1580*, ed. by D. Gaimster and R. Gilchrist (Leeds: Maney, 2003), pp. 9–28 (pp. 16–17).
63 Joseph Leo Koerner, *The Reformation of the Image* (London: Reaktion, 2004), p. 12.

und Sakrament (1525)[64] is a likely source for one of Donne's most striking religious "pictures": the picture of Christ crucified "marked in the heart" in his Holy Sonnet "What if this present were the world's last night."

It is this dialectic around images, explored so delicately by Koerner in *The Reformation of the Image*, that Gilman picks up on in his work on the image question in Donne's writing. His claim that "the making and breaking of images becomes Donne's figure for registering the deepest conflicts of his imagination"[65] with which I began the chapter is epitomised by the quotations he chooses for his titles: "Donne's 'Pictures Made and Mard'", from "Witchcraft by a Picture", is the title of the chapter on Donne in his *Iconoclasm and Poetry*, and "To adore, or scorne an image..." serves as the title for an earlier version of the chapter, published in the *John Donne Journal* in 1986.[66] Gilman's selection of these two quotations as titles sum up the tension between "form" and "deformity" that he identifies as fundamental to Donne's engagement with images: "one hand forming sacred images that the other hand deforms as profane", as he concludes his chapter.[67] The chapter opens, however, with Donne's image of the "huge hill" of Truth that immediately follows the "adore, or scorne an image" line in Satyre 3:

> On a huge hill,
> Cragged and steep, Truth stands, and he that will
> Reach her, about must and about must go,
> And what the hill's suddenness resists, win so. (Satyre 3, ll. 79–82)[68]

Gilman acknowledges the possible iconographic sources of the allegorical representation of Truth and the "huge hill", proposing the allegorical female personifications of Ripa's *Iconologia* or the *Tabula Cebetis*. He does so, however, in order to argue that "the iconographic potential of Donne's 'Truth' fades as he urges us on to the rigors of the climb itself". For Gilman this is a prime example of the gap between Donne's evident interest in visual art and his apparent avoidance of images. Strangely, he makes his point most clearly in a footnote. Countering Paul Sellin's claim that Satyre 3's hill is an ekphrasis of Donne's medallion commemorating the Synod of Dort with "Jehovah hover[ing] ... invisible behind a cloud" at the top of the hill, Gilman insists that his point is, rather, that "in his poetic ascent Donne

[64] *D. Martin Luther's Werke. Kritische Gesamtausgabe*, ed. by J. F. K. Knake (Weimar: Hermann Bohlaus Nachfolger, 1883–1997), 18: 37–214.
[65] Gilman, *Iconoclasm*, p. 135.
[66] Ernest Gilman, "'To adore, or scorne an image': Donne and the Iconoclast Controversy", *John Donne Journal* 5 (1986): 63–100.
[67] Gilman, *Iconoclasm*, p. 148.
[68] Stringer *et al.*, eds., *Variorum 3: Satyres*, p. 92.

approaches, but then swerves away from, [the] idolatrous prospect, evoking but then effacing the picture behind his text".[69]

Gilman's description here of the speaker of Satyre 3 approaching yet "swerving away from" the image, the "picture behind the text" both evoked and erased, puts into words the way my own interest in this topic began: the double process that I noticed in one poem that sparked off the whole project. While teaching a class on "At the round earth's imagined corners" it suddenly occurred to me that the Holy Sonnet could be formally and structurally illuminated by comparison with the spatial construction of sixteenth-century paintings of the Last Judgement. The comparison was not sparked by any "pictorial" description, in Hagstrum's terms, although the angels blowing their trumpets and the souls arising from death may invite parallels with the iconographic tradition of painted representations of Judgement. Rather, what caught my attention was that Donne evokes these details in the context of a spatial mapping that achieves effects similar to the painted tradition of the scene, by way of a management of space, and the evocation of a tension between order and chaos. In the sonnet the list of all those who have died – "All whome Warre, death, age, agues, Tyrannies, / Despaire, Lawe, Chaunce, hath slayne" (6–7) – crowds the end of the second quatrain with far too many stresses, and expands the lines almost beyond the possibilities of the iambic pentameter.[70] This seemed to me to parallel the way the "numberles Infinities / Of soules" (3) crowd the space of paintings of the Last Judgement, sometimes threatening to spill over the edges of the frame. It is not only the "imagined corners" of the first line that conjure up the scene of Judgement in Donne's sonnet, but the play with the pattern of the metre that creates a spatial effect.

Although this means that the lines are, arguably, "capable of translation into painting" the process is quite different from the descriptive "pictorial" quality that Hagstrum describes.[71] Most importantly, though, if a "visual analogue" is generated by the words of this sonnet, it is incomplete. The angels with their trumpets, the bodies of the resurrected, the spatial logic of Judgement are all there in the octave, but the centre of the "image", the figure of the Judge, is notably missing. With the lines "*you* whose eyes / *Shall* behold God and neuer tast Deaths woe" (7–8, my emphasis) the sonnet opens up to include the people alive at the moment of the Last Judgement, and promises the sight of God's face. But this vision is withheld, and the abrupt turn to the horizontal in the sestet with "But let them sleepe, Lord..."

[69] Gilman, *Iconoclasm*, p. 117; p. 213n.2. Cf. Paul R. Sellin, "The Proper Dating of John Donne's 'Satyre III'" *Huntington Library Quarterly* 43:4 (Autumn, 1980): 275–312 (p. 282 ff.).

[70] Stringer *et al.*, eds., *Variorum 7.1: Holy Sonnets*, p. 8.

[71] Hagstrum, *Sister Arts*, pp. xxi–xxii.

removes this prospect, not only postponing the moment of Judgement for another season but also effectively cancelling the picture that the octave of the sonnet had promised.

The *volta* of the sonnet enacts the "swerving away" that Gilman remarks on, the "evoking but then effacing the picture behind the text". The image is simultaneously made present and cancelled, at once "made and marred". If this, according to Gilman, is the dynamic that defines Donne's poetic imagination, what exactly is going on here? In this sonnet, what seems to be at stake is the representation of the divine. The moment where the spatial and pictorial potential of the sonnet collapses is when the octave fails to represent the face of God in the scene of Judgement. In this sense the resistance could be interpreted as being in line with the concerns of the reformers, and it is certainly in Donne's religious poems that we find the most compelling examples of "turning away" from visual images: most notably perhaps in "Goodfriday 1613, Riding Westward", where the speaker does *not* see the "spectacle" of the Crucifixion and "turns [his] back" on God.

It would be too simple, though, to state that Donne's apparent anxiety regarding visual art simply reflects the reformers' fear of idolatry; he seems to swerve away not only from the vision of the divine but from the image itself; the same pattern can be identified in his secular poetry too. He addresses the limits of representation most directly in some of his elegies, epigrams and songs and sonnets, and these are discussed in Chapter 1. His elegy "His Picture" is one of the few poems that undeniably stages a painting, and here we witness Donne's characteristic fascination with the mechanics of painting and seeing, and in visual art as a metaphor. But we also see the same swerving away from the potentially pictorial that Gilman has described. Repeatedly, in poems such as "Phrine" and "Sappho to Philaenis", Donne questions to what extent art can create a "likeness" of reality. All representational art, not just religious art, is called into question.

Contemplation of the divine, though, adds another layer to his problematisation of the visual, and Donne often uses the idea of the "picture" to approach the ineffable in his divine poems and in his *Sermons*. Hurley has commented on Donne's interest in the craft of the artist and the material properties of paintings, but she also observes that in the sermons and the letters the reference Donne makes to visual art "is not an end in itself ... it is largely incidental, mentioned through analogy or in passing".[72] It is perhaps not surprising that in a sermon Donne would refer to visual artworks not as objects in themselves but as metaphors or analogies to illustrate his

[72] Hurley, *John Donne's Poetry*, p. 163. She claims that "it is in the poems, rather, particularly in the verse letters where [Donne's aesthetic response] receives its full development".

theological or pastoral points, and visual art is just one small part of the repertoire of metaphors and illustrations he draws on. Yet the sermons provide valuable clues as to Donne's sources for some of his most compelling visual art metaphors which help to illuminate the ways he uses visual art to give shape to theological mysteries. Semler and Hurley, most notably, have argued that Donne's evident knowledge regarding painterly practice in the sermons may come from contemporary treatises on visual art such as Lomazzo or Hilliard.[73] While Donne is a magpie in his acquisition of images and metaphors from a wide range of sources, it appears, as I discuss in Chapter 2, that some of his most sustained visual art metaphors can be traced, instead, to theological treatises – specifically Nicholas of Cusa's *De Visione Dei* and the *Mystical Theology* of Pseudo-Dionysius the Areopagite. These seem to be sources not only of the metaphors but of Donne's overall method of using the material image to illuminate the immaterial. This locates Donne's thinking about images in a long tradition of using visual art metaphorically to approach the ineffable, which helps in the interpretation of the visual and spatial logic of his visual references in many of his divine poems.

The interlinked sonnet sequence "La Corona" provides a good example of his spatial metaphors. Often considered as evidence of Donne's lingering Catholic devotional practices because of the emphasised presence of the Virgin Mary, the sequence both invites and frustrates visualisation of these scenes from the lives of Mary and Christ. For George Klawitter, "La Corona"'s Annunciation and Nativity sonnets, along with Donne's occasional poem "On the Annunciation and the Passion falling upon one day. 1608", are "conventional in their Marian images".[74] I argue in Chapter 3, however, that Donne's evocations of the Annunciation are far from the pictorial visualisation of the scene that this would seem to imply. Rather, we witness once again a "swerve away from" these conventional images towards a set of spatial and conceptual paradoxes that highlight the representational conundrum of the incarnation. If a "visual analogue" is sparked by these meditations on Annunciation, it is more formal than pictorial. Parallels can be drawn between Donne's spatial paradoxes and the methods of fifteenth-century Italian painters who played with the newly developed technique of linear perspective in order to demonstrate how the divine always escapes from human comprehension and human reality.

[73] Semler, *English Mannerist Poets*, pp. 48–49; Hurley, *John Donne's Poetry*, pp. 174–176.
[74] George Klawitter, "John Donne's Attitude toward the Virgin Mary: The Public versus the Private Voice", in *John Donne's Religious Imagination: Essays in Honor of John T. Shawcross*, ed. by Raymond-Jean Frontain and Frances M. Malpezzi (Conway AR: UCA Press, 1995), 122–140 (p. 126).

Donne uses similar formal strategies when he directly addresses the paradox of Christ's Crucifixion. In his long poem "The Crosse" he asks, "who from the Picture would avert his Eie?" (7),[75] and in the Holy Sonnet "What if this present were the world's last night", the speaker conjures up "the Picture of Christ crucified" (3).[76] But none of these pictures proves to be simple. The depiction of Christ's Crucifixion and the simple representation of his cross were contested images in Reformation England, and in different ways, all of Donne's poems dealing with the cross considered in Chapter 4 address the difficulty of seeing the Crucifixion. The sonnet's "Picture of Christ crucified" is projected into the heart; the speaker of "Goodfriday 1613" insists on looking in the opposite direction from the Crucifixion; and "The Crosse", often read as a simple anti-iconoclastic defence of the devotional object, multiplies cross images that overlap and contradict each other until the symbol becomes unreadable. In all of these poems Donne addresses the destruction already written into the iconography of the crucifix, and finds that the image of the cross cancels itself out.

As mentioned, Donne's recurrent meditation on the Last Judgement was the starting point for my investigation, the Holy Sonnet "At the round earth's imagined corners" being the source of my intuition that the mapping out of the sinner's salvation has a spatial logic that bears comparison with painted representations of the scene. The deferring of the sight of the face of Christ in that sonnet is echoed in other Holy Sonnets, highlighting a new problem contained within the larger issue of the representation of the divine: how to make present the figure of the glorified Christ. Donne's Last Judgement poems, considered in the final chapter alongside his treatment of the Resurrection and the Transfiguration, all dramatise the relationship between man and God as the end approaches. The moment of encounter with God that is both willed and deferred in these sonnets can be said, paradoxically, to both magnify and condense Donne's anxieties about religious iconography, as the poems reproduce the representational problems encountered in visual art in verbal terms.

In all of these cases, the conventional image we might expect is circumvented – recast as a meditation on spatial paradox, cancelled out or deferred. All "visual analogues" that can be established between Donne's poetry and visual art seem to be subject to this kind of reorientation. Certainly, visual art is evoked. But the uneasiness identified by Sypher and Praz in Donne's poetry does not lead to an easily definable analogy with the art of the period. Rather, we seem to be invited to compare visual art and verbal art for the problems they face in the service of representation.

[75] Johnson *et al.*, eds., *Variorum 7.2: Divine Poems*, p. 147.
[76] Stringer *et al.*, eds., *Variorum 7.1: Holy Sonnets*, p. 25.

Introduction: Visual and verbal art

W. J. T. Mitchell observes in *Picture Theory* that unmotivated word-image comparisons often lead nowhere: "the historicist course in 'comparative arts' that compares (say) cubist paintings with the poems of Ezra Pound, or the poems of Donne with the painting of Rembrandt, is exactly the sort of thing that seems unnecessary...". Where the subject becomes "necessary and unavoidable", he claims, is when the subject is "the problem of the image/text", Mitchell's term for "a problematic gap, cleavage, or rupture in representation". [77] Donne's recurrent recourse to the frames, materials and genres of visual art to highlight ruptures in representation seems to fit Mitchell's category of the image/text. The imperfect or cancelled images suggested by Donne's texts reflect back on the possibility of representation in words. He suggests the word-image comparison explicitly in "The Storme", where he compares his own "lines" to "a hand, or eye / By *Hilliard* drawne" (3–4) and invites Christopher Brooke's "judgment" on them. But each swerve away from the "pictorial" reproduction of a scene calls into question the possibility of verbal representation. Donne's insistence on painterly craft, both in the sense of material techniques and of the effects achieved, point up this comparison, and the lines and angles, perspectives and proportions of visual art provide him with a vocabulary to describe the limitations of representation more generally. Finally, perhaps, this is the way in which Donne's "visual analogues" work: by establishing visual art as an analogue for the practice of verbal art.

[77] W. J. T. Mitchell, *Picture Theory* (Chicago: University of Chicago Press, 1994), p. 88, p. 89, n. 9. Alongside image/text, indicated with a slash, Mitchell also coins the terms "imagetext and "image-text": "The term 'imagetext' designates composite, synthetic works (or concepts) that combine image and text. 'Image-text' with a hyphen, designates *relations* of the visual and verbal".

Chapter 1

SHADOWS

Others at the Porches and entries of their Buildings sett their Armes, I, my Picture; if any Colours can deliver a Minde soe plaine, and flatt, and through light as mine. (John Donne, Epistle, *Metempsychosis*)[1]

The opening of Donne's Epistle prefacing his *Metempsychosis*, in the epigraph above, both declares an interest in portraits and expresses some doubts about what they can "deliver". The "picture" he is accustomed to set at the entrance to his "buildings", seems to refer to the convention of the portrait frontispiece of a printed book.[2] The Epistle was placed first in the 1633 edition of his *Poems*, even though that edition had no frontispiece, and in 1635 it faces the Marshall engraving of the poet – oddly, in this case, separated from the rest of *Metempsychosis* and functioning as a preface to the whole collection. Just as a heraldic coat of arms provides an emblematic key to identity so the function of a frontispiece "picture" is to "deliver a Minde", and Donne may be referring here to Cicero's "*imago animi vultus est*" (the face is the image of the mind).[3] But there is some doubt about whether the "Colours" will be able to "deliver" a likeness of their subject's inner self, although Donne inverts expectations by saying that his *mind* is too plain and flat to be captured on the painter's cloth. This doubt about the ability of portraits to deliver a representation is explored in Donne's poems dealing with different kind of portraits, and also forms an intriguing subtext to the actual portraits of Donne that we know of.

There are five known portraits of John Donne at different stages of his life, a surprisingly large number for a non-aristocratic subject, rare for a

[1] Stringer *et al.*, eds., *Variorum 3: Satyres*, p. 249.
[2] On the portrait frontispiece, see Steven Rendall, "The Portrait of the Author", *French Forum* 13.2 (1998): 143–151.
[3] Cicero, *De Oratore*, trans, and ed. by E. W. Sutton and H. Rackham, Loeb Classical Library (Cambridge, MA: Harvard University Press, 1948) III, lix, p. 221. Cited in Rendall, p. 144.

poet of his time.[4] This in itself provides material evidence of Donne's interest in painting. One of the earlier likenesses, the "Lothian portrait" now in the National Portrait Gallery in London (fig. 1), is apparently the earliest existing oil portrait of an Elizabethan poet.[5] These multiple portraits might suggest an egotistical desire to preserve and record his identity, to imprint an image of the self on the world, but studying them closely reveals something quite different. Despite providing such a rich and complete iconography of their subject, and frequently being invoked to support biographical claims, the pictures provoke questions about how they should be understood. Interpreting Donne's portraits is complicated by the way so many of them are mediated by texts, whether mottos, companion pieces, or intertextual references. While they certainly provide information about him at different periods of his life, we should be cautious about assuming that they "deliver" his mind. They self-consciously stage a fluid and shadowy figure, suggesting, if anything, the unreliability of self-representation.

This concern with the difficulty of pinning down the self and the unreliability of representation is paralleled in his poetry. "Elegy. His Picture" is his only poem to give an extended depiction of a portrait, and, largely because of this, it has often been read as autobiographical. I argue, however, that just as the paintings of Donne resist a fixed meaning, "His Picture" and his other poems referencing paintings themselves call into question the possibility of ever achieving a faithful "likeness". When a portrait is described as "like me" or "like thee" in the poetry, the comparison is never innocent. In poems such as "The Legacie" and "Sappho to Philaenis", he employs established conventions of love poetry such as the lover's gift of a portrait and the image imprinted in the heart, only to take them apart and use them to question the limits of representation. In doing so he calls into question not only the representational function of the artwork but also the possibility of any knowledge of the self. In both the secular poems and the divine poems, his knowledge of the forms and techniques of visual art serves as a source of metaphors for our imperfect knowledge of the human condition.

PORTRAITS OF DONNE

The very fact that such a significant number of images of John Donne exist bears witness to his interest in the process of portraiture. Although in most cases we can only surmise the extent to which he may have contributed to

[4] A full iconography is provided by Geoffrey Keynes, *A Bibliography of Dr John Donne, Dean of St Paul's*. Fourth edition (Oxford: Clarendon, 1973), pp. 372–376.

[5] Tarnya Cooper, *Citizen Portrait: Portrait Painting and the Urban Elite of Tudor and Jacobean England and Wales* (New Haven and London: Yale University Press, 2012), p. 177. See also David Piper, *The Image of the Poet: British Poets and their Portraits* (Oxford: Clarendon, 1982), p. 28.

the process of creating these images, we are given one particularly gripping account of his involvement in his final portrait. In the 1675 edition of his *Life of Donne*, Isaak Walton recounts Donne's design of his own deathbed portrait. Donne, Walton tells us, dressed himself in a winding-sheet tied at the head and feet and stood on a carved urn so that a "choice Painter" could "draw his picture". The picture was eventually turned into the carved effigy by Nicholas Stone that still stands in St Paul's Cathedral, but before that the picture was set by Donne's bedside, where, Walton relates, it "became his hourly object until his death".[6] Richard Wendorf comments that with this story "Walton shows us a figure who, in the moment of death, has literally turned himself into a work of art, a visual representation of that temporal moment that most interests any biographer: the point at which man and art absolutely merge".[7] Wendorf's comment not only astutely identifies the method of the biographer and indeed of many biographical critics; it also implies the biographical tendency to seek truth in visual representations, particularly portraits. At the same time, it shows that Donne had already pre-empted his biographer, and not content with having "preach't his own Funeral Sermon",[8] he had also, if not painted, then actively staged his own deathbed image. Walton's account describes Donne taking on multiple roles with regard to the creation of this image. He directs the process of creation, is the subject of the painting, and finally is the spectator as he meditates on his own image. At the same time Walton's version of both the creation and the reception of the deathbed image demonstrates to what extent this image, like any image, remains open to interpretation.

In the biography Walton goes on to juxtapose the image of Donne in his winding sheet with other pictures he has seen, focusing on one in particular:

> I have seen one picture of him, drawn by a curious hand at his age of eighteen; with his sword and what other adornments might then suit with the present fashions of youth, and, the giddy gayeties of that age; and his Motto then was,
>
> *How much shall I be changed,*
> *Before I am chang'd.*
>
> And, if that young, and his now dying Picture, were at this time set together, every beholder might say, *Lord! How much is Dr. Donne already chang'd, before he is chang'd?* And, the view of them, might give

[6] Izaak Walton, *The Lives of Dr John Donne, Sir Henry Wotton, Mr Richard Hooker, Mr George Herbert* (London: Richard Marriot, 1675), pp. 71–72.
[7] Richard Wendorf, "Visible Rhetorick: Isaak Walton and Iconic Biography", *Modern Philology* 82.3 (1985): 269–291 (p. 283).
[8] Walton, *Lives*, p. 68.

my Reader occasion, to ask himself with some amazement, *Lord! how much may I also, that am now in health be chang'd, before I am chang'd? before this vile, this changeable body shall put off mortality?* and, therefore to prepare for it.⁹

Walton is referring here to the engraving by William Marshall that is used as a frontispiece to the 1635 *Poems*. This earlier portrait is not reproduced in the *Life*: the frontispiece of the whole volume (which also includes lives of Henry Wotton, Richard Hooker and George Herbert) shows the portrait of Donne painted in 1622 when he was forty-nine and already Dean of St Paul's. The Marshall engraving of the portrait of Donne at the age of eighteen, dated 1591, with motto, sword, "and other adornments" (fig. 2), is accompanied in the 1635 volume by an elegiac poem written by Walton, which again compares the youthful Donne with the sober, older Dean of St Paul's.

> This was for youth, Strength, Mirth, and wit that Time
> Most count their golden Age; but t'was not thine.
> Thine was thy later yeares, so much refind
> From youths Drosse, Mirth, & wit; as thy pure mind
> Thought (like the Angels) nothing but the Praise
> Of thy Creator, in those last, best Dayes.
> Witnes this Booke, (thy Embleme) which begins
> With Love; but endes, with Sighes, & Tears for Sins.¹⁰

It is assumed that Marshall's engraving is based on a painted portrait that is now lost. As mentioned in the Introduction, twentieth-century speculation – involving very little evidence – that it might have been based on an original by Nicholas Hilliard, tried to establish a definite connection between Donne and the leading miniaturist of his day.¹¹ But even without this somewhat tenuous connection to Hilliard, Donne's relationships with important English painters are certainly documented in later years. The miniature of him by Hilliard's former pupil Isaac Oliver, dated 1616, in the Royal Collection at Windsor Castle, and of course Nicholas Stone's effigy of Donne in his shroud (1631) – Donne had also commissioned Stone to make a funeral effigy of his wife¹² – show that Donne associated with the best-known English visual artists of his time. The attraction of the Marshall/Hilliard theory is that it also allows us to locate this knowledgeable, culturally aware Donne at the beginning of his career, and as Dennis Flynn argues in the opening pages of *John Donne and the Ancient Catholic Nobility*, if the

⁹ Walton, *Lives*, pp. 73–74.
¹⁰ *Poems, by J D., with Elegies on the Authors Death* (London: M. Flesher for J. Marriot, 1635).
¹¹ See Introduction, p. 8, n. 32.
¹² Hurley, *John Donne's Poetry*, p. 35.

original of the Marshall engraving was indeed by Hilliard, it would give us important information about Donne's standing at court in his youth.[13]

The absence of a painted original, however, means that our knowledge and understanding of this early portrait is particularly mediated by text. Our appreciation of the monochrome print is enhanced by Walton's textual ekphrasis in his *Life*, and by his elegy accompanying it in the 1635 *Poems*, and of course its use as a frontispiece juxtaposes it directly with Donne's own texts.

Walton's description draws attention to yet another textual feature of the portrait, the motto in Spanish in its top right-hand corner, which reads "Antes muerto que mudado". Both the motto and Walton's reference to it have provoked much discussion. Walton mistranslates it as "How much shall I be changed / Before I am changed", which fits his conversion narrative that casts Donne as "a second St Austin", as well as his moralising appropriation of the image.[14] The correct translation would be something like "Sooner dead than changed". Edward Terrill has identified the source of the phrase, in Jorge de Montemayor's pastoral romance *La Diana* (1559).[15] The Spanish poem was known at the English court, translated into English in 1598 by Bartholomew Yong. It was also translated by Philip Sidney and was evidently an influence on his *Arcadia*.[16] As Catherine Cresswell discusses in detail, once we know the source of Donne's Spanish motto, its irony becomes apparent. In Montemayor's poem, the line is not to be taken literally: it is "a fickle woman's vow of constancy", written on the sand by the faithless Diana, and remembered some time later by her lover Sireno, by then aware of Diana's infidelity.[17]

While on the surface this Spanish motto could convey "unwaveringly stoic asseveration", as Flynn puts it,[18] once it is read in tandem with its intertextual source it appears to comment ironically on constancy and mutability. No longer a comment on the inconstancy of women, the motto seems to ask to what extent the portrait can be a faithful representation. As Cresswell has

[13] Dennis Flynn, *John Donne and the Ancient Catholic Nobility* (Bloomington and Indianapolis: Indiana University Press, 1995), pp. 1–5.

[14] Walton, p. 38. On Walton's mistranslation, see Catherine J. Cresswell, "Giving a Face to an Author: Reading Donne's Portraits and the 1635 Edition", *Texas Studies in Literature and Language* 37:1 (1995): 1–15 (p. 1) and Flynn, *John Donne and the Ancient Catholic Nobility*, p. 2; p. 196 n. 2.

[15] T. Edward Terrill, "A Note on John Donne's Early Reading", *Modern Language Notes* 43 (1928): 318–319 (p. 318), cited by Flynn, *John Donne and the Ancient Catholic Nobility*, p. 196 n. 2.

[16] Walter R. Davis and Richard Lanham, *Sidney's Arcadia* (New Haven and London: Yale University Press., 1965), p. 46.

[17] Cresswell, "Giving a Face", pp. 7–9.

[18] Flynn, *John Donne and the Ancient Catholic Nobility*, p. 2.

pointed out, the portrait functions as an emblem, but an emblem-portrait in which "Donne's motto and figure counter one another". As she goes on to propose, "rather than reveal Donne, the emblem-portrait foregrounds not the portrayed subject but the very procedures of portraiture, its own and its subject's constructed, fictive nature".[19] The motto's ironic comment on inconstancy counters any attempt to "fix" a meaning on the portrait and opens it up to a much more complex interpretation.

This combination of image and contradictory words occurs in other portraits we have of Donne. Most notable is one of the best-known: the "Lothian portrait", dated c. 1595, described in Donne's will as "that picture of mine which is taken in Shaddowes",[20] also contains an inscription, in gold lettering at the top of the image, following the curve of the oval that surrounds Donne's figure (fig. 1). The inscription references the painting's "shadows" while reinforcing the image of Donne as melancholy lover: "Illumina tenebr[as] nostras Domina" (Lighten our darkness O Lady). Like the motto of the Marshall engraving, it is in a foreign language, like the typical motto of an impresa or emblem, and this too is an altered quotation, altered again in terms that change the gender of the source text. The source has been identified both as an Evensong collect from the Book of Common Prayer: "Lighten our darkness, we beseech thee, O Lord" and as Psalm 17: 29 in the Vulgate: "Deus meus illumine tenebras meas" (My God illumines my darkness).[21]

The Lothian portrait has been mediated through text in yet another way. Unlike the Marshall engraving of Donne in 1591, it was only known to exist because of fragmentary verbal clues, until it was rediscovered in the collection of the Marquess of Lothian at Newbattle Abbey by John Bryson in 1959.[22] Apart from the "picture taken in Shaddowes" reference in Donne's will, which bequeathed it to Robert Carr, Earl of Ancrum, two other verbal traces of the portrait seemed to corroborate its existence. William Drummond of Hawthornden refers to the bequest: "J. Done gave my L. Ancrum his picture in a melancholie posture with this word about

[19] Cresswell, "Giving a Face", p. 10; p. 11.
[20] Bald, *Donne*, p. 567.
[21] For an identification of the source as the Book of Common Prayer, originating in the Sarum Breviary, see Louis L. Martz, "English Religious Poetry", in *From Renaissance to Baroque: Essays on Literature and Art* (Columbia and London: University of Missouri Press, 1991), p. 8; The National Portrait Gallery identifies the source as the Vulgate. National Portrait Gallery – Conservation Research – NPG 6790; John Donne http://www.npg.org.uk/collections/search/portraitConservation/mw111844/John-Donne
[22] John Bryson. "Lost Portrait of Donne". *The Times*. (London) October 13, 1959: p. 13; p. 15.

it *De Tristitia ista libera me Domina"* (From this sadness deliver me O Lady).²³ Another reference is to be found in R. B. [Richard Baddily]'s *Life of Dr Thomas Morton*:

> For my selfe have long since seen his (Donne's) Picture in a dear friends Chamber of his in *Lincolnes Inne*, all envelloped with a darkish shadow, his face & feature hardly discernable, with this ejaculation and wish written thereon; *Domine* [sic] *illumina tenebras meas*, which long after was really accomplished.²⁴

While both Drummond and R. B. misremember the inscription, it is worth noting that they both emphasise its part in the portrait. Although R. B. failed to notice, or to recall, the playful misattribution of gender (and therefore inscribes the portrait in a narrative of conversion to spirituality that is similar to Walton's), Drummond, while getting more of the words wrong, does remember the play on gender. Bryson, and most subsequent critics, concur with Drummond's reading that Donne is assuming the posture of a melancholy lover. The floppy hat and the crossed hands correspond to the description of the "Inamorato" in Robert Burton's *Anatomy of Melancholy* (1621).²⁵ The combination of the consciously assumed posture and the inscription leads Kate Frost to describe this portrait, too, as an "impresa" to be interpreted.²⁶

Tarnya Cooper, formerly curator of the Tudor and Jacobean galleries at the National Portrait Gallery, describes the Lothian portrait as "extraordinary" and "an exception",²⁷ and the Portrait Gallery's commentary on the painting notes that:

> Given the nature of the pose and format, the portrait must have been carefully orchestrated by Donne; the inscription suggests that it may originally have been painted for a lover or for a friend. It is possible that the painter was a friend or associate – perhaps a painter working on theatrical events at the Inns of Court – who took instruction directly from the young poet about the nature of the composition. ²⁸

This involves a lot of speculation, of course, but it corresponds to Walton's account of Donne's involvement in the composition of his own deathbed

23 National Library of Scotland, MS 2060, f.44v, quoted in Bryson.
24 R. B. *The life of Dr. Thomas Morton, late Bishop of Duresme*, 1669, pp. 101–102.
25 Robert Burton, *The Anatomy of Melancholy* (Oxford: John Lichfield and James Short, for Henry Cripps, 1621), pp. 250–251. See Kate Gartner Frost, "The Lothian Portrait: A Prologemenon", *John Donne Journal* 15 (1996): 95–125 (pp. 96–97).
26 Frost, "The Lothian Portrait: A Prologemenon", pp. 98–99.
27 Cooper, *Citizen Portrait*, p. 175.
28 National Portrait Gallery – Conservation Research – NPG 6790; John Donne.

image, and provides one more suggestion that Donne may have been involved in the production of an actual work of art as more than simply a sitter, inviting us to interpret the composition of the painting – and its intertextual inscription – as resulting from Donne's initiative.

Donne's apparent involvement in the composition of both the Lothian portrait and the Marshall image has obvious parallels with his orchestration of his deathbed image as described by Walton. Indeed, all the different pieces of information we have connecting Donne with visual art place him in multiple positions in relation to the material object. Often, as with the deathbed image, he assumes several positions simultaneously. He is the subject of the painting but also its orchestrator, and its spectator. He is a collector, a connoisseur and, as his will shows, a donator of paintings. Frost has suggested that, taken as a whole, the extant portraits of Donne could be seen as representing "a progress through his life, a kind of self-conscious ages of man scheme".[29] Even if this claim cannot be sustained, the similarities between the two earliest portraits of Donne in 1591 and 1595 do suggest, if not a "deliberate program", certainly a continuing concern with issues of self-representation. Despite their differences, these two early portraits resemble each other in what David Piper has described as their "role-playing",[30] as well as in their punning intertextual inscriptions, which problematise our understanding of the paintings and remove the possibility of a simple identification of the face in the portrait as a true representation of Donne. Indeed, Cresswell holds that Donne's portraits "resist a coherent reading". She makes the point with reference to the Marshall engraving but goes on to argue that readers of all of Donne's portraits "will not uncover the true Donne… but a rhetorical figure".[31] Rather like his poems, they both invite and resist interpretation, their layers of meaning adding to the impression of an elaborate artifice, challenging any expectation that a portrait will "deliver" the mind of the sitter.

"HIS PICTURE"

The "picture … taken in shadows" thus resists easy assumptions about a portrait's representational power. In a poem written around the same time as the Lothian portrait was produced, Donne plays on the polysemy of the word "shadow", and approaches the question of the representation of the self through an imagined work of visual art. "Elegy: His Picture" is the only one

[29] Kate Gartner Frost, "The Lothian Portrait: A New Description", *John Donne Journal* 13 (1994): 1–11 (p. 2).
[30] Piper, *Image of the Poet*, p. 28.
[31] Cresswell, "Giving a Face", p. 4; p. 12.

of his poems that stages a painting at any length. As such it can certainly be described as an ekphrasis, a verbal representation of a visual work of art.[32] But rather than describing the portrait likeness, as we might expect, the poem goes beyond or beneath the finished surface of the painting to focus instead on the material and painterly process of making a likeness.

"Elegy: His Picture" opens by dramatising the presentation of a portrait gift and its appreciation, and in the first lines a play on the word "shadow" parallels the artwork with the speaker's death and alerts us to the uncertain status of visual representation:

> Here take my picture, though I bid farwell
> Thyne in my hart, wher my Soule dwells shall dwell.
> T'is like me now, but I dead, t'wilbe more
> When we are shadows bothe, then t'was before. (ll. 1-4).[33]

The basic pun – that shadow can mean both "portrait" and "ghost" – parallels the picture and the moment of death in a number of ways. Once dead, the speaker of the poem will be more like his portrait than he was alive. "Shadow" implies a comparison on grounds of insubstantiality: both a portrait and a ghost are insubstantial "copies", counterfeits, of the original man,[34] and may also recall the sense of "shadow" as "actor": "a walking shadow, a poor player that struts and frets his hour upon the stage" (*Macbeth* V.5.24–25).

But "shadow" also has the very material denotation of the act of painting: in the late sixteenth and early seventeenth centuries "to shadow" may mean simply to paint or to draw.[35] "Shadow" may also carry the more technically precise meaning of an underdrawing, the bottom layer or rough draft of a painting, echoing the Italian *adumbratio*.[36] Due to the paucity of artistic vocabulary in English, as Lucy Gent has shown, the word "shadow" has multiple possible meanings when used in the context of visual art. As well as describing these well-established painterly techniques the word is also associated with the very new (in the late sixteenth century) painterly use of shadow, of *chiaroscuro* creating the illusion of depth, which, along with

[32] James Heffernan proposes a good working definition of ekphrasis as "the verbal representation of graphic representatation" in "Ekphrasis and Representation", *New Literary History* 22. 2 (1991): 297–316 (p. 299).

[33] Quotations from "His Picture" are from Stringer *et al.*, eds., *Variorum 2: Elegies*, p. 264.

[34] OED *shadow* n. 6b; see also Claire Pace, "'Delineated Lives': themes and variations in seventeenth-century poems about portraits", *Word and Image* 2.1 (1986): 1–17 (p. 6).

[35] See OED *shadow v.* 8. and Lucy Gent, *Picture and Poetry 1560–1620* (Leamington Spa: James Hall, 1981), p. 19.

[36] See Gent, *Picture and Poetry*, p. 19.

perspective, was beginning to be recognised as "one of the chief means of achieving a greater illusion of reality".[37] Fifteen ninety-six (the probable date for this poem)[38] is quite early for "shadow" to have this sense – but given the existence of the Lothian portrait, dated one year earlier, we know that Donne in this period was aware of painting making use of shadows. The technique itself is considered to be rare for such an early date, when an "unshadow'd" style was still more popular.[39] Many years later, in a sermon preached at Whitehall in February 1628, Donne once again demonstrates his technical knowledge of artistic technique and the metaphorical potential of the word "shadow" when he compares the "dying man, that dies in Christ" with a picture printed from a copper engraving:

> Bee pleased to remember that those Pictures which are deliver'd in a minute, from a print upon a paper, had many dayes, weekes, Monoths time for the graving of those Pictures in the Copper; So this Picture of that dying Man, that dies in Christ ... was graving all his life; All his publique actions were the lights, and all his private the shadowes of this Picture. And when this Picture comes to the Presse, this Man to the streights and agonies of Death, thus he lies, thus he looks, this he is. (8: 190)

Donne's evident technical knowledge of engraving and the production of prints furnishes him with metaphors to describe man's relationship to mortality: the actions of a man's life are compared to the long-drawn-out creative process of engraving the copper, while the actual picture is the final product. At the end of his life a man becomes the print, that static, unchangeable result, in a logic that parallels the "when we are shadows both" metaphor in the Elegy.

Donne's knowledge of painterly technique allows all these secondary meanings of "shadow" to hover in "His Picture", even if the primary sense can be taken as that of "portrait" or "copy". But the pun depends on the idea that the copy is simultaneously material and immaterial. The dead man and the picture are not only compared because they will be similarly insubstantial; paradoxically, when they are "shadows bothe" they will be paralleled in substance. The body of the poem's speaker, which has become "foule and course" (l. 12), separated into different layers, parallels the material construction of the picture.

This elegy has attracted a good number of biographical readings, as have many of the other valediction poems. From a fairly early date in modern Donne criticism, the voyage on which the speaker is departing has been linked to one of Donne's own sea-voyages, most likely to Cadiz

[37] Pace, "Delineated Lives", p. 6; cf. Gent, *Picture and Poetry*, p. 26.
[38] See Stringer *et al.*, eds., *Variorum 2: Elegies*, pp. 820–821.
[39] Pace, "Delineated Lives", p. 6.

with Essex in 1596.[40] The dating of the poem seems to be largely based on that biographical assumption.[41] And, perhaps inevitably, this biographical reading extends to a desire to link the "picture" to a specific material portrait of Donne himself. Given that the estimated dating of the poem to 1596 coincides so neatly with the 1595 date attributed to the Lothian portrait, it is perhaps surprising that critics have not in general attempted to identify "His Picture" with Donne's "picture taken in shadows". This may simply be because, as Helen Gardner says in her edition of the *Elegies*, the Lothian portrait "is hardly the size to hand to a lady",[42] but equally, the critical desire to find an actual portrait predates the 1959 rediscovery of the Lothian portrait. In a tradition which apparently begins with E. K. Chambers' edition *The Poems of John Donne*, the elegy has instead been identified with the Marshall engraving.[43] There is no particular reason why the elegy shouldn't be linked to the Marshall image, but also no particular reason why it should. Most critics concur that the scene set up in the first line of the elegy evokes the convention of the departing lover presenting his beloved with a portrait miniature.[44] If one were tempted to see this as more than a literary device and to search for a physical portrait, then the martial stance of the young Donne in the Marshall engraving provides, as Ann Hollinshead Hurley puts it, "an appropriate anticipatory, tongue-in-cheek commentary on the young lover of 'His Picture' whose inner being is characterized as 'faire and delicate'".[45] Nonetheless, the identification of the Marshall engraving with "my picture" in the Elegy under discussion remains problematic, and not only because of the biographical fallacy involved in such an assumption. The very idea that we might find a physical companion image to Donne's Elegy is highly ironic because what Donne goes on to do in this poem is to problematise representation and strip down the image of the man to its constituent elements.

[40] Edward Dowden, "The Poetry of John Donne", *The Fortnightly Review* 47 (1890): 791–808 (p. 801).
[41] Stringer *et al.*, eds., *Variorum 2: Elegies*, pp. 820–821 and pp. lxi–lxvii.
[42] Helen Gardner, ed., *John Donne. The Elegies and The Songs and Sonnets* (Oxford: Clarendon Press, 1965), p. 143.
[43] E. K. Chambers, ed., *The Poems of John Donne* (London: Lawrence and Bullen; New York: E. P. Dutton, 1896), I, p. 237; see also Gardner, ed., *Elegies*, p. 143; Hurley, *John Donne's Poetry*, pp. 52–53.
[44] Bryson, "Lost Portrait", p. 15; Gardner, ed., *Elegies*, p. 143.
[45] Hurley, *John Donne's Poetry*, p. 53. Hurley combines the traditional juxtaposition of "His Picture" with the Marshall portrait with the hypothesis of the lost Hilliard original in order to parallel "His Picture", "Hilliard's portrait of Donne" and Hilliard's treatise "On the Art of Limning", reading all three as attempts to problematise the nature of representation (pp. 53–60).

Various critics over the years have suggested that Donne offers us two "pictures" in the Elegy: first "my picture" offered by the speaker to his lover as he departs for war, which is not described to us, beyond perhaps what is implied in the phrase "faire or delicate" (l. 17). Second, there is "another picture",[46] the verbal image we are given in lines 5–10 of the returning soldier, battle-scarred and sunburned:[47]

> When weatherbeaten I come back; my hand
> Perchance with rude Oares torne, or Suns beams tand,
> My face and breast of hayre cloth, and my head
> With Cares rash sodain horines orespread,
> My body a sack of bones, broken within
> And powders blew staines scatterd on my skin ... (ll. 5–10)

An offshoot argument to the notion of the two pictures is that the image of the "sun-tanned, blue-stained returning warrior" is more "attractive", his "bristles, rough hands, and ... other craggy features" more "appetising to women", as John Carey puts it, than was the original picture.[48] Yet attractive as the notion of this sunburned soldier may be, the "returning warrior" description, far from giving us an image of a whole man, is fragmented, in more ways than one.

These lines provide us with a blazon of the speaker's body, and this in itself could be seen as a verbal portrait, since in his *Art of English Poesie*, George Puttenham describes the poetic blazon as the prime example of "*Icon*, or resemblance by imagerie or pourtrait, alluding to the painters terme".[49] However while Puttenham specifies that the poet should "resemble every part of [the] body to some naturall thing of excellent perfection in his kind", in the Elegy the speaker's body is paralleled with rough materials and images of disintegration. Rather than itemising the body in order to represent the whole, this blazon insists on fragmentation, presenting us with a body "torne" (l. 6), a man reduced to a roughened hand and chest, a hoary head and finally a "sack of bones, broken within" (l. 9).

Donne's play with tropes of similitude here opens out into a larger commentary on the notion of verisimilitude in general. The poetic

[46] Rosemond Tuve, *Elizabethan and Metaphysical Imagery: Renaissance Poetic and Twentieth-Century Critics* (Chicago: Chicago University Press, 1947), p. 54.
[47] Tuve, *Elizabethan and Metaphysical Imagery*, p. 54; John Carey, *John Donne: Life, Mind and Art* (Oxford: Oxford University Press, 1981), p. 51; Thomas Docherty, *John Donne, Undone* (London and New York: Methuen, 1986), p. 128.
[48] Hurley, *John Donne's Poetry*, p. 59; Carey, *John Donne*, p. 52.
[49] George Puttenham, *The Arte of English Poesie: Contrived into three Bookes: The first of Poets and Poesie, the second of Proportion, the third of Ornament* (London: Richard Field, 1589), p. 204.

convention of the immortalising portrait, that "the painted image will survive, while the actual physical appearance of the sitter decays"[50] can be seen, for example, in Thomas Randolph's "Upon his picture" (1638), in which the speaker contemplates the portrait of his younger self at the moment when "death displays his coldness in my cheek, / And I myself in my own picture seek, / Not finding what I am, but what I was" (ll. 5–7).[51] Donne pays lip service to this trope with the line "This [the portrait] shall say what I was" (l. 13), but in contrast to Randolph's more conventional poem, in Donne's it is precisely in the coldness of death that the speaker will be most "like" the portrait. Donne's defining "shadow" pun insists on a rethinking of the *likeness* of sitter and portrait: "T'is like me now, but I dead, t'wilbe more / When we are shadows bothe, then t'was before" (ll. 3–4).

Thomas Docherty is the most insistent of the critics who read the "weatherbeaten" speaker of lines 5–10 as "another, entirely dissimilar, portrait" in which "Donne" is "*changed*" and the subject of the portrait "becomes, finally, unnameable, unidentifiable".[52] While I agree – up to a point – with Docherty, that this poem is in many ways about the impossibility of representation, I disagree with his insistence that there are "(at least) two pictures" and particularly with the idea that "there is no identity between the picture[s]".[53] Rather than offering a "second picture" in these lines, I would argue that Donne goes beyond – or beneath – the surface of one portrait in order to explore the physical processes by which the image, and the man, are constituted. The fragmenting blazon of lines 5 to 10 applies not only to the man but also to the picture: *his picture* too is reduced to the materials required for pictorial representation: the cloth, the white base, the crushed bone and blue powder that make up pigments.

"Powders blew stains scatterd on my skin" in line 10 retains, of course, the sense of gunpowder on the returning sailor,[54] but in the context of a discussion of a painted portrait, "powders blew staines" also strongly suggests the mixing of paint from powdered lapis lazuli or azurite. Hurley proposes something similar in her analysis of the elegy, suggesting that "the actual craft of making miniatures may well have been in his mind ... when

[50] Pace, "Delineated Lives", p. 3.
[51] See Philip McCaffrey, "Painting the Shadow: (Self-)Portraits in Seventeenth Century Poetry", in *The Eye of the Poet: Studies in the Reciprocity of the Visual and Literary Arts from the Renaissance to the Present*, ed by Amy Golahny. (Lewisberg: Bucknell University Press, 1996), pp. 179–195 (pp. 181–182).
[52] Docherty, *John Donne, Undone*, p. 126.
[53] Docherty, *John Donne, Undone*, p. 128.
[54] John Shawcross, ed., *The Complete Poetry of John Donne* (Garden City, NY: Anchor, Doubleday, 1967), p. 64; A. J. Smith, *John Donne: The Complete English Poems* (Harmondsworth: Penguin, 1971), p. 419.

he refers to the 'blew staines' of gunpowder ... prompting his audience to recall the familiar blue background of the idealizing portrait miniature".[55] Such an interpretation is reinforced by the other physical details enumerated in lines 5–10, all of which are open to a similar double reading. The "hayre clothe" of the soldier's roughened skin has echoes of the painter's cloth – a term commonly used to refer to painters' canvas in the sixteenth century, for example in Richard Haydocke's translation of Lomazzo's *Trattato*.[56] Although haircloth is not a traditional support for oil painting, it is a stiff woven cloth not unlike canvas. The addition of "hayre" emphasises the roughness of the material and highlights the parallels between body and painting, while simultaneously evoking the hair shirt of the penitent, humbled man.[57] Moreover, the "horines orespred" could refer not only to a new crop of white hairs on the care-worn head but also to the white layer of binder, chalk and pigment called "*gesso*" spread over the canvas to prepare it for the application of oil paints. Pursuing this interpretation, "My body a sack of bones, broken within" (l. 9) could refer to the use of crushed bones in making pigment – particularly the black known as "bone black" made from the powder of charred bones burned at a high temperature.[58] The National Portrait Gallery's recent conservation research into the Lothian portrait reveals that it does contain the pigment bone black, particularly in the sleeve on the right.[59]

The conviction of the National Portrait Gallery curators that Donne must have been actively involved in the "orchestration" of the Lothian portrait suggests that he would have been aware of the details surrounding the material production of an oil painting, including the somewhat gruesome process required to produce a painting's colours. Not only may the "sack of bones" in the Elegy refer – at least in part – to the material production of the painting's "shadows", but other details that have emerged during the restoration of the Lothian portrait may also correspond to the poem.

[55] Hurley, *John Donne's Poetry*, p. 173.

[56] Giovanni Paolo Lomazzo, *A Tracte Containing the Artes of Curious Paintinge Caruinge Buildinge Written first in Italian ... and Englished by R [ichard] H [aydock]* (Oxford: Joseph Barnes, 1598), p. 6; p. 23.

[57] C. A. Patrides, ed., *The Complete English Poems of John Donne* (London: J. M. Dent, 1985), p. 14.

[58] The "Suns beams" too fit into this reading, as Italian painters exposed freshly painted oil pictures to the sun after each layer was added, "to remove by evaporation the yellow coat of oil which always rose to the surface, and which if not removed by this process darkened the colours", Mary Merrifield, *Original Treatises on the Arts of Painting* [1849] (New York: Dover, 1967), I, p. cccvii.

[59] National Portrait Gallery – Conservation Research – NPG 6790; John Donne http://www.npg.org.uk/collections/search/portraitConservation/mw111844/John-Donne#paintsampling

The examination of its layers has revealed not only substantial traces of bone black but also the preparation layers of a "thick chalk ground and a relatively substantial priming containing lead white" which may imply that Donne had some knowledge of the priming process and which could be connected to the "horines orespred".[60]

I am not using the Lothian portrait to make yet another identification of "His Picture" with an actual work of art. The picture in the poem stripped back to its constituent layers is emphatically *not* the Lothian portrait, especially as this is painted on panel rather than cloth.[61] In fact it does not really bear resemblance to any of the extant portraits of Donne – or to any completed artwork. The "shadows both" pun may, in part, parallel the elegy with the metaphor of the dying man as a finished work of art developed in the 1628 sermon: "when this Picture comes to the Presse, this Man to the streights and agonies of Death, thus he lies, thus he looks, this he is" (8: 190). Yet "His Picture" is barely concerned with how the speaker looks, or with the "fair or delicate" finished product (l. 17), but rather with the "foule and course" process (l. 12) required to produce a painting.

Donne's insistence on the materials that go into the making of the picture demonstrate his interest in process and in the painter's practice of his craft, and is in keeping with his general attention to making rather than to "made work". Such a material and painterly ekphrasis of a work of visual art is in keeping with the long tradition of verbal representation of visual representation, whose *locus classicus* is the description of Achilles' shield in the *Iliad* Book 18, ll. 478–608. As Lessing famously observes in his *Laocoon*, Homer "does not paint the shield as finished and complete, but as a shield that is being made".[62] Homer's ekphrasis of the shield insists on the difference between what is represented and the medium of representation.[63] And yet despite all Donne's evident interest in painterly creation, the effect of "His Picture" is less a mimicking of the creative process than a process of excavation, a peeling back of the layers. The elegy begins by appearing

[60] National Portrait Gallery – Conservation Research – NPG 6790; John Donne http://www.npg.org.uk/collections/search/portraitConservation/mw111844/John-Donne#paintsampling.

[61] Although most surviving English portraits from the sixteenth century are on panel rather than canvas, the earliest portrait on canvas examined in the National Portrait Gallery's "Making Art in Tudor Britain" project dates from 1546, and many English people in the period owned painted cloths depicting a range of subjects. Charlotte Bolland, Project Curator (Making Art in Tudor Britain), personal communication.

[62] Gotthold Ephraim Lessing, *Laocoön: An Essay on the Limits of Painting and Poetry*. Trans. Edward Allen McCormick (Indianapolis and New York: Bobbs Merrill, 1962), p. 95.

[63] See Heffernan, "Ekphrasis", p. 301.

to proffer a "picture" but proceeds to undo the possibility of knowing a person through a portrait – or through their surface appearance – by taking the picture apart and showing the layers that go into its composition. In a sermon preached one Whitsunday at Lincoln's Inn, Donne compares the practice of the painter and the printer, and describes the painter who "makes an eye, and an eare, and a lip, and passes his pencill an hundred times over every muscle, and every haire, and so in many sittings makes up one man" (5: 38). In "His Picture", the effect is rather the opposite – one man (who at the beginning of the poem we assume we know, from literary convention or the traditional association with the poet) is unmade.

Donne's progressive deconstruction of the trope of the portrait gift thus raises questions about the material status of the painting, the nature of representation, and in particular the possibility of representing the self. In the second part of "His Picture", in parallel with the unmaking of the self I have been describing, the speaker slips out of the picture frame and becomes the connoisseur. Through both the portrait gift and the disintegrating blazon of his body, the poem has constructed the speaker as an object to be gazed at. But in the second half he shifts speaking positions to put words in his mistress's mouth:

> This shall say what I was, and thou shalt say,
> Do his hurts reache mee? doth my worth decay?
> Or do they reach his judging mind, that he
> Should like and love les, what he did love to see? (ll. 13–16)

The conventional notion, that the portrait represents him as he was, is complicated by the way his lover's words construct him as a viewing, "judging mind", rather than the object of the painting. Paradoxically, when he is "speaking" in lines 1–13, he is the object of other people's gaze; when the words are supposedly those of his lover, he becomes a judging subject. The portrait is taken apart and reduced to its constituent layers; and simultaneously, Donne presents us with a sitter who does not remain fixed, as an object to be looked at, but escapes from the picture to become a viewing subject.

THE PICTURE IN THE HEART

At the same time as drawing attention to the painting's material construction, Donne parallels the portrait gift with another poetic trope: that of the picture in the lover's heart, in the second line of the elegy: "Here, take my picture", the speaker urges: "Thyne in my hart, wher my Soule dwells shall dwell" (ll. 1–2). This, perhaps, is a truer "other picture" than that identified by Tuve and Docherty in the later lines describing the weather-beaten,

powder-stained veteran. And while the poem proceeds to peel back the layers of his material portrait, the immaterial picture of her in his heart, once mentioned, is left untouched. I cited "Witchcraft by a picture" in the Introduction as one of the best examples of Donne's doubling and ambivalent attitude to images. In that poem, the speaker's reflection in his lover's eyes conjures up the fear that through "wicked skill" (l. 5), the "pictures made, and marrd" (l. 6) might be used, like an effigy, to hurt or kill the speaker. But the mimetic power of the initial "picture" is called into question. In James Knapp's words, the representation is "true in that it resembles [the speaker's] appearance but false in that it fails to capture the truth of his dynamic self". There is thus a similar undermining of the picture's "ability to tell the truth" as in "His Picture".[64] But the destructive potential of the visual representation is countered by the stability and safety of the poem's final "Picture": "One Picture more, yet that will bee, / Beeing in thyne owne hart, from all mallice free" (ll. 12–13).[65] The idea that the internal image is the truer picture, untarnished by time and not subject to the imperfections and inaccuracies of a painter's reproduction, already casts some doubt on material paintings' ability to represent. Yet although the poetic convention is that the image in the heart will last longer than the physical work of art,[66] when Donne uses it, the internal image often seems to be preserved at the expense of the lover's physical self.

While the trope of the lover's heart that may be given as a gift, returned, or broken, is a conventional one, I am interested here in what happens when this is combined with the idea of the immortalising image. The closest verbal parallel to the second line of "His Picture" is to be found in his Holy Sonnet "What if this present were the world's last night": "Mark in my hart, Ô Soule where thou dost dwell / The Picture of Christ crucified" (ll. 2–3), which will be discussed at length in Chapter 4, concerning the Crucifixion.[67] The trope of the image in the heart recurs several times in the *Songs*

[64] James A. Knapp, "Looking At and Through Pictures in Donne's Lyrics", in *The Art of Picturing in Early Modern English Literature*, ed. by Camilla Caporicci and Armelle Sabatier (New York and London: Routledge, 2019), pp. 33–49 (p. 41). Knapp reads these two poems, and "The Crosse", in the light of the legal paradox of *veritas falsa*.

[65] Quotations from the *Songs and Sonnets*: "Witchcraft by a picture" and "The Dampe" are from Johnson *et al.*, eds., *Variorum 4.3: Songs and Sonnets*, p. 227; p. 194; "Image of her, whom I loue" and "The Elegie" (known as "The Legacie" in some other editions) are taken from Johnson *et al.*, eds., *Variorum 4.2: Songs and Sonnets*, p. 88, p. 156.

[66] See Pace, "Delineated Lives", pp. 3–4.

[67] Quoted from Stringer *et al.*, eds., *Variorum 7.1: Holy Sonnets*, p. 25. (Revised Sequence).

and Sonnets and it is notable that each time the image is paralleled by a damaged or physically disintegrating body. In "Image of her, whom I loue", the lover's "fayre Impression, in my faythfull heart / Makes me her Medall" (2–3). Once the image is imprinted, though, stamped and coined (another material image to which Donne returns more than once), the speaker is not convinced that he can physically continue to bear it. It becomes "ominously powerful",[68] "growne too Greate, and good for mee" (6), and he wonders if it might be easier to live without his heart and its burden: "take my hart from hence" (5). The contemplated removal of the heart in "Image of her" seems relatively painless and rhetorical, but in other poems the idea of the extraction of the image from the heart is expanded to a much more visceral opening up of the body. In "His Picture", as we have seen, the "shadow" was associated with the disintegrating body of the speaker. In "The Dampe" the speaker is already dead, and the "Picture" proven to be the cause. Whereas in the elegy, the body is "torne" and reduced to "a sack of bones", in "The Dampe" it is cut open with the precision of a post-mortem:

> When I am Dead, and Doctors knowe not why,
> And my friends curiositie
> Will have mee cutt vp, to survey each part,
> When they shall finde your Picture in my heart … (ll. 1–4)

In both of these cases, as in "His Picture", the image in the heart seems to be in conflict with the physical integrity of the speaker, as if they cannot co-exist in the same space. David Anderson, in an article on Donne's "internal images" in the light of the iconoclastic controversy, argues that his use of the trope in his secular poetry "parallels [his] argument about holy images, stressing the benefits and dangers of a picture's transcendent power".[69]

The most extreme example of this kind of opening up of the body to reveal an image is the poem "Elegie" (known as "The Legacie" in most modern editions), a poem whose staging of a shifting, unrepresentable self recalls the shifting subject positions of "His Picture" as well as the anatomical excavation of "The Dampe". Like the love elegy, "Elegie" is a valediction poem of sorts, involving a gift or bequest, a poem in which death and the self are both treated highly ambiguously and become fluid concepts. As in

[68] David K. Anderson, "Internal Images: John Donne and the English Iconoclast Controversy", *Renaissance and Reformation / Renaissance et Réforme*, 26.2 (2002): 23–42 (p. 36).

[69] Anderson, p. 36. More tenuously, perhaps, Philip Ayres has suggested that the "Picture in my heart" of "The Dampe" resembles the Passion scene reportedly inscribed physically in the heart of St Clare of Montefalco. "Donne's 'The Dampe', Engraved Hearts, and the 'Passion of St. Clare of Montefalco", *English Language Notes* 13 (1976): pp. 171–173.

"The Dampe", Donne's speaker in "Elegie" is already dead for love, and as in "Image of Her", he plays with the convention of the lover who sends his heart. But in this poem the speaker has difficulty locating his heart. After he has "search'd where hearts should lye" (14), all he can find is:

> … something like a hart,
> But collours it, and Corners had;
> It was not good, it was not bad,
> It was intire to none, and fewe had part,
> As good, as could bee made by Arte
> It seem'd … (17–22)

With the notable exception of Ilona Bell, critics of "Elegie" have tended to read "corners" as implying that the object is not perfect, not true, because not a perfect circle, while "collours" is often read as suggesting something artificial, cosmetic and therefore negatively connoted: "a painted [heart], not a 'true plain' one"; "a painted heart, i.e. a hypocritical one".[70] Although it has been read as an "ingeniously simulated" heart,[71] the focus on form and colour does not seem to have been extended to the idea that the coloured, painted object is indeed a painting, or at least the idea of a painting, occupying the same space in the heart as the picture in "The Dampe".[72]

In the last line of "Elegie", the object like a heart proves to belong not to the speaker but to his lover: "no man could hold it, for 'twas thine" (24). The shifting ownership of the heart is part of the exchange-of-hearts trope, but here there seems to be an insistence on the interpretation of this represented heart. No one can fully grasp it; only very few people can begin to understand the multiple, shifting, fluid self through this representation of it. What is notable here, and comparable to "His Picture" and "The Dampe", is the violence done to the body of the speaker in the search for the representational object. The body of the lover is "ripped" and "killed … again" (15) in the attempt to access its "true" heart, but all that is to be found is the picture, the counterfeit, which can only ever be an imperfect copy of

[70] Theodore Redpath, ed., *The Songs and Sonnets of John Donne*, second edition (New York: St Martin's Press, 1983), p. 116; Arthur L. Clements, *John Donne's Poetry* (New York and London: Norton, 1966), p. 10. Ilona Bell identifies "colours" and "corners" in the poem as legal terminology: "Women in the Lyric Dialogue of Courtship: Whitney's Admonition to al yong Gentilwemen and Donne's 'The Legacie'", in *Representing Women in Renaissance England*, ed. by Claude J. Summers and Ted-Larry Pebworth (Columbia and London: University of Missouri Press, 1997), pp. 76–92.

[71] Smith, ed., *Complete English Poems*, p. 382n.

[72] I am grateful to Kader Hegedüs for first suggesting this interpretation to me. Hegedüs. "Maps, Spheres and Places in Donnean Love. Donne's spatial representations in the 'Songs and Sonnets.'" MA (University of Lausanne), 2012, p. 17.

the self it represents: "it was not good, it was not bad ... As good, as could bee made by Arte / It seem'd" (19; 21–22).

In parallel with this, the poem stages a self that is grammatically fractured, in a bewildering confusion of pronouns that begins in the opening stanza and becomes even more pronounced in the second: "I heard mee say, tell her anone, / That my selfe (that's you not I) / Did kill mee..." (ll. 9–11). The speaker (if it's possible to use the term in this poem) is simultaneously "mine owne executor, and Legacie" (l. 8). Carey describes this as "an exasperating poem, of course", a key example of Donne's interest in what he calls the "fluidity of the self".[73] The confusion of subject and object here echoes that in "His Picture", where, similarly, the self slips between multiple possible roles. Once more a painting – this time an internal image – is paralleled with an unreadable and ungraspable self. The colours and corners of paintings seem to generate reflection on the impossibility of pinning down the self and the unreliability of representation. Donne's doubt in the epistle to Metempsychosis as to whether "any colours can deliver a minde ..." seems to be at work again here. Something *like* a heart will not give access to the speaker's inner self.

LIKENESS

Among the genres of Renaissance art, the portrait is perhaps particular in that its painter was praised for achieving a perfect likeness, even while appreciation of art in general may have been moving towards an understanding of art as more than simply literal representation.[74] "His Picture" and "Elegie" demonstrate Donne's interest in the idea of "likeness": the shadow which will be more "like" the sitter when he is dead; the poetic trope that proves to be only "something like a heart". As the reading of "Elegie" begins to suggest, poems like these test the limits of both pictorial and verbal representation. The idea of "likeness" is also a literary trope, and as we have seen, Puttenham uses portrait painting to contextualise his discussion of similes: "*Icon*, or resemblance by imagerie or pourtrait, alluding to the painters terme".[75]

The poem that plays most with the idea of *likeness*, while not staging a portrait as such, is Donne's elegy "The Comparison", often considered one of his more misogynistic poems. It alternates many flattering and extremely unflattering similes to describe a female figure, although its conclusion, that "She, and comparisons are odious", suggests that the misogyny has been at

[73] Carey, *John Donne*, p. 175.
[74] Lee, *Ut Pictura Poesis:*, p. 10.
[75] Puttenham, *Art of Poesie*, p. 204.

least partly directed towards an examination of the trope of the simile.⁷⁶ A comparable whiff of misogyny surrounds his exploration of likeness in two further poems, the epigram "Phrine" and the longer heroic epistle "Sappho to Philaenis". Both develop the investigation of the limits of representation that we have seen in "His Picture" and the actual portraits of Donne, but through the depiction of the female body. The poetic convention of blazoning and praising the female form makes it ripe for parody as well as for exploring the limits of "likeness". There is nonetheless something slightly uncomfortable about the way these two poems pursue this through mocking or belittling constructions of female figures, with "Phrine" mobilising the negative connotations of the "painted" woman, and "Sappho to Philaenis" evoking the banality of lesbian desire.

In the deceptively simple epigram, "Phrine", Donne plays with the ambivalent connotations of the word "painted":

> Thy flattering picture Phrine, is like thee,
> Only in this that yow both painted be.⁷⁷

This is another example of a staging of a material portrait, this time condensed into two lines. Here, as in "His Picture", Donne shows himself to be fascinated by idea of producing a "likeness", and the compressed space of the epigram brings the words "picture", "like", and "painted" together in an economical interrogation of the possibility of mimetic representation. The basic pun on "painted" here compares the portrait to the painted face of the prostitute, and invokes the general suspicion of face-painting and cosmetics used to "alter or enhance the external body [and] destroy[ing] divine workmanship".⁷⁸ The epigram is, however, as Norman Farmer observes, "much more than just a cut at prostitutes".⁷⁹

The poetic convention of the "flattering picture" is generally used either to flatter the sitter – as Claire Pace puts it, "no painted image can approach the perfection of the living model"⁸⁰ – or to praise the painter for the hyper-realism of his imitation of nature, as in Cowley's "On the Death of Sir

76 "Elegy 2. The Comparison", Stringer *et al.*, eds. *Variorum 2: Elegies*, p. 53. On the misogyny of "The Comparison", see Achsah Guibbory, "'Oh, Let Mee Not Serve So': The Politics of Love in Donne's Elegies" *ELH* 57.4 (1990): 811–833 (pp. 816–818); Elizabeth Bobo, "'Chaf'd Muscatts Pores': The Not-So-Good Mistress in Donne's 'The Comparison'", *ANQ: A Quarterly Journal of Short Articles, Notes and Reviews* 25:3 (2012): 168–174.
77 The text of "Phrine" is taken from Gary A. Stringer *et al.*, eds., *Variorum 8: Epigrams*, p. 11.
78 See Farah Karim-Cooper, *Cosmetics in Shakespearean and Renaissance Drama* (Edinburgh: Edinburgh University Press, 2006), p. 40.
79 Farmer, *Poets and the Visual Arts*, p. 24.
80 Pace, "Delineated Lives", p. 5.

Anthony Vandike": "His pieces so with their live *Objects* strive / That both or *Pictures* seem, or both *Alive*".[81] Donne's "flattering picture" flatters neither sitter nor artist. By insisting that the only likeness between model and artwork lies in their both being painted, he insists on the artificiality of the picture rather than the realism for which portraits were so often praised. In "Phrine", verisimilitude turns out to be not only illusionary but impossible.

There is another level, however, to Donne's concise investigation of verisimilitude in this epigram. Phrine is not a random name given to a prostitute but was the name of the Athenian courtesan (*hetaira*) used by Apelles in the fourth century BCE as the model for his painting of Aphrodite rising from the waves, and was also the model for Praxiteles' statues of Aphrodite at Delphi (made of gold) and at Cnidos.[82] Phrine is thus known, in the early modern as in the classical period, for being painted in both senses of the word, but not only that – she is famous for providing a model for a representation of Aphrodite. Classical tradition held that Praxiteles' statue of Aphrodite at Cnidos, in particular, was so "lifelike" that the goddess herself was convinced that Praxiteles must have seen her naked. A tradition of hyperbolic ekphrastic epigrams giving voice to the goddess herself developed this idea.[83]

While Donne's epigram as a whole establishes likeness between painting and model based on their similarly painted and deceptive surfaces, the opening of the second line which claims that this is the "onely" likeness between them calls into question the whole issue of verisimilitude and the relationship of art to nature, much debated in the Renaissance as in the classical period. As Rensselaer Lee discusses, two different beliefs concerning the relationship of art to nature co-existed in the sixteenth century: the older notion that art should be "an exact imitation of nature", and the more Aristotelian concept that art should represent an ideal nature that improves on actual nature.[84] Lee points out that these two incompatible concepts are both represented in Lodovico Dolce's dialogue *Aretino* (1557). Moreover, as an example of how the artist may first imitate, and then improve on nature, Dolce specifically takes the example of Apelles' use of Phryne as a model for his painting of Aphrodite, recommending that the artist "choose the

[81] Abraham Cowley, "On the Death of Sir Anthony Vandike, the Famous Painter", *Poems* (London: Humphrey Moseley, 1656), p. 9. quoted in Pace, p. 5.

[82] See Helen Morales, "Fantasising Phryne: The Psychology and Ethics of Ekphrasis", *The Cambridge Classical Journal* 57 (2011): 71–104.

[83] See Morales, "Fantasising Phryne", pp. 81–85; e.g. "Paphian Cytherea came through the waves to Cnidus, wishing to see her own image, and having viewed it from all sides in its open shrine, she cried, 'Where did Praxiteles see me naked?" (Plato, *Planudean Anthology*, p. 160, quoted in Morales 2011, p. 81).

[84] Lee, *Ut Pictura Poesis*, p. 9.

most perfect form he can, and partly imitate nature".[85] There is no evidence that Donne would have had access to Dolce's treatise, though Liam Semler identifies several of his statements on the visual arts that have parallels in Dolce's *Aretino* or *Dialogue on Painting*.[86] Yet it is striking that Dolce tells the Phryne story precisely in the context of the debate on imitating or surpassing nature, which is what Donne manages to condense in his epigram. This complicates his mocking critique of the trope of verisimilitude. The work of art for which Phryne modelled was praised to the skies for its verisimilitude – but a resemblance to its subject Aphrodite rather than to its model. It is a "flattering picture" in that it surpasses the near perfection of the model, Phryne, to represent the perfect beauty of the subject, Aphrodite. To what extent, then, can the picture be said to be "like" Phrine?

Philip McCaffrey, describing the epigram as "a typical Donnean inversion", holds that "the [painted] medium is found adequate only in its ability to portray (reflect) artifice". He continues, "By implicit contrast, the medium of poetry claims the authenticity necessary to satirise the artifice of both portrait and subject".[87] This implicit comparison between picture and poetry underlies all of the poems considered so far in this chapter, but it is far from clear that Donne grants poetry any greater claim to authenticity than he does visual art. Indeed, as Donne repeatedly chips away at the layers of the paintings he stages, revealing the mechanisms and devices whereby the surface illusion is created, it seems increasingly clear that this expresses an anxiety about artifice not only in visual art but in all artistic representation.

This is best illustrated in his "Sappho to Philaenis", which also makes use of the trope of the image in the heart. Donne's version of Sappho's address to her lover Philaenis is modelled on Ovid's *Heroides*. While Ovid's letter in Sappho's voice is addressed to a male lover, Donne's Sappho addresses a woman, making it a rare early modern example of a lesbian relationship in poetry, albeit written by a heterosexual man.[88] It is not exactly a celebration of lesbian love, however, as the same-sex address in the poem seems to be primarily to be a device with which to explore the limits of *likeness*.

Compared to the picture in the heart in "Witchcraft by a Picture", which is "from all mallice free", or the one in "His Picture" which "dwells" with his soul, the picture in "Sappho to Philaenis" is far less securely fixed, far less certain of immortality:

[85] Ludovico Dolce, *Aretin: A Dialogue on Painting. From the Italian of Ludovico Dolce* (London: P. Elmsley, 1770), pp. 127-130.
[86] Semler, *English Mannerist Poets*, p. 59; p. 73.
[87] McCaffrey, "Painting the Shadow", p. 188.
[88] See James Holstun, "'Will you Rent our Ancient Love Asunder?': Lesbian Elegy in Donne, Marvell, and Milton", *ELH* 54:4 (1987): 835–867.

> Only thine image, in my heart, doth sit,
> But that is waxe, and fires environ it.
> My fires have driven, thine have drawne it hence;
> And I am robbed of *Picture, Heart*, and *Sense*. (ll. 9–12)[89]

Made of wax, and encroached upon by the fires of passion, this is another "picture made and marred", simultaneously created in the heart and threatened with destruction. The pun on the word "drawne" in line 11 suggests the designing of the image, the magnetic force of physical attraction and the fanning of the destructive flames, all at the same time. It is clear from the opening lines of the poem, however, that the tension between creation and destruction is being evoked primarily in the context of poetry: it is Sappho's "poetique fire" (5) that is under threat:

> Where is that holy fire which verse is said
> To haue, is that enchantinge forces decayd?
> Verse, that drawes Natures woorkes from natures law
> Thee her best work, to her work cannot draw. (ll. 1–4)

This association of fire and creation opens the poem, and it is clear that the question of artistic creation and imitation of nature is being addressed specifically in the context of verbal art. The pun on "draws" is already in place here, setting up once more the question of whether art can ever imitate nature and also perhaps implying a comparison between verbal and visual art, as *verse* is said to *draw*. These very words, though, are employed to illustrate the "decay" of Sappho's "holy fire". They are part of a pattern of plodding repetition that emphasises the failure of her verse. While Gardner argues that the "repetitive" and "monotonous" quality of the poem, and its "metrical dullness ... matched by the poverty of its vocabulary" suggest that the poem was unlikely to have been written by Donne,[90] more recent critics have read this flatness of style as deliberate, a dramatised poetic failure. As James Holstun puts it, the "poem's lyric shortcomings are its dramatic successes". For Holstun, in these opening lines, "Sappho's reiterated words are so close in meaning to their originals that they fall flat".[91] The words that are repeated in these lines, "verse", "nature", "work" and "draw", concentrate our attention on the failure of art to imitate nature.

Donne is once again exploring the issue of representation and the very possibility of creating a "likeness". Appropriating the voice of Sappho, he takes apart one of her most famous similes, the opening of fragment 31 that

[89] Quotations from "Sappho to Philaenis" are from Stringer *et al.*, eds., *Variorum 8: Elegies*, pp. 409–410.
[90] Gardner, ed., *Elegies*, p. xlvi.
[91] Holstun, "Lesbian Elegy", p. 837; p. 838.

was later adapted by Catullus: "he seems to me to be equal to the gods".[92] In the hands of Donne's Sappho this comparison is drawn out to the point of redundancy and ridicule:

> Thou art soe faire
> As Gods, when gods to thee I doe compaire,
> Are grast thereby; and to make blynde men see
> What thinges Gods are, I say they are like to thee... (ll. 15–18)

Not only does the heavy-handed repetition again emphasise poetic failure, but the simile itself fails in its self-reflexivity: Philaenis may be compared to gods because gods can be compared to Philaenis. A similar tautology governs Donne's Sappho's next attempt to represent her lover, which is through a poetic blazon. Sappho might almost have Puttenham's *Art of Poesie* open at the page dealing with "Icon", as these two attempts at comparison in the poem cover the two kinds of "Icon, ... or resemblance by imagerie or portrait" that Puttenham outlines. If the comparison to the gods corresponds to the instruction to "liken a humane person to another in countenance ... or other qualitie", Donne's Sappho then proceeds "to resemble every part of her body to some naturall thing of excellent perfection in his kind, as of her forehead, browes, and haire".[93] But this attempt too produces only tautology. In a swift rejection of the Petrarchan blazon, the natural comparison fails, as Philaenis can only be compared to herself:

> Thou art not softe, and cleere, and strait, and faire
> As Downe as Starrs Cedars and lillies are
> But thy right hand, and cheeke, and eye onlye
> Are like thy other hand, and cheeke and Eie. (ll. 21–24).

Everything else in nature is inadequate to represent by comparison nature's own "best work". Sappho's poetic invention is unable to *draw* on nature in order to generate the required comparisons.

This has been described as a "crisis of signification ... a regression to self-referential collapse and signifying failure".[94] It is certainly a breakdown of poetry, and more specifically, it is a breakdown of Icon. The verbal portrait cannot be "drawn" because nature and/or poetic inspiration is inadequate, so it ends up being nothing but a self-perpetuating reflection, perfectly symmetrical but poetically empty. Twenty lines later, the self-referential

[92] On Donne's knowledge of and reference to Sappho see Don Cameron Allen, "Donne's 'Sapho to Philaenis,'" *English Language Notes* 1 (1964): 188–191.
[93] Puttenham, *Art of Poesie*, p. 204.
[94] Barbara Correll, "Symbolic Economies and Zero-Sum Erotics: Donne's 'Sapho to Philaenis'", *ELH* 62.3 (1995): 487–507 (p. 495; p. 499).

blazon is re-doubled, as Sappho compares her own features to those of her lover Philaenis, concluding:

> My two lips, Eyes, thighes differ from thy two
> But soe as thine from one another doe
> And oh noe more; The likenes being such
> Why should they not alike in all parts touch?
> Hand to strange hand, lip, to lip none dennies
> Why should they brest to brest or thighs to things?
> Likeness begets such strange selfe flatterie,
> That touching my selfe all seems done to thee. (ll. 44–52)

Here the tautological blazon of lines 21–24 is transferred onto the spectacle of Sappho's body mirrored in the body of Philaenis, their physical "likenes" represented verbally in the doubled blazon of body parts: "hand to strange hand, lip to lip … brest to brest … thighs to thighs". Almost immediately, though this doubling turns out to be an actual mirror: "myne owne hands I kiss … Mee in my glasse I call thee" (53–55). This slippage from lesbian love to "masturbatory consolation", as Barbara Correll puts it, does seem dismissive of same-sex love, as "lesbian erotics are represented as simple self-pleasuring, not as a union of two distinct lovers".[95] More than this, however, the "likeness" of this imagined lesbian encounter meditates on the impossibility of artistic imitation. Sappho's self-love seems almost to be generated by the failure of the simile, the icon, the verbal portrait.

"Sappho and Philaenis" is a poem about what would happen if the iconic system broke down. If a portrait (or a poem) could represent nature exactly, this is what it would be like: repetitive, doubling, banal, "narcissistically sterile".[96] In the real Sappho fragment 31 the speaker is also made speechless by the presence of the beloved, but this is a temporary speechlessness due to the fires of passion. Ovid, and following him, Donne, develops this into a trope of poetic failure. The threatened wax image in the heart, however, seems to be Donne's own, an almost incidental reference to visual art in this illustration of failed verbal representation. But that picture in the heart makes this elegy part of the network of poems discussed above, with which it shares an undermining of Petrarchan conventions and a questioning of the relationship of art to nature. The fragile waxen image in the heart is the illustration of the failed verbal portrait, encapsulating both the hope of capturing the lover's "likeness" and its impossibility.

[95] Correll, "Symbolic Economies", p. 499.
[96] Elizabeth D. Harvey, "Ventriloquizing Sappho: Ovid, Donne, and the Erotics of the Feminine Voice", *Criticism: A Quarterly for Literature and the Arts* 31:2 (1989): 115–38 (p. 131).

In his *Life*, Walton quotes Henry Wotton's comment on Donne's funeral effigy: "it seems to breathe faintly, and posterity shall look upon it as a kind of artificial miracle".[97] It seems an appropriately ambiguous counterpart to this final likeness of John Donne, highlighting both the artifice and the impossible aspiration of the image. It is a strange paradox that the portraits are so often considered to deliver some kind of biographical truth about Donne, and that "His Picture" is repeatedly claimed to be one of the most autobiographical of his poems. In fact, we see quite the contrary. All of the portraits and poems considered in this chapter demonstrate Donne's fascination, throughout his life, with the processes of visual and verbal representation, and the artifice involved in producing a true likeness. The Donne of the 1590s, who staged himself visually in the Marshall engraving with its curious motto, shows himself to be deeply interested in conventions of self-representation in both painting and poetry. But beyond this it is hard to draw on the engraving for very much information about Donne himself, as it plays with the very idea of faithful representation. The portraits present us with an artificial self, and thwart any attempt to read beyond their staged surfaces. The elegy's verbal representation of a visual representation proves doubly unreliable. In "His Picture", in "Phrine", in "Sappho to Philaenis", the word "like" sparks a profound questioning of what artistic reproduction implies, not only in the abstract terms of Classical or Renaissance discussions of mimesis, but also through a reflection on the technical processes that lie behind a "likeness", whether these involve canvas, primer and pigments or paper, words and tropes.

The chapters that follow consider what happens when Donne pursues these considerations in the context of religious art. The fundamental issues at stake remain the same, and his fascination with the painter's craft and the limits of representation are just as evident in his sermons and divine poems. When Donne calls mimetic representation into question in his love poems and undoes the possibility of knowing the subject through the picture, he is tapping into the essential paradox of the Christian image highlighted by Joseph Koerner. As Koerner puts it, every Christian image can be seen as essentially iconoclastic, "meant to train our eyes to see beyond the image, to cross it out without having to … actually [destroy] it".[98] Margaret Aston comments, "On this view, all art inherently clashes with reality; a portrait as much as an icon is to be 'crossed out' of the viewer's receiving mind because (like any crucifix) it seemingly makes present a person we cannot see, an

[97] Walton, *Lives*, p. 77.
[98] Koerner, *Reformation of the Image*, p. 12.

unseen presence."[99] Donne's playful and paradoxical treatment of likeness and representation in his secular poetry engages with this inherent tension in the image and sets the scene for his exploration of the representation of the divine and the "picture" as a vehicle for understanding the incomprehensible relationship between the individual and God.

[99] Aston, *Broken Idols*, p. 3.

Chapter 2

ART AND THE APOPHATIC

"When we seek the Image of God in man, we begin with a negative".
Sermon Preached to the King at Court,
April 1629 (9: 76)

The concern about seeing and representation already evident in Donne's secular poetry becomes more acute when he comes to consider the theological mysteries. His exploration of the words "image" and "likeness" discussed in the previous chapter acquires a new, biblical, resonance in the context of God's creation of man in Genesis 1: "And God said, Let us make man in our image, after our likeness" (Genesis 1: 26). And his early secular poems resemble the sermons from the other end of his career in that artworks still figure not as objects of interest in themselves, but as a starting point for the exploration of something further.[1] Where we might expect to find ekphrasis, or a conclusive link to material visual art, we discover instead a move towards abstraction. The *Sermons*, more than any other of Donne's works, demonstrate a knowledge of and interest in visual art that – as we might expect by now – goes beyond a mere surface appreciation. Donne's practical and theoretical knowledge of painterly technique may well contribute to the visual art metaphors in the sermons, but, as in the poems, what appears on first sight to reference the material proves to lead towards the immaterial. Tracking down the sources of two of Donne's key visual metaphors in the sermons opens up a new context for his ambivalent references to art. A reference to a "well-made" portrait whose eyes follow you round the room can be traced back to Nicholas of Cusa's *De Visione Dei* (1453), while an

[1] Ann Hurley observes that in the sermons Donne "refers to painting atypically for his time, that is with attention to the craft of the artist or to the handling of painting's material properties". At the same time she observes / points out that his "aesthetic response" in the sermons and letters is "largely incidental, mentioned through analogy or in passing". Hurley, *John Donne's Poetry*, p. 163.

analogy based on a sculptor's craft has its source in the *Mystical Theology* of the sixth-century theologian known as Pseudo-Dionysius the Areopagite. Donne is not generally considered as a "mystical" writer or theologian and I do not intend to identify him as such, but the apophatic approach to God laid out in both of these theological texts provides an illuminating context for his references to artworks. Identifying the source of Donne's painting and sculpture images in his reading of theology, rather than in his involvement in the art world, leads us away from physical art, away from representation entirely, in a way that parallels his own method when he draws on the field of visual art for his subject matter or metaphors. Indeed his habit of both evoking and swerving away from the image has a lot in common with the apophatic method, and in later sermons he develops his own apophatic take on analogies drawn from visual art, reconciling the notion of the *imago Dei* with the ultimate unknowability of God.

THE "WELL-MADE AND WELL-PLACED PICTURE"

When Jean Hagstrum, in *The Sister Arts*, classifies Donne as "unpictorial and undescriptive", his prime example of this is that "Donne appears less interested in portraits as works of art than in the way they appear to stare at you from the wall wherever you stand".[2] As we have seen, in other contexts Donne seems particularly interested in portraits, as owner and subject of several. But it is true that Donne's recurrent references in the sermons to "a well-made, and well-plac'd picture, [which] looks always upon him that looks upon it", do not correspond to Hagstrum's definition of the "pictorial" as "an image ... capable of translation into painting or some other visual art ... imaginable as a painting or a sculpture".[3] What Donne develops in this metaphor is not the subject matter of the picture but the experience of viewing it. While not "pictorial" in Hagstrum's sense, the metaphor is very much concerned with spectatorship, with ways of looking.[4] Donne's unpictorial picture sets up a mirror relation between picture and spectator – between God and man – that is dynamic rather than static.

This image of a portrait recurs four times in sermons preached between 1619 and 1622. The first dated occurrence is in the "Sermon of Valediction at my going into Germany", given on April 18, 1619, before his departure

[2] Hagstrum, *Sister Arts*, p. 113. Hagstrum cites Milton Rugoff as his source, who describes this as "typically Donnean... just the sort of odd phenomenon to catch Donne's fancy". *John Donne's Imagery* (New York: Russell and Russell, 1962), p. 109.

[3] Hagstrum, *Sister Arts*, pp. xxi–xxii.

[4] W. J. T. Mitchell defines *spectatorship* as "the look, the gaze, the glance, the practices of observation, surveillance, and visual pleasure". "The Pictorial Turn", in *Picture Theory* (Chicago and London: University of Chicago Press, 1994), p. 16.

on a diplomatic embassy to Germany with James Hay, Viscount Doncaster. Preaching on memory, he instructs his listeners to

> go to thine own memory; for as St *Bernard* calls that the stomach of the soul, we may be bold to call it the Gallery of the soul, hang'd with so many, and so lively pictures of the goodness and mercies of thy God to thee [...] And as a well made, and well plac'd picture, looks alwayes upon him that looks upon it; so shall thy God look upon thee, whose memory is thus contemplating him...[5]

The last dated occurrence is from a sermon given on Easter Monday 1622 where he preaches on ways of contemplating the face of Jesus:

> See him in that seal which is a copy of him, as he is of the father; see him in the Sacrament. Look him in the face as he lay in the manger [...] Look him in the face in the Temple [...] Look him in the face, as he look'd upon Friday last; when he whose face the Angels desire to look on [...] was so marr'd more than any man [...] and then look him in the face as he look'd yesterday[...] rais'd by his own power [...] Look him in the face in all these respects, of Humiliation, and of Exaltation too; and then, as a picture looks upon him, that looks upon it, God upon whom thou keepest thine eye, will keep his Eye upon thee. (*Sermons*, 4: 130)

The picture metaphor is also to be found in two undated sermons on the Penitential Psalms, which are estimated to be from the period 1616–1619.[6] The first refers to the universal applicability of King David's life story, while the second is again on the virtue of looking at God:

> His example is so comprehensive, so generall, that as a well made, and well placed Picture in a Gallery looks upon all that stand in severall places of the Gallery, in severall lines, in severall angles, so doth *Davids* history concern and embrace all. (5: 299).

> So our eyes waite upon God, *till hee have mercy,* that is, while he hath it, and that he may continue his mercy; for it was his mercifull eye that turned ours to him, and it is the same mercy, that we waite upon him. And then, when, as a well made Picture doth alwaies looke upon him, that lookes upon it, this Image of God in our soule, is turned to him, by his turning to it, it is impossible we should doe any foule, any uncomely

[5] Potter and Simpson, eds., *Sermons*, p. 237.

[6] Paul Stanwood identifies a series of sermons preached on the penitential psalms, which he argues are from the beginning of Donne's preaching career, "as early as 1616 and likely before travel with Doncaster in May 1619". "Donne's Earliest Sermons and the Penitential Tradition", in *John Donne's Religious Imagination: Essays in Honour of John T. Shawcross*, ed. by Raymond-Jean Frontain and Frances M. Malpezzi (Conway AR: UCA Press, 1995), p. 366.

thing in his presence. [...] Can any man give his body to uncleannesse, his tongue to prophanenesse, his heart to covetousnesse, and at the same time consider, that his pure, and his holy, and his bountifull God hath his eye upon him? Can he looke upon God in that line, in that Angle, (upon God looking upon him) and dishonour him? (9: 368)

These recurrent references to pictures that look back at their viewer have prompted critics to seek the source of Donne's knowledge in treatises on visual art. Liam Semler finds parallels for the specific technique employed in this "well-made picture" in both Richard Haydocke's translation of Lomazzo's *Trattato dell'arte* and in Nicholas Hilliard's *Art of Limning*. Lomazzo praises "Cimon Cleondus [who] did much beautifie the arte by finding out the fore-shortning of Pictures, casting the countenance so artificially, that it seemed to looke every way", while Hilliard includes in his closing list of topics: "Howe to make the picture seeme to looke one in the face which waie soe ever he goe or stand".[7]

Yet although Donne's knowledge of the visual arts and art theory undoubtedly underpin his interest in this particular metaphor, his use of this particular image is strongly reminiscent of a theological source, Nicholas of Cusa's *De Visione Dei* (1453). In this influential treatise Cusanus explores ideas drawn from mystical theology through the analogy of a painting whose eyes seem to follow its viewer around the room. This "omnivoyant icon" is used to elucidate the idea that the intellect must try to see God, although God cannot be seen. Milton Rugoff is right when he claims this is "just the sort of odd phenomenon to catch Donne's fancy".[8] The image seems so "typically Donnean" that it is almost surprising to find that it does not originate from his own observations. But Donne's repeated use of it in the sermons establishes connections with the thinking of Nicholas of Cusa that are perhaps more revealing of his method than an original metaphor based on his own observation might be.

In the twenty-five chapters of his *De Visione Dei*, Nicholas of Cusa takes the example of the "well-made picture" as the starting point that allows him to elaborate on ways in which his readers' experience of physical sight could help to approach the understanding of God. When he originally sent his treatise to the Abbot and brothers of the Benedictine Abbey of Tegernsee in Southern Germany, he evidently enclosed an actual painting, an "image of someone omnivoyant, so that his face, through subtle pictorial artistry, is such that it seems to behold everything around it". He tells his addressees

[7] Semler, *English Mannerist Poets*, p. 52. See Lomazzo, *A tracte*, p. 7; Arthur F. Kinney and Linda Bradley Salamon, eds., *Nicholas Hilliard's Art of Limning* (Boston: Northeastern University Press, 1983), p. 45.
[8] Rugoff, *John Donne's Imagery*, p. 109.

that he proposes to "attempt to lead [them] – by way of experiencing and through a very simple and very common means – into most sacred darkness".⁹ He will "convey [them] by human means unto divine things", he explains, by means of "a likeness". He gives famous examples of many such "excellently depicted faces", including "the one of the preeminent painter Roger in his priceless painting in the city hall at Brussels".¹⁰ In his introduction Cusanus illustrates at length how the "omnivoyant figure" or "Icon of God" may function:

> Hang this icon somewhere, e.g., on the north wall; and you brothers stand around it, at a short distance from it, and observe it. Regardless of the place from which each of you looks at it, each will have the impression that he alone is been looked at by it. [...] [M]arvel at how it is possible that [the face] behold each and every one of you at once.... Marvel at the changing of the unchangeable gaze.
> Moreover, if while fixing his sight upon the icon he walks from west to east, he will find that the icon's gaze proceeds continually with him; and if he returns from east to west, the gaze will likewise not desert him. He will marvel at how the icon's gaze is moved immovably. (*DVD*, 115)¹¹

9 Jasper Hopkins, ed., *Nicholas of Cusa's Dialectical Mysticism: Text, Translation, and Interpretive Study of De Visione Dei*, second edition (Minneapolis: Arthur J. Banning, 1988), p. 113. Hereafter references to *De Visione Dei* will be abbreviated *DVD* in the text.

10 Rogier van der Weyden, whose lost mural *The Justice of Trajan and Herkinbald* in the town hall in Brussels reportedly contained a self-portrait of the artist, looking out of the painting. A copy survives in a tapestry in the Historiches Museum, Bern. Erwin Panofsky, *Early Netherlandish Painting* [1953] (New York: Icon/Harper and Row, 1971), vol. 1, p. 248.

11 I am very grateful to Piers Brown for first drawing this passage to my attention. Eugene Cunnar also identifies Cusanus's *De Visione Dei* as Donne's source in "Illusion and Spiritual Perspective in Donne's Poetry", in *Aesthetic Illusion: Theoretical and Historical Approaches*, ed. by Frederick Burwick and Walter Pape (Berlin and New York: Walter de Gruyter, 1990), pp. 324–336. Comparisons between Donne and Cusanus, though not of this specific passage, have also been suggested by Isamu Muroaka, "Donne to Cusanus", *Eigo Seinen (The Rising Generation)* 114 (1968): pp. 216–217 and Mitsuo Arakawa, *Shinpishiso to Keijijoshijintachi [Mystical Thought and Mystical Poets]* (Tokyo: Shohakusha 1976). Many thanks to Makiko Okamura for generously translating these articles for me. Michael Martin also suggests Cusanus as an influence in his chapter "A Glass Darkly: Donne's Negative Approach to God", in *Literature and the Encounter with God in Post-Reformation England* (Farnham: Ashgate, 2014), pp. 47–84, though he does not develop the parallels with Nicholas of Cusa at any great length.

Donne's repeated appropriations of this passage all condense Nicholas of Cusa's account of the reciprocal nature of the omnivoyant gaze.[12] Three out of the four times that Donne uses the analogy in a sermon, his message is a variation on "God upon whom thou keepest thine Eye, will keep his Eye upon thee" (4: 130). His virtually word-for-word repetitions of the "picture [that] looks upon him, that looks upon it" in the three longer occurrences of the metaphor create a chiasmus that echoes the reciprocal gaze of Cusanus's image, and unpacks the condensed Latin pun *De Visione Dei* which means, in the words of Jasper Hopkins, both "*God's vision* of creatures [and] *creatures' vision* of God".[13]

Donne does not appropriate Cusanus' imagery wholesale, but selects carefully to integrate it into the needs of his sermon. With his reference to the "Gallery of the soul" in the 1619 sermon Donne characteristically expands Nicholas of Cusa's idea, both internalising the image by making it hang in "the Gallery of the Soul" (2: 237) and multiplying it. While Cusanus has one painting being watched in wonder by multiple spectators, Donne furnishes his gallery with "so many, and so lively pictures" but mentions only one witness. In both metaphors, God is the picture. Man contemplates God; but in Donne's version he contemplates God in multiple examples. In many ways Donne's gallery here resembles Marvell's later and better-known exploitation of a similar idea, "The Gallery" (1648–1649), which is widely celebrated as an original and creative extension of the possibilities of the internal image, hanging multiple images of the same woman in the gallery of the soul:

> Clora come view my soul, and tell
> Whether I have contrived it well.
> Now all its several lodgings lye

[12] Donne does not explicitly cite Nicholas of Cusa in any of his references to the omnivoyant icon. There can be no doubt that Donne knew Cusanus's work, however, since in his *Essays in Divinity* (written in 1614 or 1615), he refers to the Cusan's work on the Koran, *Cribratio Alkorani*: "The *Alcoran*… had received *Cribrationem*, a sifting by *Cusanus*…" and clearly indicates that he has read it, as he goes on to observe that Luther could certainly not have read Cusanus's book "for else he could not have said that the Cardinal had only excerpted and exhibited to the world the infamous and ridiculous parts of [the Koran], and slipped the substantial". John Donne, *Essays in Divinity*, ed. by Evelyn M. Simpson (Oxford: Clarendon, 1952), p. 9. He may possibly be referring to *De docta ignorantia* in a sermon preached at St Paul's when he discusses "a learned ignorance, which is a modest, and a reverent abstinence from searching into those secrets which God has not revealed in his word" (9: 234), although the concept of *docta ignorantia* is not original to Cusanus and is also used by Augustine. Martin cites this passage in the context of Donne's knowledge of Nicholas of Cusa in *Literature and the Encounter with God*, p. 62.

[13] Hopkins, "Interpretative Study", *Nicholas of Cusa's Dialectical Mysticism*, p. 17 (emphasis in original).

Composed into one gallery;
And the great arras-hangings, made
Of various faces, by are laid:
That, for all furniture, you'll find
Only your picture in my mind. (ll. 1–8)[14]

Marvell's biographer, Pierre Legouis, celebrates his ability to "renovate the hackneyed metaphor by enlarging it. His imagination reveals itself spacious without strain".[15] Marvell's internal gallery, with its descriptions of Clora's multiple faces, does correspond to Hagstrum's category of the pictorial, and Hagstrum praises Marvell's originality in adapting Giambattista Marino's "largely literal" *Galeria* (1619–1620) "into a psychological metaphor; Marvell's gallery is in the soul".[16] Such praise for scope and invention must equally apply to Donne's gallery of images of God's mercy, which predates Marvell's by about thirty years, and is virtually contemporary with Marino's poem.[17]

For Hopkins, *De Visione Dei* is Nicholas of Cusa's "sole *literary* masterpiece".[18] It provides Donne with a metaphor that helps him to theologically elucidate the intellectual sight of the unseeable God, but it is also a literary model that parallels and perhaps to some extent inspires Donne's own method of using analogies drawn from material art to illustrate abstract theological ideas. Rather than linking Donne to the world of material, representational artwork, the image of the picture that "looks always upon him that looks upon it" leads, in the words of Cusanus, towards "divine things", towards "the most sacred darkness", towards, in fact, that which cannot be seen.

THE SCULPTOR AND THE STATUE

The association of Donne's visual art metaphors with the Cusan's "most sacred darkness" is reinforced when we consider it in parallel with another visual art analogy from the sermons. A sermon preached at St Dunstan's on Trinity Sunday, 1627, contains another passage which has been cited as evidence of Donne's familiarity with early modern visual culture, but which is better understood as part of his reflection on negative theology.

[14] *Andrew Marvell: The Complete Poems*, ed. by Elizabeth Story Donno (London: Penguin, 1972), pp. 40–41.
[15] Pierre Legouis, *Andrew Marvell: Poet, Puritan, Patriot* (Oxford, 1965), p. 31.
[16] Hagstrum, *Sister Arts*, p. 114.
[17] Marino's *Galeria* was translated into English by Samuel Daniel in 1623 (Hagstrum, *Sister Arts*, p. 114).
[18] Hopkins, "Interpretative Study", p. 44 (my emphasis).

Discussing, once again, our ways of conceptualising the divine, he compares the practices of sculptors and painters:

> To make representations of men, or of other creatures, we finde two wayes; Statuaries have one way, and Painters have another: Statuaries doe it by Substraction; They take away, they pare off some parts of that stone, or that timber, which they work upon, and then that which they leave, becomes like that man, whom they would represent: Painters doe it by Addition; Whereas the cloth, or table presented nothing before, they adde colours, and lights, and shadowes, and so there arises a representation. Sometimes we represent God by Substraction, by Negation, by saying, God is that, which is not mortall, not passible, not moveable: Sometimes we present him by Addition; by adding our bodily lineaments to him, and saying, that God hath hands, and feet, and eares, and eyes; and adding our affections, and passions to him, and saying, that God is glad, or sorry, angry, or reconciled, as we are. (8: 54)

Semler and Hurley both cite this passage in their overviews of Donne's knowledge of the visual arts, both finding parallels in exactly the same passages from Lomazzo's *Tracte*, Vasari's *Lives of the Artists* and Henry Wotton's *Elements of Architecture*.[19]

The language of the Wotton passage is indeed remarkably close to Donne's, describing as it does how "the *Plasterer* doth make his Figures by *Addition*, and the *Caruer* by *Substraction*…"[20] Wotton cannot be ruled out as a source, but in the passage from his *Elements* he is describing the practice of actual plasterers and carvers literally and not metaphorically. Donne uses the techniques employed by painters and sculptors to represent the human form analogously, to describe the ways we imagine the divine. His comparison of addition and negation in human attempts to comprehend God strongly suggests that his principal source is the work of the late fifth- or early sixth-century philosopher known as Pseudo-Dionysius. In particular, his reference to the craft of the "statuary" as an analogy for representing God "by negation" looks like a direct reference to Dionysius' very similar, and well-known, use of a statue in the second chapter of his *Mystical Theology*, his short work that lays out the principles of negative or apophatic theology:

> I pray we could come to this darkness so far above light! If only we lacked sight and knowledge so as to see, so as to know, unseeing and unknowing, that which lies beyond all vision and knowledge. For this would be really to see and to know: to praise the Transcendent One in a

[19] Semler, *English Mannerist Poets*, pp. 47–48; Hurley, *John Donne's Poetry*, p. 176.
[20] Henry Wotton, *The Elements of Architecture* (1624), pp. 107–108.

transcending way, namely through the denial of all beings. We would be like sculptors who set out to carve a statue. They remove every obstacle to the pure view of the hidden image, and simply by this act of clearing aside they show up the beauty which is hidden.[21]

As with his multiple references to Nicholas of Cusa's "omnivoyant image", with the image of the sculptor Donne picks up on a metaphor from a text of mystical theology and makes it his own. Once more a reference to visual art serves to explain human perception of the divine. And while the painter, who represents by addition, is used to describe a kataphatic, or affirmative, way of imagining the divine, the sculptor chipping away at his statue, paradoxically, is used to lead us away from any sort of material representation, into the apophatic darkness of the *via negativa*.

In what is still the most developed consideration of Donne's attitude toward negative theology to date, Arnold Stein argues that while "Donne's formal positions as theologian have little sympathy with the negative approach to God", he is nonetheless "honestly attracted to some of the doctrines of unknowing" although they "do not engage [his] mind so deeply as other problems of consciousness".[22] Although more recent critics have argued that the influence of mystical writers such as Pseudo-Dionysius and Nicholas of Cusa had a much more profound influence on Donne's thought and work,[23] Stein's balanced and cautious assessment remains convincing.

Donne uses the sculptor image much more concisely in his poem "The Crosse" (ll. 33–36), which will be discussed in Chapter 4. The influence of the ideas of Pseudo-Dionysius is also evident in his secular poetry. His short poem "Negative Love" is, in the words of Sean Ford, a "compact expression of the *via negativa*",[24] drawing on both Dionysian and Cusan ideas. As we have already seen, exchanges and encounters between lovers provide a context for Donne's exploration of the possibility – or impossibility – of representing the self, or the other. Similarly to the failed and fragmented blazons of "The Comparison" and "His Picture", "Negative Love" rejects Petrarchan verbal portraiture: "I neuer stoopd soe lowe as they, / Which on an eye, cheeke, lip, can pray" (1–2), claiming that acknowledging the impossibility of ever fully knowing the other person "though sillie is more braue" (7). The second stanza succinctly sums up the principles of the *via negativa*:

[21] Pseudo-Dionysius, *The Complete Works*. Trans. Colm Luibheid (New York: Paulist Press, 1987), p. 138.

[22] Arnold Stein, *John Donne's Lyrics: The Eloquence of Action* (Minneapolis, MN: University of Minnesota Press, 1962), p. 175; p. 180, and p. 181.

[23] See Martin, *Literature and the Encounter with God*, pp. 61–68.

[24] Sean Ford, "Nothing's Paradox in Donne's 'Negative Love' and 'A Nocturnal upon S. Lucy's Day,'" *Quidditas* 22 (2001): 99–113 (p. 104).

> If that bee simply perfectest,
> Which cann by noe waie bee exprest
> But Negatiues, my love is soe
> To all which all loue, I saie no.
> If any who deciphers best,
> What we know not our selues can know,
> Let him teach mee that nothing ... (ll. 10–16[25])

Ford compares this directly to the sculptor image of the *Mystical Theology*: "the 'hidden statue' of the Pseudo-Dionysius finds its parallel in the love described in the poem, which pushes negative definition to its extremes to argue that denying all positive attributes ultimately leads to nothingness".[26] Donne's most extended discussion of Pseudo-Dionysius's negative theology is in the *Essays in Divinity*, where he refers directly to Pseudo-Dionysius's *On the Celestial Hierarchies*, describing its author as "a devout speculative man". Although he acknowledges that attempting to draw "knowledge of God ... from *effects*" will be inadequate, the *via negativa* does not provide a fully satisfactory alternative:

> Canst thou rely and leane upon so infirm a knowledg [sic], as is delivered by negations? And because a devout speculative man hath said, *Negationes de Deo sunt verae, affirmationes autem sunt inconvenientes,* will it serve thy turn to hear, that God is that which cannot be named, cannot be comprehended, or which is nothing else? When every negation implyes some privation, which cannot be safely enough admitted in God; and is, besides, so inconsiderable a kind of proofe, that in civill and judic<i>all practice, no man is bound by it, nor bound to prove it.[27]

[25] Johnson *et al.*, eds., *Variorum 4.3: Songs and Sonnets*, p. 237.

[26] Ford, "Nothing's Paradox", pp. 104–105. Ford and Stein both identify "A Nocturnall Upon St. Lucie's Day", with its references to absence, darkness and non-existence as Donne's fullest exploration of the implications of the *via negativa*, Stein, *John Donne's Lyrics*, p. 175; p. 180; Ford, "Nothing's Paradox", pp. 106–112; see also Jennifer L. Nichols, "Dionysian Negative Theology in Donne's 'A Nocturnall upon S. Lucies Day'", *Texas Studies in Literature and Language* 53.3 (2011): 352–367 (p. 352).

[27] Donne, *Essays in Divinity*, p. 21. The writings of Pseudo-Dionysius circulated widely in Latin translation in the sixteenth century. According to Karlfried Froehlich, the version most read among humanists, including Protestant reformers, was the 1436 Latin translation by Ambrogio Traversari, first printed in Bruges in 1480 (Karlfried Froehlich, "Pseudo-Dionysius and the Reformation of the Sixteenth Century", in Pseudo-Dionysius, *Complete Works*, pp. 33–46 (p. 34)). Donne may also have been aware of the translation by Marsilio Ficino (Florence, 1496). According to Philippe Chevallier's *Dionysiaca*, sixty-four editions of Pseudo-Dionysius's *Mystical Theology* were produced in the sixteenth century, seventeen of them based on Ambrogio's Latin translation and sixteen on Ficino's (*Dionysiaca*, ed. by Philippe Chevallier (Stuttgart-Bad Cannstatt: Frommann-Holzboog, 1989), 1, p. lx). Donne's citation of

The ambivalent attitude toward the apophatic here supports Stein's view that Donne's undoubted knowledge of and interest in negative theology does not make him a mystical poet or theologian. I would, however, dispute Stein's conclusion that his lack of engagement is simply because his imagination is more stimulated by "other problems of consciousness". Donne repeatedly invokes the language and imagery of negative theology not as an end in itself but because doing so allows him to develop his own arguments. In doing so he both adapts apophatic thought to his own purposes and uses it to challenge and expand his ideas.

THE *RED GLASSE*

One of the key ways in which Donne appropriates and adapts the language of mystical theology is by turning away from the darkness of unknowing and focusing rather on Christ and the sacrifice of the Crucifixion, a shift that is to be found in his divine poems too. In his sermons we can trace a network of references to the ideas of Pseudo-Dionysius and Nicholas of Cusa which combine mystical thought with a much more Christological theology, and interestingly he often achieves this through visual and optical metaphors – sometimes drawn from Cusanus and sometimes apparently his own. His references to the Cusean "well-made picture" are to be found in sermons preached between 1619 and 1622, and his use of the Dionysian metaphor of the sculptor is in a sermon from 1627. These seem to be periods in which he is particularly preoccupied by mystical theology and its implications, as the threads in this network of optical imagery confirm. It can become quite complicated tracing the variations and echoes of his adaptations of apophatic thought, but the echoes and cross-references in different sermons and poems, moving from seeing to darkness, and from darkness to Christ's blood, weave a convincing web of adapted apophatic imagery.

A good place to start is Donne's "Hymne to Christ, at the Authors last going into Germany", which opens with the visual imagery of the emblem, a ship which is "my Embleme of thy Arke" (2) at sail on a sea that functions as "an Embleme of thy bloud" (4).[28] The apparent gloom and self-negation of the hymn has attracted many biographical readings. His valediction poems, as we observed in Chapter 1, often tend to generate biographical associations, and the commonly used title of this hymn fixes it to a specific

Pseudo-Dionysius here seems to be drawn virtually word for word from Thomas Aquinas, *Summa Theologica*, I[a] q. 13 a. 12 arg. 1 (http://www.unifr.ch/bkv/summa/kapitel14-12.htm), although Donne's use of *inconvenientes* rather than Aquinas's *incompactae* suggests he had direct knowledge of one of the Latin translations, possibly via the edition of his works published in Cologne in 1556.

[28] Johnson *et al.*, eds., *Variorum 7.2: Divine Poems*, p. 172.

journey, Donne's departure on the embassy to Germany in 1619 with James Hay, Viscount Doncaster. Donne's letters reveal a certain lack of enthusiasm at the prospect of this trip:

> I leave a scattered flock of wretched children, and I carry an infirm and valetudinary body, and I go into the mouth of such adversaries as I cannot blame for hating me, the Jesuits, and yet I go.[29]

For R. C. Bald, in this poem we see Donne "weighed down by fears of shipwreck or of drowning".[30] Anthony Parr observes that the poem reflects "Donne's particular circumstances and state of mind before departure ... there is every indication that illness and financial worries were besetting him and that he feared he would not return alive".[31] But as well as placing the hymn at a particular moment in Donne's life, the date and title relate it to his Valediction sermon preached before the same trip – which is where we find his most developed reference to the "well-made and well-placed picture": Nicholas of Cusa's omnivoyant icon. Several sermons from the period of the embassy and the years just following contain references to mystical theology, and reading the hymn in this context reinforces the impression that it is one of Donne's most explicitly apophatic poems. It draws on the mystical tradition of the *via negativa* in its closing lines, which strongly evoke Nicholas of Cusa's "sacred darkness" or Pseudo-Dionysius' "darkness so far above light":

> Churches are best for Prayer that haue least light;
> To see God only, I goe out of sight:
> And to scape stormy dayes, I choose an everlasting Night. (ll. 26–28)

Like Cusanus's "omnivoyant icon", the imagery of the hymn leads "by human means unto divine things", from allusions to the material world of emblem books to the darkness of unseeing.

John J. Pollock has found thematic and linguistic correspondences between the valedictory hymn and sermon, particularly in the sermon's references to the Ark metaphor – "God remembered Noah"– and the "sea of his blood" (*Sermons* 2: 236; 249). He finds a patterning of light and dark in both poem and sermon, although the sermon is resolved in images of light while the hymn concludes with an image of darkness.[32] Pollock

[29] Letter to Henry Goodyer, dated 9 March [1619], *Letters to Severall Persons of Honour*, 174–175. See Johnson, *Theology of John Donne*, pp. 107–110, for a discussion of the biographical context and circumstances of the composition of the hymn.
[30] Bald, *Donne*, p. 343.
[31] Anthony Parr, "John Donne, Travel Writer", *Huntington Library Quarterly* 70:1 (2007): 61–85, 77.
[32] John J. Pollock, "A Mystical Impulse in Donne's Devotional Poetry", *Studia Mystica* 2:2 (1979): 17–24. Evelyn Simpson also cites (and quotes in full) the "Hymn to

concludes that in the Hymne to Christ Donne reveals "an impulse toward the purely mystical apprehension of God", yet also points out that in the valedictory sermon he seems more critical of mystical attitudes, observing that "retiring thyself from the world [may] degenerate into a contempt and despising of others, and an overvaluing of thine own perfections" (2: 243).[33] It is worth recalling Stein's cautious assessment that Donne's "honest attraction" to negative theology does not necessarily influence his formal theological stance.[34] While Donne's public prose maintains a distance from the doctrines of unknowing, the poetic persona of the "Hymne to Christ" allows him to approach the subject from a different angle. This does not necessarily mean that we should read the hymn as Donne himself choosing "the total abandonment of the self into the nothingness of the Godhead," as Pollock suggests.[35] The "hymn" permits Donne, rather, to dramatise such an abandonment of the self, and through the poet's sleight of hand the confident "I" of the first stanza, who is able to find earthly and material metaphors to describe his understanding of Christ, finishes by "go[ing] out of sight" in order to "see God only".

The speaker's contemplation of Christ's blood in the first stanza of the hymn, as the first step in his apophatic journey, suggests further links with Donne's adaptation of the thought and imagery of Nicholas of Cusa in his sermons, where we see him turning the language of negative theology to more specifically Christological ends. Other sermons from the period of the embassy and the years just following contain apophatic passages that can be linked directly with the "Hymne to Christ" and with Nicholas of Cusa's meditations on the omnivoyant icon in *De Visione Dei*. Two stand out particularly: the sermon preached at The Hague in December 1619 on the embassy's way back to England, and the one preached at Hanworth on August 25, 1622, to James Hay and company. The latter contains a passage which resonates with the apophatic conclusion of Donne's hymn:

> Man *sees* best in the *light*, but *meditates* best in the *darke*; for our sight of God, it is enough, that God gives the light of *nature*; to behold him so, as to fixe upon him in meditation, God benights us, or eclipses us, or casts a cloud of medicinall afflictions, and wholsome corrections upon us. (4: 174)

Although removed in time by a few years, the Hanworth sermon is linked to the 1619 valedictory sermon and poem through the person of James Hay, who, as Viscount Doncaster, had headed the embassy to Germany. In his

Christ" as an illustration of Donne's mysticism in the first edition of *A Study of the Prose Works of John Donne* (Oxford: Clarendon, 1924), p. 103, although interestingly she removes this passage from the second edition published in 1948.

[33] Pollock, "Mystical Impulse", p. 23.
[34] Stein, *John Donne's Lyrics*, p. 175, p. 180.
[35] Pollock, "Mystical Impulse", p. 23.

address to Hay and the assembled company, including Hay's father-in-law, Henry Percy the Earl of Northumberland, Donne navigates between life experiences of tribulation and of privilege, steering a middle way between the seeing of God in darkness and the revelation of God in light. Despite the apparently mystical language, before very long the suggestion of the apophatic gives way to "darkness" in the sense of "affliction" and "correction". This suggests that Donne is to some extent tailoring his moral to his audience – the references to affliction are clearly directed, at least in part, to Henry Percy, recently released from the Tower of London, while the counter-examples of riches and privilege characterise Hay's legendary prodigality and excess.[36] The blurring of mystical darkness with earthly tribulation in the sermon provides the context for Donne's development of Nicholas of Cusa's imagery in ways that are comparable to the valediction hymn.

The "Hymne to Christ"'s opening reference to the visual representational tradition of the emblem book shifts and becomes increasingly problematised as the poem develops from the middle of the first stanza onwards:

> Though thou with Clowds of Anger doe disguise
> Thy face, yet through that Mask I know those eyes
> Which though they turne away sometimes, they never will despise. (5–7)

There are strong echoes of Nicholas of Cusa's omnivoyant icon in this insistence on the eyes of God. Yet Donne plays with Cusanus's ideas – and the ideas of negative theology more generally – in a number of ways, raising questions about the representation of the divine. In the sermons, Donne's repeated reference to the "well-made, and well-placed picture" is ultimately reassuring – so long as you keep your eye on God, he will keep his eye on you. In the hymn, though, the eyes of God may be turned away. God is attributed both a face and a human emotion in the description of the "clouds of anger" obscuring him, a kataphatic representation that seems likely to have its roots in the thinking of Nicholas of Cusa and Pseudo-Dionysius.

In the third chapter of *Mystical Theology* Dionysius acknowledges the ways God has been described as having human actions and attributes: "his anger, grief and rage, of how he is said to be drunk and hungover, of his oaths and curses, of his sleeping and waking".[37] This is precisely what Donne himself describes in the passage from the 1627 sermon that introduces the analogy with the sculptor and the painter: "Sometimes we present him by Addition; by adding our bodily lineaments to him, and saying, that God hath hands, and feet, and eares, and eyes; and adding our affections, and

[36] See Johnson, *Theology*, pp. 79–80.
[37] Pseudo-Dionysius, *Complete Works*, p. 139.

passions to him, and saying, that God is glad, or sorry, angry, or reconciled, as we are" (8: 54). He also explores the topic in the 1619 sermon preached at The Hague during the Doncaster embassy:

> God in the Scriptures is often by the Holy Ghost invested, and represented in the qualities and affections of men; and to constitute a commerce and familiarity between God and man, God is not only said to have bodily lineaments, eyes and eares, and hands, and feet, and to have some of the natural affections of men, as Joy, in particular... And pity too... (2:288–289)

This attribution of human emotions to God is part of the network of references Donne makes to the principles of negative theology around this time, and in the "Hymne to Christ" the "clouds of anger" are succeeded by a play on the Old Testament description of a "jealous God" compared to human jealousy:

> As thou
> Art jealous, Lord, soe I am iealous nowe...
> O, if thou car'st not whom I loue, Alas, thou lou'st not me (ll. 17–18; 21).

The projection of human emotion onto God is highlighted by Donne's speaker's rather petulant insistence that "I am jealous nowe" and the hyperbolic conclusion that "if thou car'st not whom I love, Alas, thou lov'st not me". The chiasmus in line 18 (jealous Lord / I am jealous) emphasises the idea that the human emotions ascribed to God are only a reflection of the speaker's own emotional state, and this idea too can be traced to Nicholas of Cusa's *De Visione Dei*.

Extrapolating from his starting point of the painted face that always seems turned towards spectators, no matter where they stand in the room, Cusanus develops, like Donne in the Hymn, the idea that humankind projects human emotions onto the divine:

> Just as while I look from the east at this depicted face it seems likewise to look eastwardly at me [...] In a similar way, Your Face is turned toward every face that looks unto You. [...] Accordingly, whoever looks unto You with a loving face will find only Your Face looking lovingly upon him [...] Whoever looks angrily unto You will find Your Face likewise to display anger. Whoever looks unto You joyfully will find Your Face likewise to be joyous, just as is the face of him is looking unto You. (*DVD* 6.20, 137)

For Nicholas of Cusa, mankind's vision of God is necessarily mediated by his own subjective condition. Limited by his human frame of knowledge and experience, man can only visualise God in human terms. The passage continues directly:

> For just as the bodily eye, in looking through a red glass, judges as red whatever it sees, and as green whatever it sees if looking through a green glass, so each mental eye, cloaked with contraction and passion, judges You who are the object of the mind, according to the nature of the contraction and the passion. A man can judge only in a human way. (*DVD* 6.20, 137)

Cusanus's optical imagery here is quite striking and memorable, concisely conveying the idea that human perception is limited. Donne picks up on the reference to "looking through a red glass" in the 1622 sermon preached to Hay and company at Hanworth. Although, as before, he does not cite Cusanus as his source, he does seem to refer directly to this passage of *De Visione Dei*. Significantly though, he adapts it to his own purposes, rather as he did with the "well-made picture", and the new emphasis he gives to the metaphor of the "red glass" is indicative of the use he makes of mystical theology in general.

Immediately following the apophatic-like reference to meditating best in the dark towards the end of the Hanworth sermon, Donne incorporates the idea of the "red glass" into his elaboration on "darkness" in the sense of "affliction":

> Man *sees* best in the *light*, but *meditates* best in the *darke*; for our sight of God, it is enough, that God gives the light of *nature*; to behold him so, as to fixe upon him in meditation, God benights us, or eclipses us, or casts a cloud of medicinall afflictions, and wholsome corrections upon us. Naturally we dwell longer upon the consideration of God, when we see the Sun eclipsed, then when we see it rise, we passe by that as an ordinary thing; and so in our afflictions we stand, and looke upon God, and we behold him. A man may see God, and forget that ever he saw him ... but Christ remembers that they did see him, but not *behold* him, see him, and looke off, see him so as aggraved their sin, more then if they had never seene him. But that man, who through his owne *red glasse*, can see Christ, in that colour too, through his own miseries, can see Christ Jesus in his blood, that through the calumnies that have been put upon himself, can see the revilings that were multiplied upon Christ, that in his own imprisonment, can see Christ in the grave, and in his owne enlargement, Christ in his resurrection, this man ... beholds God... (4: 174–175, italics in original)[38]

[38] This reference to *De Visione Dei* is not recorded in Stephan Meier-Oeser's indispensable guide to Nicholas of Cusa's legacy, *Die Präsenz des Vergessenen: Zur Rezeption der Philosophie des Nicolaus Cusanus vom 15. bis zum 18. Jahrhundert* (Münster, Germany: Aschendorff, 1989), or its follow-up: Stephan Meier-Oeser, "Die Cusanus-Rezeption im deutschen Renaissancehumanismus des 16. Jahrhunderts",

For Nicholas of Cusa, looking through the red glass simply illustrated the way in which all the perceptions of the "bodily eye" will be coloured by the medium through which it looks – if the glass is red or green the view will be tinted with red or green too – and in the same way mankind can only approach God with human sight and human preconceptions. Like seeing through a glass darkly (1 Cor. 13.12), the red glass metaphor illustrates the inevitable distortion imposed on spiritual understanding by the human condition. For Donne, however, the glass is tinted red by the miseries and afflictions that are part of man's fallen condition, and it is precisely this human misery that allows him to approach and contemplate "Christ Jesus in his blood" and thence "Christ in his resurrection" in which lies the hope of salvation. (He abandons the Cusan's green glass, which does not have these fleshly overtones.) To view Christ through the red lens of human suffering is to find a particular understanding of Christ's sacrifice.[39]

The paradox of entering darkness in order to see, encapsulated in the closing lines of the "Hymne to Christ", is fundamental to the *via negativa*. The sermons of 1619 and 1622 treat the tenets of mystical theology more circumspectly. But if the speaker of "Hymne to Christ" ultimately abandons the emblem of the sea of blood and other kataphatic representations of the divine to enter into the darkness of unknowing, the path taken by Donne the preacher in the sermons is just as compelling. In the sermons, Donne evokes mystical and apophatic language only to turn it to a much more Christological use. In the Hanworth sermon, mystical darkness becomes the darkness of affliction, and Nicholas of Cusa's metaphor of the "red glass" to describe limited human perspective is similarly transformed into the "red" of human suffering and of Christ's blood. The way Donne combines the apophatic and the Christological becomes particularly significant in his divine poems dealing with the Crucifixion, which will be discussed in Chapter 4.

The references to Nicholas of Cusa's *De Visione Dei* in both the 1622 Hanworth sermon and in the 1619 valedictory sermon, and the parallels of both to the 1619 hymn, make it tempting to speculate that mystical theology in general or Nicholas of Cusa in particular were interests that Donne and

in *Nicolaus Cusanus zwischen Deutschland und Italien*. Edited by Martin Thurner (Berlin: Akademie, 2002), pp. 617–632.

[39] Cf. another reference to "spectacles" in the fifth of Donne's Prebend Sermons upon five Psalms: Preached at S. Pauls: "I am not able of my selfe to dye that glasse, that spectacle, thorow which I looke upon this God, in what colour I will; whether this glasse shall be black, through my despaire, and so I shall see God in the cloud of my sinnes, or red in the blood of Christ Jesus and I shall see God in a Bath of the blood of his Sonne". *Sermons*, 8: 123.

Hay shared, since he was a key figure in the auditory for both sermons.[40] It seems reasonable, at any rate, to deduce that Donne and Hay shared an interest in visual art, as Donne bequeathed to Hay the "picture of the Blessed Virgin Mary which hangs in the little dining-chamber", which was almost certainly a work by Titian.[41] This may be considered merely a detail, but it reinserts a material artwork into the discussion, rooting Donne's imagery in his ownership and donation of visual art, rather as Nicholas of Cusa's treatise was apparently accompanied by an actual example of an omnivoyant image, the better to illustrate his points. In a sermon preached to Hay, Donne adapted Cusanus's omnivoyant image hanging on the wall into a gallery of illustrations of God's mercy, and then ten years later took a painting from the wall of his own "art gallery" and presented it to his friend and patron. Donne's practical interest in material visual art may well contribute to the fact that what he primarily takes from the mystical texts of Pseudo-Dionysius and Nicholas of Cusa are their visual metaphors – the picture, the sculptor, the red glass. But as in his exploration of the limits of representation in his secular poetry, he consistently uses these metaphors of art and painting to go beyond the material, to point to what cannot be seen or understood.

THE "CURIOUS MASTERPEECE" AND THE *IMAGO DEI*

The Cusan idea that material images may function as the "human means" by which listeners are "conveyed ... unto divine things" re-emerges in an exaggerated fashion in a sermon Donne preached in April 1629. He preached two sermons to the court of Charles I on Genesis 1: 26, "And God said, Let us make man in our image, after our likeness." In the second sermon, particularly, he picks up on the visual vocabulary employed in this bible verse and problematises it. It is a strange sermon in many ways, especially in the way it employs imagery drawn from visual culture. As so often when Donne turns to metaphors drawn from visual art, the sermon has provoked responses that may seem opposed. Norman Farmer quotes from it at length as "impressive for its sustained use of the picture as metaphor", while David Anderson sees it as evidence that "as he neared the end of his life, Donne grew less comfortable with holy images".[42] The sermon's imagery in fact follows the pattern we have seen elsewhere in Donne's work: "the picture" is initially presented as if uncomplicated, but it becomes increasingly complex

[40] Johnson (*Theology*, pp. 78–79) suggests rather that Henry Percy's known interest in natural philosophy and alchemy provides a context in which to read the Hanworth sermon.

[41] Johnson, *Theology*, p. 84; Milgate, Dr. Donne's Art Gallery, pp. 318–319.

[42] Farmer, *Poets and the Visual Arts*, p. 20; Anderson, "Internal Images", pp. 26–27.

and problematic as his metaphor develops. What is to be "seen", finally, is not the picture but what lies beyond it. Donne's method here could indeed be described as apophatic, as he develops metaphorical descriptions of material artifacts only to clear them out of the way, a progression from the kataphatic to the apophatic that recalls what we have seen in the "Hymne to Christ" and the Cusanus-inflected sermons.

Donne's concern about the dangers of representing the divine in the second of these sermons is couched in terms drawn from negative theology: he cautions that "as when we seek God in his essence, we are advised to proceed by *negatives* (God is *not mortal, not passible*:) so when we seek the image of God in man, we begin with a *negative*, This image is not his *Bodie*" (9: 76). He rebuts several heretical variations on this (that God had a body; that God assumed a body for the moment of creation; that the reference was to the body of Christ), and takes the opportunity to explicitly condemn religious iconography with a sideswipe at "them of the *Roman* perswasion" who "come too near giving God a body in their pictures of God the Father" (9: 77). At the same time, though, he makes the anti-iconoclastic claim that "there is no more danger out of a picture, then out of a history, if thou intend no more in either, then example" (9: 76). Rather as he did in his "*Væ Idolalatris … Væ Iconoclastis*" sermon given two years earlier in 1627 (7: 433), Donne again rhetorically juxtaposes the making and breaking of images and leaves us poised between the two, observing that "God, we see, was the first, that made images; and he was the first, that forbad them. He made them for imitation, he forbad them in danger of adoration" (9: 75). This ambivalence is characteristic of Donne's treatment of images throughout the sermons, though this time, with some audacity, he attributes both positions to God himself. Given the argument that develops, it might be more accurate to say that God was the first to use the word "image" metaphorically, to describe the relationship between human and divine in terms of images, but not implying material likeness. The language of the book of Genesis appears to prompt Donne's exploration of the same vocabulary of "image" and "likeness" that had stimulated him in his secular poetry.

His method in the opening section of this sermon is somewhat bizarre but serves to highlight and problematise the key terms of his text, "image" and "likeness". He begins by insisting on the difference between the two terms, and on the multiple interpretations they have generated: "The variety which the holy Ghost uses here, in the pen of *Moses*, hath given occasion to divers, to raise divers observations, upon these words, which seem divers, *Image* and *likenesse*, as also in the variety of the phrase" (9: 70). He digresses at length – for ninety-eight lines or three pages – on the importance of paying attention to the most minute distinctions between words in

the history of scriptural commentary. This lengthy discussion is followed, however, by a move that Jeffrey Johnson describes as "puzzling" and David Colclough as "ironic". Donne swerves away from actually carrying out the comparison between "image" and "likeness", and states that for the purposes of the sermon he will treat them as "illustration[s] of one another" for the somewhat unconvincing reason that he does not have time to address the distinction properly.[43] Donne's apparent wavering between identifying a distinction between the two terms and allowing them to be taken as synonyms may reflect the fact that Calvin, in his commentary on Genesis, had insisted that there was no distinction between them.[44] But in setting up the expectation of a distinction between image and likeness and then apparently dismissing it, Donne creates a certain confusion that nonetheless has the effect of sharpening our alertness to the shades of meaning attached to the terms in the discussion to come. Having drawn our attention to the terms and insisted, with heavy repetition, on their "divers" significations, he sets up the multiple visual culture metaphors that he will draw on in the course of the sermon.

He continues his double-handed approach to the image question, using the Platonic distinction between original and copy, first of all in an apparent attempt to free the word "image" from its idolatrous associations, but then to reinforce the potential for idolatry in any artificial likeness. "We are made to an image, to a pattern", Donne reminds his listeners: "God himselfe made all that he made according to a pattern. God had deposited, and laid up in himselfe certaine forms, patterns, *Ideas* of every thing that he made" (9: 73–74). And he develops this, invoking the Platonic theory of mimesis in the service of the commandment against idolatry: "For, *Qualis dementiæ est id colere, quod melius est?* What a drowsinesse, what a lazinesse, what a cowardlinesse of the soule is it to worship that, which does but represent a better thing than itself" (9: 75).[45] By juxtaposing the ideas of image as God's

[43] Johnson, *Theology*, p. 24; David Colclough, ed., *The Oxford Edition of the Sermons of John Donne, Vol. 3: Sermons Preached at the Court of Charles I* (Oxford: Oxford University Press, 2013), p. 427. Colclough (p. 425) identifies Donne's probable source of information on the debate as Benedict Pererius's commentary on Genesis: Benedict Pererius, *Commentariorum et Disputationum in Genesim* (Lyon, 1599); see also Katrin Ettenhuber, *Donne's Augustine: Renaissance Cultures of Interpretation* (Oxford: Oxford University Press, 2011), p. 91.

[44] John Calvin, *A Commentarie... vpon the first booke of Moses called Genesis*, C6r. [*Institutes* 1.15.3] See Colclough, *Sermons*, p. 427; Winfried Schleiner, *The Imagery of John Donne's Sermons* (Providence, RI: Brown University Press, 1970), p. 118.

[45] Colclough points out that this passage appears to have undergone significant authorial revision (p. 429), which in itself suggests the care that Donne was taking in establishing his Platonic analogy. The version printed in *Six Sermons Upon Severall Occasions* (Cambridge 1634), which Colclough uses as copy-text, reads: "God (we see) was the first that made images, and he was the first that forbad them; he made

pattern and image as inferior copy, he invokes the idea of God the creator as craftsman, validating the image metaphor while simultaneously casting suspicion on material likenesses.

The passage of the sermon that Farmer finds so "impressive" for its "sustained use of picture as metaphor"[46] grows out of this tension within the idea of the image. In three pages of dense visual imagery Donne guides his listeners through a sequence of different metaphors drawn from visual art in order to elucidate the "image of God in the soule of man" (9: 79). Extremely rich in its evocation of detail, in its description of both the materials and the culture of visual art, Donne's riff on material artworks can feel at times like an overdose of the visual, and like the emblematic opening of the "Hymne to Christ", it is eventually replaced by a more apophatic conclusion.

On the surface, the passage is a development and illustration of his two key points about the *imago Dei*: that to speak of man being made in God's image does not imply that God exists physically; and that God's image should not be overwritten. The image of God is in man's body, he explains, as a precious painting is housed within an outer case:

> as you see some pictures, to which the very tables are Jewells; some Watches, to which the very cases are Jewells, and therefore they have outward cases too; and so the Picture, and the Watch is in that outward case, of what meaner stuffe soever that be: so is this Image in this body as in an outward case. [...] [T]he body is but the out-case, and God looks not for the gilding, or enamelling, or painting of that: but requires the labour, and cost therein to be bestowed upon the table it selfe, in which this Image is immediately, that is the soule. (9: 79)

The embedded structure of the artefact in this metaphor is echoed in Donne's way of developing it, moving outward in layers to establish the difference, and the distance, between the *imago Dei* and the body of man. He first emphasises the material on which the image is executed, describing pictures painted on the surfaces of jewels, which Colclough suggests may refer to engraved gems, or oil paintings on onyx.[47] In contrast to such a treasure the body is merely the case of "meaner stuff" that contains the precious artwork. Here Donne impresses on his listeners that while they should take care of the "out-case" that contains such a treasure, it is the soul rather than the body that requires care, attention and maintenance. Even as he distinguishes between body and soul, the description he gives of the soul as the "table [made of] Jewells" that receives the image of God emphasises

them for imitation, he forbad them in danger of adoration. For, what a basenesse, what a madness of the soul is it, to worship that which is no better, nay, not so good as it self!" (Colclough, *Sermons*, p. 183).
[46] Farmer, *Poets and the Visual Arts*, p. 20.
[47] Colclough, *Sermons* (citing the art historian and curator Susan Foister), p. 432.

that even the soul is only the surface upon which the *imago Dei* is painted, and not the image itself.

A reiteration of the analogy at the beginning of the next paragraph exchanges the miniature artworks evoked above, the watch-case and the painted precious stone, for larger images of containment and interiority:

> The Sphear then of this intelligence, the Gallery for this Picture, The Arch for this Statue, the Table, and frame and shrine for the Image of God, is inwardly and immediately the Soul of man. Not immediately so, as that the soule of man is a part of the Essence of God; for so essentially, Christ onely is the Image of God. (9: 79)

Donne maintains the sense of interiority and enclosure but by shifting his referents he creates the effect of zooming out of the original metaphor to insist on the soul as only the container of the image. Not only are the artworks of a larger size, but the imagined physical space in which they are situated magnifies the distance between man and God, between body, soul and divine image.

He then shifts focus again, to a metaphor he returns to repeatedly, that of the imprint in a wax seal, reiterating the point that man's soul is simply the material that receives God's image:

> this Image is in our soule, as our soule is the wax, and this Image the seale. The Comparison is Saint *Cyrills*, and he addes well, that no seale but that, which printed the wax at first, can fit that wax, and fill that impression after. No Image, but the Image of God can fit our soule (9: 80).[48]

Winfried Schleiner devotes a sub-chapter to the imagery of the seal, and related vocabulary of imprinting, impressing and engraving, to describe the *imago Dei*, which recurs throughout the *Sermons*.[49] Donne develops the idea of "no Image, but the image of God..." with a series of new seals – "a Rose, or a bunch of Grapes" – that cannot replace God's original seal.[50]

Yet ironically, perhaps, the seal imagery is quickly replaced by an extended metaphor based on paintings. It represents his fullest development of a visual art metaphor in the sermons, and is based not on the production of an image, but on the purchasing of paintings:

> We should wonder to see a Mother in the midst of many sweet Children passing her time in making babies and puppets for her own delight. We

[48] Colclough (*Sermons*, p. 432) identifies Donne's source as Cyril of Alexandria, *Thesaurus de Sancta et Consubstantiali Trinitate*, Assertio XXXIV (PG 75. 609).

[49] Schleiner, *Imagery*, pp. 110-114.

[50] This idea of images opposed to each other, in competition or conflict, is one to which Donne returns, and illustrated well by a passage from another sermon preached in 1624 to the Earl of Exeter, *Sermons* 6: 158-159.

should wonder to see a man, whose Chambers and Galleries were full of curious master-peeces, thrust in a Village Fair to looke upon sixpenny pictures, and three farthing prints. We have all the Image of God at home, and we all make babies, fancies of honour, in our ambitions. The master-peece is our own, in our own bosome; and we thrust in countrey Fairs, that is, we endure the distempers of any unseasonable weather, in night-journies, and watchings: […] we indure the guiltinesse, and reproach of having deceived the trust, which a confident friend reposes in us, and solicit his wife, or daughter: we endure the decay of fortune, of body, of soule, of honour, to possesse lower Pictures; pictures that are not originalls, not made by that hand of God, nature; but Artificiall beauties. And for that body, we give a soule, and for that drugge, which might have been bought, where they bought it, for a shilling, we give an estate. The Image of God is more worth then all substances; and we give it, for colours, for dreames, for shadowes. (9: 80–81)

Donne picks up on the tension between image-original and image-copy that he established several pages earlier, and into this narrative of images in competition he builds both the positive and the negative connotations that he attributes to artworks. At the same time, he uses vocabulary that locates this positive-negative contrast within the hierarchies of visual art. The term "curious" was commonly used to "indicate the art associated with Dürer, or Michelangelo, or Hilliard" and to distinguish it from house-painting or other forms of painting. Richard Haydocke translated Lomazzo's "trattato dell'arte della pittura" as "the art of curious painting".[51] And "masterpiece" to designate "a work of outstanding mastery or skill" (OED) was a relatively recent calque, or loan translation, into English from Dutch or German, and Donne is not original in his figurative use of it to describe man as God's creation.[52] The term recurs several times in Donne's writing, in the sermon preached at the funeral of Sir William Cockayne, 1626 (7: 259), in a verse letter to the Countess of Bedford,[53] and finally in "Death's Duell" where he describes himself as "the Masterpeece of the greatest Master" (10: 232). The hierarchy established between the "curious master-peeces" and the "sixpenny pictures", "lower Pictures" puts different painterly terms into conflict. While Donne's little parable identifies "curious" and "master-peece" positively with the terms "originals… made by that hand of God, nature", a more negative connotation attaches to the "colours" and "shadows" of

[51] Gent, *Picture and Poetry*, p. 7.
[52] According to the OED "in early use [it was] often applied to man as the 'masterpiece' of God or nature". *masterpiece* 1 a. The OED gives its first usage as 1600.
[53] "To the Countesse of Bedford" ["Reason is our Soules left-hand"], l. 33. Johnson *et al.* eds., *Variorum 5: Verse Letters* (2019), pp. 278–279 (p. 279).

the "Artificiall beauties" representing the undesirable counter-images that distract from God's original, the *imago Dei*.

In the contrast between "the Image of God at home" and the "night-journies ... to possess lower Pictures", Donne invokes the association of idolatry and adultery that was a staple of much anti-idolatry rhetoric. The Elizabethan *Homilie against Perill of Idolatrie* (1563), asks:

> Doeth not the word of GOD call Idolatrie spiritual fornication: Doeth it not call a gylte or painted Idol or Image, a strumpet with a painted face: Bee not the spirituall wickednesses of an Idols inticing, like the flatteries of a wanton harlot: Bee not men and women as prone to spirituall fornication (I meane Idolatrie) as to carnall fornication.[54]

In Donne's sermon, by contrast, the association seems to be reversed – rather than equating idolatry with fornication, here the transgression of soliciting a friend's wife or daughter is described as "possess[ing] lower Pictures; pictures that are not originalls, not made by that hand of God, nature; but Artificiall beauties". Adultery and fornication are described in terms of poor aesthetic judgement, and perhaps even of a poor investment.

Donne does, as Hurley observes, "readily" turn to visual art as a source of analogy for moral and theological points in the sermons.[55] But something a bit different seems to be happening here. The proliferation of so much art imagery over more than fifty lines is rich to the point of being overpowering. Donne insists on the materiality of his metaphorical objects, with the detail of the "jewels" that make paintings or watchcases, the "outcases" that do not require "gilding or enameling or painting", the multiple seals that cannot efface God's original, the "master-peece" and the prints. His metaphors are all of enclosing, of layering and superimposing. Like the layers of paint that deface and obscure the seal of the *imago Dei* in the 1624 sermon, the layers of Donne's imagery here feel overdone, overworked, with so many materials and media competing for space. Combined with the abrupt shifts in the ground of his metaphor this does nothing to clarify the *imago Dei*, but makes it confusing and indistinct.

One page later Donne makes a move that may explain, or at least provide context for, his encrusted visual metaphors, as he returns to his old fascination with "nothing":

> In Nature then, man, that is, the soule of man hath this Image of God, of God considered in his Unity, intirely, altogether, in this, that this soule is made of nothing, proceeds of nothing. All other creatures are made

[54] *Homilie against Perill of Idolatrie* (1563), *Certaine Sermons or Homilies* (London 1623; facsimile Gainsville, Florida: Scholars' Facsimiles and Reprints, 1965), p. 61. Quoted and discussed by Gilman, *Iconoclasm and Poetry*, p. 132.

[55] Hurley, *John Donne's Poetry*, p. 175.

of that pre-existent matter, which God had made before, so were our bodies too; But our soules of nothing. Now, not to be made at all, is to be God himselfe: Onely God himselfe was never made. But to be made of nothing; to have no other parent but God, no other element but the breath of God, no other instrument but the purpose of God, this is to be the Image of God. (9: 82)

Although not articulated explicitly as such, Donne's method here is apophatic. The mess of material objects has been evoked in order to be brushed away. It is the contrast with the colours and shadows that preceded it that gives this moment of the sermon such force. In "Negative Love", Donne's speaker asked, "Let him teach mee that nothing" (16), and in this sermon he seems to be employing material objects as the "human means" to teach and understand the divine nothing. After all his material metaphors of making, Donne shifts to his essential, anti-corporeal point: God is not made; and the soul is made of nothing.

It may seem somewhat ironic that the principal images Donne draws from the negative theologians are their metaphors of visual artworks, when they ultimately recommend moving beyond sight into darkness. But the way that visual art metaphors and negative theology repeatedly intersect in the sermons reveal something about Donne's attitude to both. Material art provides him with analogies to illustrate abstract theological ideas. All of the material metaphors discussed here – the *imago Dei*, the omnivoyant icon and the statue metaphor – provide different angles on the incommensurable relationship between man and God. As Nicholas of Cusa's picture demonstrates, God's creation of man "in his own image and likeness", and His vision of humanity are mirrored by mankind's vision of God and attempts to conceptualise the divine, whether in positive or in negative terms. And like Nicholas of Cusa, Donne uses all these metaphors of art and painting to point beyond any material understanding of the human condition, towards what cannot be seen or understood.

Chapter 3

ANNUNCIATION: REPRESENTING THE UNREPRESENTABLE

How to behold what cannot be held?
 Richard Howard[1]

'Twas much that man was made like God before,
But that God should be made like man, much more.

 John Donne, Holy Sonnet 12 (Original Sequence)

Perhaps unsurprisingly, in Donne's divine poetry there is no direct staging of a material visual representation of religious subject matter comparable to "Here, take my picture." But as in his secular poetry and his sermons, he continues to use words like "picture" and a vocabulary of visual appreciation that evokes devotional art, even when the images he stages seem to be internal or imagined. Explicit references like the "Picture of Christ crucified" inscribed in the heart in the Holy Sonnet "What if this present was the worlds last night?", or the mental image of the Crucifixion suspended in the East in "Good friday, Made as I was Rideing westward, that daye", to take just two examples, draw attention to Donne's reflection on the limits of representation. His interlinked sonnet sequence "La Corona" provides his most extensive reflection on the representation of the divine. Given its subject matter and visual vocabulary, it has often been read in the light of Christian iconography. But though, at first glance, it may appear to be a rather conventional meditation on the life of Christ, it proves strangely resistant to any translation into visual form, despite the best efforts of many readers. Patrick O'Connell describes "La Corona" as the "paradigm and interpretative key for the entire body of Donne's religious poetry", in the way it dramatises the difficulties and dangers facing all writers of religious

[1] Richard Howard, "Giovanni da Fiesole on the Sublime, or Fra Angelico's Last Judgement". *Poetry* (October 1970).

verse.² I suggest that Donne addresses the risk of idolatry by encouraging comparison of his sequence with Christian visual art, only to make that comparison extremely problematic, if not impossible. Far from providing an easy companion text to visual representations of Christ, "La Corona" reflects on what it means to represent the divine, visually or verbally. Its circular form provides Donne with a structural conceit with which to explore the circumscription of the divine, using geometrical metaphors as a device to reconcile the paradoxes of the Incarnation. The sequence may frustrate the desire to find direct pictorial parallels for it but it proposes an alternative visual and spatial approach to the issue of representation.

The seven sonnets of "La Corona" have inevitably invited comparisons with other formal sequences and cycles, both verbal and visual, such as the mysteries of the rosary or medieval mystery plays. Most influentially, Louis Martz pointed out in the 1950s that "corona" might reference not only the Italian sequence of linked sonnets, the *"corona di sonnetti"*, but also a type of rosary popular in the sixteenth and seventeenth centuries.³ The sonnets, focused on moments from the life of Christ, are taken to refer to the mysteries of the rosary, and the presence of the Virgin Mary in the first sonnets of the sequence reinforces the association. Such parallels have often led to "La Corona" being categorised as a more "Catholic" work.⁴ This may contribute to the frequent assumption that the sequence makes direct reference to serial representations of the life of Christ from the Catholic

2 Patrick F. O'Connell, "'La Corona': Donne's Ars Poetica Sacra", in *The Eagle and the Dove: Reassessing John Donne*, ed. by Claude J. Summers and Ted-Larry Pebworth (Columbia: University of Missouri Press, 1986), pp. 119–130 (p. 130).

3 Martz, *Poetry of Meditation*, pp. 107–110. Martz points to the "The Corone or Crowne of Our Ladie", mentioned in the preface of Thomas Worthington's "The rosarie of our Ladie", containing 63 "Aves" for the years of Our Lady's life and divided into seven parts. He also mentions a "Corone of our Lord" consisting of thirty-three Pater nosters. Thomas Worthington, *The rosarie of our Ladie. Otherwise called our Ladies psalter With other godlie exercises mentioned in the preface*. Antwerp, 1600. Preface, n.p. STC (second ed.): 17546.

4 Ernest Gilman describes the sequence as "highly Anglo-Catholic in nature", "'To adore or scorne": 63–100 (p. 89). While George Klawitter finds in this a reflection of Donne's "recusant background", he also observes that the two sonnets in "La Corona" are "gentle meditations on Mary's motherhood ... conventional in their Marian imagery". As with the description of Mary in "Upon the Annunciation and the Passion", these would be inoffensive to Protestant and Catholic alike, as Mary's divine motherhood was uncontroversial. George Klawitter, "John Donne's Attitude toward the Virgin Mary: The Public versus the Private Voice" in Frontain and Malpezzi, *John Donne's Religious*, pp. 122–140 (p. 126). As Klawitter points out, Marian references in Donne's poetry are very scarce: only six of Donne's poems mention Mary at all. The others he cites are "Good Friday 1613. Riding Westward", "To Mr Tilman after he had taken orders", "A Litanie" and the "Second Anniversarie".

iconographic tradition, whether the mysteries of the rosary or series of stained-glass windows.

Certainly, there is something in "La Corona" that seems to inspire direct comparison with visual art – even if critics tend to quickly double back on any such identification. Helen Gardner describes the sonnet sequence's "emphasis on the beginning and close of the life of Christ" as "characteristic of medieval art, whether we think of a series of windows like those at Fairford, or of the medieval dramatic cycles" although she is quick to acknowledge that there is in fact very little visual detail in these sonnets.[5] The addition of titles to the individual sonnets of the sequence may reinforce the impression of a series of key iconographic moments in the Christian story, but these titles are probably not authorial, appearing as they do in only one manuscript group.[6] Yet other details within the sonnets have also sparked associations with visual art. Ernest Gilman finds the treatment of Christ's life and death reminscent of two of the paintings Donne owned, described in his will as "the Picture of the B: Virgin and Joseph" and "Picture of layinge Christe in his Toombe".[7] What Wesley Milgate called Donne's "art gallery", may provide, Gilman suggests, "the perfect imaginative setting" for "La Corona". Developing the "echo of womb and tomb" that he finds particularly in the enclosed spaces of the "Annunciation" and "Crucifying" sonnets, Gilman reads the line "Thou hast Light in darke" (2, 13) as a "chiaroscuro detail".[8] This attribution of painterly terminology to the sonnet's themes of light and dark reinforces the parallels he is attempting to establish with the visual tradition. Albert Labriola similarly reads the

[5] Gardner, ed., *Divine Poems*, pp. xxii–xxiii.

[6] The titles to individual sonnets appear in the first edition of the Divine Poems in 1633, and in one manuscript group. The *Donne Variorum* does not rule out the possibility that the titles of individual sonnets in "La Corona" could be part of a "last, minor authorial revision", but states that there is not sufficient evidence to identify them as indisputably authorial, and does not print them as part of the text. Jeffrey S. Johnson et al., eds., *Variorum 7.2: Divine Poems*, p. 13. Gardner judges the titles to be inauthentic (*Divine Poems*, 57), and observes that "the essential unity of the poem is obscured by the titles given to sonnets 2–7, which also make 'La Corona' appear to be the title of the first alone, instead of the title to the set", and the *Variorum* editors observe that "the subheadings strike us as helpful, but neither necessary nor inspired; they are thematic glosses, but do little to complicate or enhance the poem's meaning, and, as has been pointed out, they actually frustrate the poem's repetitive structure" (p. 13).

[7] Ernest B. Gilman, *Iconoclasm and Poetry in the English Reformation: Down Went Dagon* (Chicago and London: University of Chicago Press, 1986), p. 122. "Donne's Will", Bald, *Donne: A Life*, Appendix D.II; p. 563, p. 565.

[8] Gilman, *Iconoclasm*, p. 122. All quotations from "La Corona" are taken from Johnson et al., eds., *Variorum 7.2: Divine Poems*, pp. 5–7.

same sonnet with reference to the iconography of painted Annunciations, finding parallels with the motif of the extinguished candle in, for example, the Annunciation triptych known as the Merode Altarpiece (fig. 3).[9]

The scenes from the life of Christ that make up the sonnets of "La Corona" are all popular subjects for paintings, and Donne clearly does make reference to details also found in the iconographic tradition. But although the sequence seems to invite verbal-visual parallels, it also frustrates any desire for direct and simple ekphrasis, as most critics acknowledge. As Gardner remarks in *The Divine Poems*, despite her fleeting identification of the sequence with stained-glass windows, there is no attempt in "La Corona" to picture events in any detail: "Instead of the scene of the maiden alone in her room at Nazareth, there is a theological paradox ... The scandal of the Cross is presented not by a vivid picture ... but by the thought that here the Lord of Fate suffered a fate at the hand of his creatures".[10] Gardner's shift from visualisation to theological paradox mirrors what happens in the reading of the sequence. Martz, too, identifies a progression in the reading of the sonnets that he connects with Donne's "mastery of the whole art of Catholic meditation on the life of Christ". If the Nativity sonnet begins with the meditative technique of "visualizing the scene with 'thy faiths eyes,'" this soon leads into "the intellectual development of paradoxes from the visual scene".[11] The sequence's surface resemblance to a series of illustrations or stained-glass windows is the first step in enabling its spatial and visual paradoxes to point to the mystery of what cannot be seen: the mystery of the Incarnation.

The desire to find painterly parallels for the scenes in the sonnets is to some extent inspired by the language of the sequence itself, or what Annabel Patterson has described as the "frequent appeals to the visualization of these scenes".[12] A line like "Ioseph turne backe; *See* where your Child doth sitt" (4, 2, my emphasis) addresses the figure of Joseph within the fourth sonnet, but it also invites the poem's readers to visually construct the scene that is evoked. In her article "Donne's Re-formed *La Corona*", Patterson responds to this invitation to "see" by combining the search for visual art parallels with Martz's rosary reading. Developing Martz's identification of Worthington's *The Rosarie of our Ladie* as a potential source for Donne's sequence, she identifies close correspondences between the episodes from Christ's life that both Worthington and Donne choose to focus on. More than

[9] Albert C. Labriola, "Iconographic Perspectives on Seventeenth-century Religious Poetry", in *Approaches to Teaching the Metaphysical Poets*, ed. by Sidney Gottlieb (New York: Modern Language Association of America, 1990), p. 63.
[10] Gardner, ed., *Divine Poems*, pp. xxii–xxiii.
[11] Martz, *Poetry of Meditation*, p. 109.
[12] Patterson, "Re-formed", p. 85.

this, she proposes that the engraved illustrations to Worthington's *Rosarie* were a direct source of visual inspiration for Donne, who might, Patterson suggests, have "had Worthington's book and its engravings before him as he wrote". She finds various parallels between a number of the engravings and their corresponding poems in "La Corona", going so far as to describe the central image of the closing sonnet ("Ascension") – "Behold the Highest, parting hence away, / Lightens the darke Clouds, which he treads vpon" (7, 5–6) – as "a virtual ekphrasis of Worthington's illustration".[13]

Patterson's article is a detailed analysis of the ways in which Donne is "salvaging" the devotional form of the rosary to make it acceptable in the hostile environment of early seventeenth-century England, rather as he did with his "Litany". The direct parallels that she makes with the illustrations to Worthington's book, however, are the least convincing part of her argument. Like Gardner's comparison of the sequence to a series of stained-glass windows, such parallels tend to fix "La Corona" in a superficial verbal-visual relationship that does not do justice either to Donne's "re-forming" practice or to the ambiguity of his verse. A good example of this is Patterson's take on the third sonnet, on the Nativity, where the reflexive nature of the "appeal to visualisation" is made explicit, as the speaker invites his soul to contemplate the scene: "Seest thou my Soule, with thy fayths Eyes, how Hee / Which fills all Place, yett none holds him, doth lye?" (3, 9–10). For Patterson the invitation to "see" in Donne's sonnet points literally and unproblematically to the parallel illustration in Worthington's *Rosarie*: "there, indeed the child does lie in his little basket, instead of being 'held' on his mother's lap..."[14] Yet such a literal and representational understanding of the line does not fully take into account the *unrepresentability* suggested in both "Hee / Which fills all Place" and "none holds him". The paradox of the Incarnation is that the infant Jesus both can and cannot be held, that he "fills all Place" yet has been incarnated in this particular place and time. Donne's "appeal to visualisation" is thus much more complex, in that it invites readers of the sequence to "see" something that cannot be seen, and thus reflects on the role of divine poetry more generally, which must attempt to capture something that cannot be comprehended.

"IN LITTLE ROOME": THE CIRCUMSCRIPTION OF THE DIVINE

Eugene Cunnar finds "La Corona" central to understanding Donne's practice in his divine poetry generally. For him the line "Seest thou my Soule, with thy fayths Eyes" (3, 9) is paradigmatic of what he describes as "Donne's

[13] Patterson, "Re-formed", p. 85.
[14] Patterson, "Re-formed", p. 85.

visual goal". That which is visible to "faiths eyes" is not simply what is discernable on the surface, or what is representable in an illustration. As Cunnar states, explicitly, "for Donne, 'faiths eyes' do not see God just as the physical eye sees a framed picture on the wall. The illusory realism of physical sight and its representation through perspective will not allow for the vision of God".[15] Cunnar's larger argument is that Donne, with his knowledge of continental painting and painterly techniques, tapped into the way that linear perspective, both as a practice and as a cognitive metaphor, "highlighted problems concerning imitation and representation and how a thing may be known that is radically separated from the process of knowing".[16] Linear perspective, because it is an illusion, cannot function as a means to reach knowledge of God. The theological paradoxes of "La Corona", predominantly visual and spatial, draw our attention to the fact that any simple visualisation of the events of the life of Christ can only point to the mystery behind them that cannot be represented.

More recently, Kimberly Johnson has convincingly argued that the oppositions inherent in linear perspective find a parallel in the tension between form and content in vernacular lyric poetry which "sprung up" around the same time. If perspective highlights an essential tension between artificial and natural, surface and depth, figurative and literal, lyric poetry too is built on a fundamental tension between formal technique and narrative content, between "the sign for its own self and the signified it gestures toward". [17] Johnson proposes the English sonnet, in particular, as a "provocative point of entry" into the way in which "the competing signficative systems of the lyric repeat the challenges of perspectival art", and reads Shakespeare's sonnet 24 ("Mine eye hath played the painter...") and selected sonnets from Sidney's *Astrophel and Stella* to demonstrate how the sonnet may foreground the tension between, as she puts it, "narrative depth and aesthetic surface".[18] The sonnets Johnson reads, which thematise artificial representation, demonstrate well that on the level of meaning as well as of form the tension between truth and artifice is never resolved, and her conclusions chime with many of my own in the chapter that discusses Donne's questioning of the possibility of achieving a human likeness in portrait representations.

His exploration of the much more fraught question of representing the divine follows logically from his problematising of verisimilitude in

[15] Cunnar, "Illusion and Spiritual Perception, p. 325.
[16] Cunnar, "Illusion and Spiritual Perception", p. 325.
[17] Kimberly Johnson, "Linear Perspective and the Renaissance Lyric", *PMLA* 134:2 (2019): 280–297 (p. 228). Thank you to Greg Kneidel for bringing this article to my attention.
[18] Johnson, "Linear Perspective", p. 293.

portraits, but in his divine poems, particularly "La Corona", the parallels with the formal tensions of linear perspective painting are particularly pronounced. The formal qualities of the individual sonnets and the careful construction of the full sonnet crown foreground the mechanism, the aesthetic surface of the poem. The poem thematises the formal construction of its circle, the opening sonnet immediately referencing the textual "Croune of Prayer and Prayse, / Weau'd" by the human hand of the poet "in [his] lowe deuoute Melancholye" (1, 1–2). At the same time the theological paradoxes that crowd the sequence comment on the unrepresentability of the divine in a particularly spatial way.

While paradoxical wordplay is to be found throughout "La Corona", there is a particular concentration of examples in the second and third sonnets, traditionally titled "Annunciation" and "Nativity". In both sonnets Mary's body becomes the focus for a network of contradictory metaphors of enclosure that are key to understanding how the whole sequence works. In the Annunciation sonnet standard theological paradoxes are used to describe Mary's divine motherhood and relationship to Christ: "Whom thou conceiust, Conceiud; yea thou art now / Thy Makers Maker, and thy fathers Mother" (2, 11–12).[19] Echoing the iconography of the painted tradition, the whole sonnet is framed with metaphors of enclosure, of prison and cloister, describing the incomprehensible moment of the Incarnation of the divine in human flesh. The opening lines introduce

> That all, which allwayes is all euery where,
> Which cannot Sin, and yett all Sinns must beare,
> Which cannot dye, yett cannot chuse but Dye;
> Loe faythfull Virgin, yeildes himselfe to lye,
> In Prison, in thy Wombe;" (2, 2–6).[20]

The Annunciation provides a particular example of the ways linear perspective can draw attention to representational problems, and Donne's spatial contortions find parallels in some of the techniques used by painters of Annunciation scenes. In the fourteenth to sixteenth

[19] Grierson cites Augustine's *De sancta virginitate* (I, 5) as the source of the paradox in line 12: "*Maria ergo faciens voluntatem Dei, corporaliter Christi tantummodo mater est, spiritualiter autem et soror et mater*", in *Poems*, vol. 2, p. 230.

[20] Lines 2–4 of the Annunciation sonnet are used virtually word for word (though in the past tense) in Donne's long poem "Metempsychosis" (1601; ll. 74–76). In the longer poem the lines are used to contemplate the mystery of the Incarnation at Christ's Crucifixion rather than his conception, but their essential paradox is developed similarly with imagery of spatial coincidence as we learn that the cross "Stood in the selfe-same roome in Calvarie / Where first grew the forbidden learned Tree" (ll. 77–78). *Infinitati Sacrum 16. Augusti. 1601. Metempsychosis Poema Satyricon*. Stringer *et al.*, eds., *Variorum 3: Satyres*, pp. 249–268 (p. 253).

centuries, Renaissance painters sought ways to represent both the visible event narrated in the Gospel of Luke and its underlying meaning which is beyond the visible and cannot be plainly represented. The interiority essential to the iconography of the Annunciation, enclosing Mary and the divine messenger in a domestic space, or sometimes a church – echoing the enclosure of Christ within her womb – provides an opportunity for artists to exploit their mastery of linear perspective.[21] The gospel account of the Annunciation (Luke 1: 28–38) gives no details regarding where the event takes place, but the spatial conventions of Annunciation paintings develop out of the verbs of entering and departing that frame the angel's address to Mary: the angel came in; the angel departed. This framing is reinforced by the way the conversation itself is neatly enclosed, with a marked beginning and end, effectively circumscribing the unrepresentable moment of Christ's conception, and dramatising the mystery of his simultaneously divine and human natures. But the relatively new technique of linear perspective could also be manipulated in order to express the paradox of the Incarnation. The illusion of three-dimensional, enclosing space can at the same time be used to indicate how the incommensurable divine escapes from human comprehension and human reality.

In her comparison of the development of linear perspective and lyric poetry Johnson claims that both "stage the interaction of incommensurabilities".[22] It may be for this reason that Daniel Arasse claims that there is a "particular affinity" between the Annunciation and the use of perspective.[23] In his in-depth study of *L'Annonciation Italienne* and linear perspective, Arasse demonstrates how often the scene takes place in an elaborate architectural space that is subtly disproportionate or somehow fails to fully contain the figures of Mary and Gabriel.

In a 1470 Annunciation by Piero della Francesca, for example, archangel and virgin confront each other within an elaborate structure of columns and arches; it is only by reconstructing the geometry of the scene with the "intellectual eye" that the viewer realises that in three dimensions one column would logically be placed directly between Gabriel and Mary, obscuring their view of each other. This play with the visible and the invisible points towards the essential and unrepresentable object of every Annunciation – the

[21] In *Iconographie de l'art chrétien* vol. 2 (Paris: Presses Universitaires de France, 1957), p. 186, Louis Réau discusses the different traditions of enclosing the Virgin. Italian art tends to have palaces; the Netherlandish tradition goes for domestic interiors; while the French often situate the scene inside a church.

[22] Johnson, "Linear Perspective", p. 22; p. 228.

[23] Daniel Arasse, *L'Annonciation italienne: une histoire de perspective* (Paris: Hazan, 1999), p. 9.

figure of Christ.[24] Arasse indeed proposes that the painting identified by Erwin Panofsky as the first to employ a single vanishing point – an Annunciation by Ambrogio Lorenzetti (1344) – is already using perspective in order to establish a "real", human, space in contrast to an "unreal" divine space representing the arrival of the angel.[25] Such a paradoxal geometry, Arasse argues, is fundamental to the painterly representation of the meeting of two incompatible, incongruous spaces in one.

Donne's impossible "appeals to visualisation" in "La Corona" function in a similar way, inviting the reader to construct an imagined space, or picture, but at the same time using paradox to complicate any kind of visualisation. In the second sonnet of "La Corona", the phrase described by Gilman as a "chiaroscuro detail" is part of Donne's central spatial description of the fundamental paradox of the Incarnation: "Thou hast Light in darke; and shuttst in little roome, / Immensitye cloystred in thy deare wombe" (2, 13–14). Mary herself is enclosed in her "little roome" by the play of shadow and light and at the same time her body is the cloister that encloses the divine in a human space. The abstract "Immensitye" of the Annunciation sonnet's final line takes grammatical human form when it becomes the subject of the verb in the opening of the Nativity sonnet: "*Immensitye* cloystred in thy deare wombe / Now *leaves hys* welbeloved Imprisonment" (3, 1–2, my emphasis). The abstraction "immensity" is corralled in a cloister and a prison and simultaneously becomes a grammatical agent, expressible as a pronoun. This transformation functions as a very neat verbal acting out of the mystery of the Incarnation in verbal form: God takes on human shape and human function in the visible body of the Christ child, and in the very grammar of the sonnet.

The particular rhyme scheme of the corona sequence is also employed to demonstrate the process of enclosure. Between the second and third sonnets, the same rhyming words are repeated in such a way as to develop and expand the sense of enclosure. The *room-womb* rhyme creates the compact closing couplet of the second sonnet, on the Annunciation. But when the rhyme is picked up again as part of the A-rhyme of the third sonnet, *womb* and *room* are separated by three lines. The embraced rhyme scheme dilates the original couplet and delays "roome" until line 5: "But oh, for Thee, for Him, hath the Inn no roome?" (3, 5). The rhymes open up the space occupied by the Christ child, and the detail of the inn having no

[24] Arasse, *Annonciation*, pp. 41–45; citing Thomas Martone, "Piero della Francesca e la prospettiva dell'intelletto", in *Piero, teorico dell'arte*, ed. by Omar Calabrese (Rome: Gangemi, 1985), pp. 173–186.

[25] Arasse, *Annonciation*, p. 59 ff. Erwin Panofsky, "Die Perspektive als 'symbolische Form'", *Vorträge der Bibliothek Warburg 1924-1925* (1927), pp. 258–330.

room, from the gospel account of Christ's birth (Luke 2: 7), is incorporated into the pattern of paradoxes of containment.

The "little roome" of the second sonnet and the "no roome" of the third highlight the way that the textual space acts to enclose the event it describes. "Little roome", in particular, is a phrase that Donne uses elsewhere to indicate the space of his poems themselves. In "The Good Morrow", openness and enclosure collapse into one another as "love … makes one little roome, an euery where" (ll. 10–11). And in "The Canonization" he makes his metaliterary pun on stanza (the Italian for room) explicit, when his speaker muses: "if no Peece of Chronicle wee prove, / Weele build in Sonnetts pretty roomes" (ll. 31–2).[26] In "La Corona", Donne builds his "little roome" in the Annunciation sonnet; the little room enclosing Christ is also the sonnet itself. The poem, which is so concerned with enclosing, itself acts to enclose "That all, which allwayes is all euery where" (2, 2), the temporally and spatially infinite divine, into one line of iambic pentameter. If the virgin's body is a "prison of flesh", so too is the sonnet. The word "flesh" is as near the centre of the sonnet as possible, in the middle of the eighth line. The rather awkward syntax ("yett he will weare / Taken from thence, flesh which Deaths force may trye"), places "flesh" in this central position, and also serves to highlight it. Flesh, enclosed by words, thus represents the divine Word enclosed by human flesh. As in many painted Annunciations, the very composition of Donne's Incarnation sonnet serves both to enclose Christ's body and to draw attention to its containment.

CIRCUMSCRIPTION

The enclosing of him "which fills all Place" (3, 10) within the human measure of the sonnet sequence not only mimics the "cloistering" of Christ in Mary's body but also reflects on the debates surrounding the appropriateness of representing the divine in visual art at all. In its uniting of human and divine, the Annunciation is a painterly and representational riddle, and also a theological touchstone in arguments about the validity of religious art that go back at least as far as the iconoclastic controversy in the eighth-century Byzantine Church. Although far removed in time, the ideas of the Byzantine controversy circulated in theological and scholarly debates about images in the Reformation.

During the debates of the earlier controversy, the iconoclasts had maintained, particularly in the iconoclastic Council of Constantinople held in 754, that since Christ was both wholly God and wholly man, of human and divine nature at the same time, any attempt to represent Christ in

[26] Cf. Patterson, "Re-formed", p. 83.

material form was an attempt to represent the Godhead which could not be depicted, and therefore both blasphemy and a belittling of Christ.[27] The supporters of images claimed, on the contrary, that the Incarnation itself justified the production of religious iconography since Christ chose to represent himself physically, and that this very process was part of the mystery of Christ's kenosis, his self-imposed humiliation in taking human form. Visual reproductions of scenes from the gospels do more than simply portray Christ's actions: by capturing Christ's image, they echo and honour the circumscription of the divine inherent in the mystery of the Incarnation. John of Damascus wrote that:

> if we were to make an image of the invisible God, we would really sin; for it is impossible to depict one who is incorporeal and formless, invisible and uncircumscribable [*aperigraptos*]. And again: if we were to make images of human beings and regard them and venerate them as gods, we would be truly sacrilegious. But we do none of these things. For if we make an image of God who in his ineffable goodness became incarnate and was seen upon earth in the flesh, and lived among humans, and assumed the nature and density and form and color of flesh, we do not go astray.[28]

The anti-iconoclastic Second Council of Nicaea (787 CE) concluded by affirming the traditions of the church including "the making of iconographic representations – being in accordance with the narrative of the proclamation of the gospel – for the purpose of ascertaining the incarnation of God the Word ..."[29] While the Reformation iconoclasts strongly rejected these conclusions and the veneration of images they endorsed, their references to the earlier controversy made the ideas of the Byzantine period very present in the Reformation iconoclastic debate.[30]

[27] *Nicene and Post-Nicene Fathers*, series 2 (New York: Scribners, 1900), vol. xiv, p. 544, cited by William A. Dyrness, *Reformed Theology and Visual Culture: The Protestant Imagination from Calvin to Edwards* (Cambridge University Press, 2004), p. 22.

[28] St John of Damascus, *Oratio apologetica* III, 2 (and II, 5), PG 94: 1320. Translation in St John of Damascus, *Three Treatises on the Divine Images*, ed. by Andrew Louth (Crestwood, NY: St Vladimir's Seminary Press, 2003), p. 82.

[29] Definition of the Holy Great and Ecumenical Council, the Second in Nicaea, 377C. Translation in Daniel J. Sahas, *Icon and Logos: Sources in Eighth-Century Iconoclasm* (University of Toronto Press, 1986), p. 178.

[30] For the reformers, the Second Nicene Council's endorsement of the veneration of images were a prime example of false argument and false worship. "Lectures on Deuteronomy", in in Martin Luther *Werke* 14: pp. 613–614; Calvin referred to the "childish arguments for images at the Council of Nicaea (787)", in a section added to the *Institutes* in 1550, in order to "inform [his] readers how far the madness went of those who were more attached to images than was becoming to Christians", John

John of Damascus's theorising of the "circumscription" of Christ in visual art provides a useful context for examining Donne's Christology throughout "La Corona". The opening sonnet of the sequence invokes the invisible and unrepresentable God in its address to the "Ancient of Days": "Thou which of Good hast, yea, art Treasurye, / All-changing vnchangd Antient of Dayes" (1, 4). By referencing the passage from the book of Daniel, one of the very few detailed bodily manifestations of God in the Old Testament, the speaker of "La Corona" thus invokes one of the few biblically sanctioned images available to the artist before the line "Salvation to all that will is nighe" (1, 14; 2, 1), ushers in the Incarnation and the possibility of representing the divine.[31]

THE INCARNATE WORD

If the sonnets traditionally titled "Annunciation" and "Nativitie" are particularly focused on the spatial paradoxes of the Incarnation, as the sequence continues successive events from the story permit different kinds of reflection on representing the divine, each contributing to the overall framing metaphor of the encircling corona. A sermon preached on the evening of Christmas Day, 1624, provides a particularly illuminating companion text for Donne's practice in his sequence. He takes as his text the verse from Isaiah which predicts the Annunciation: "Therefore the Lord shall give you a signe; Behold, a virgin shall conceive, and beare a son, and shall call his name Immanuel" (Isa. 7: 14). As the text and the occasion suggest, the mystery of the Incarnation is central to the sermon; and in many ways its language and its concerns echo those of "La Corona". In this Christmas sermon Donne juxtaposes the Old Testament theophany of the Ancient of Days with the Nativity, in language that strongly recalls his sonnet sequence. He cites Bernard of Clairvaux on the mystery of the Incarnation: "*Immanuel est verbum infans*, saies the Father; He is the ancient of daies, and yet in minority; he is the Word it selfe, and yet speechlesse; he that is All, that all the Prophets spoke of, cannot speake [...] He is *Puer sapiens*,

Calvin, *Institutes of the Christian Religion*, ed. by John T. McNeill (Philadelphia: Westminster Press, 1960), pp. 114-116. See also Anthony Ugolnik, "The *Libri Carolini*: Antecedents of Reformation Iconoclasm", in *Iconoclasm vs. Art and Drama*, ed. by Clifford Davidson and Ann Eljenholm Nichols (Kalamazoo: Western Michigan University Press, 1989), pp. 1-32, who argues that Byzantine iconoclasm prefigures Reformation iconoclasm in many ways.

[31] "I beheld till the thrones were cast down, and the Ancient of days did sit, whose garment was white as snow, and the hair of his head like the pure wool: his throne was like the fiery flame, and his wheels as burning fire" (Dan. 7:9). On the illustration of God the Father as the Ancient of Days see Aston, *Broken Idols*, pp. 570-575.

but a child, and yet wiser than the elders, wiser in the Cradle, than they are in the Chaire" (184).[32] Here the "Antient of Dayes" from the first sonnet is placed beside the paradox of the incarnate Word who "but lately could not speake" (4, 5) of the fourth sonnet, on Christ in the Temple.

The articulation of this particular paradox, of the *verbum infans*, and the development of the gospel account of the first act of Christ's ministry,[33] make the fourth sonnet central to the sequence. As Patterson observes, this sonnet is literally as close to the centre of the seven-sonnet sequence as it can be,[34] and as A. B Chambers claims, even if the event it describes may at first sight seem relatively insignificant, its concentration on Christ's nature make it "a précis of the whole" sequence.[35] The fourth sonnet most explicitly expresses the conundrum of Christ's dual nature, particularly in the opening line of the sestet, "Hys Godhead was not Soule to hys Manhood" (4, 9). After the sonnets centred on the Annunciation and Nativity with their imagery of enclosure, the fourth sonnet begins to meditate on other ways of comprehending the divine, both verbal and mathematical. Opening with another "appeal to visualisation" – "Ioseph turne backe; See where your Child doth sitt / Blowing, yea blowing out those Sparkes of witt" (4, 2–3) – the scene of Jesus's teaching of the doctors in the temple demonstrates both his human qualities (he listens humbly, he returns home with his parents) and his divine attributes (both teaching and referring to his Father's business).[36] How can the two be rationally reconciled? The sonnet proposes that these are "Miracles exceeding Power of Man" (4, 14; 5, 1), a line which, as well as being duplicated as the last line of the fourth sonnet and the first line of the fifth, can be read in two ways: the miracles that Christ performs show that he is something more than human, and, at the same time, these miracles are incomprehensible to man; they are beyond our power to understand or represent. As Donne puts it in his 1624 Christmas sermon, introducing the words of Bernard of Clairvaux: "onely God, can comprehend God" (6: 184). And earlier in the same sermon he expresses the same thought explicitly in the language of measurement and space:

[32] Potter and Simpson, eds., *Sermons*, vol. 6, p. 184. It is worth noting that this sermon was preached just six months before the sermon on the death of James I which Patterson identifies as a "commentary on La Corona and everything it drew on", containing as it does a "riff on all the possible kinds of crowns, marked with the marginal note: 'Corona.'" Patterson, "Re-formed", p. 87; p. 71 n. 5.
[33] Luke 2: 42–52.
[34] Patterson, "Re-formed", p. 84.
[35] A. B. Chambers, "The meaning of the Temple in Donne's 'La Corona'", *JEGP: Journal of English and Germanic Philology* 59 (1960): 212–217 (p. 217).
[36] Chambers, "Meaning of the Temple", p. 213.

for things created, we have instruments to measure them; we know the compasse of a Meridian, and the depth of a Diameter of the Earth, and we know this, even of the uppermost spheare in the heavens: But when we come to the Throne of God himselfe, [...] and the vertues, and powers that flow from thence, we have no balance to weigh them, no instruments to measure them, no hearts to conceive them... (6: 174)

The human measures enumerated in this passage include not only the balancing scales and the measuring stick but also the calculations of navigation and mathematical geography and cosmography. Man is at the root of all these forms of measurement: the measure of all things. The language of measurement slips easily into the language of comprehension and perception ("no hearts to conceive them") since here measure and comprehension are practically the same thing.

In becoming man, Christ became measurable. In the Incarnation, the divine is enclosed in the dimensions of the human body, and nowhere is this clearer than in the fifth sonnet of "La Corona" where the Crucifixion is described as "Measuring Selfe-lifes Infinitye to a span / Nay to an Inch" (5, 8–9). The sequence's emphasis on enclosure becomes even more claustrophobic here, as the spatial metaphors of the Incarnation are developed to their logical conclusion. While "Immensity" was "cloysterd" in the second sonnet, here it seems as if the walls of the cloister contract, as the hand-span that encompasses Christ's human life is reduced to an inch in the space of a line.[37] The very description of this contraction, however, spills over into the sestet of the sonnet, thus reproducing formally, yet again, the simultaneous containment and impossibility of containment of the Incarnation. The unrepresentable divine both "fills all Place" yet cannot be held (3, 10).

SWERVING AWAY FROM EKPHRASIS

The cloister of the Annunciation and the contraction of the Crucifixion both enact the circumscription of the divine. And just as Donne uses the limits of the sonnet form to play with ideas of containment and measure, he uses the circular form of the whole sequence of linked sonnets to do the same on a larger scale. As the last line of each sonnet is taken up again as the first line of the next, a sense of inevitability is built into the structure of the sequence. It emphasises the impression of the sequence being "weav'd" and

[37] According to the OED the first meaning of "span" is that of the space between thumb and little finger, particularly used as a unit of measurement; this is figuratively transferred to "a short space of time, esp. as the duration of human life; the (short) time during which a person lives". Cf. the Holy Sonnet "This is my Playes last scene", l. 4: "My spans last inch, my minutes latest point".

contributes to its momentum. It becomes increasingly evident that Donne's use of the corona format is not random but that both the circular shape and the doubled lines have a particular meaning in the process of representing the life of Christ. In the transition from one sonnet to another, as we have already seen, the repeated lines change slightly in emphasis – a noun may be used in a different sense or in a different place in a sentence, for example, subtly changing its meaning. The line that closes the fifth sonnet undergoes the biggest change in meaning when it is repeated as the opening of the sixth. In the fifth sonnet, "moyst" is a verb, the speaker's request for God's action: "Moyst with one drop of thy blood, my dry Soule" (5, 14). But repeated as the first word of the sixth sonnet, it becomes an adjective: "Moyst, with one drop of thy blood, my dry Soule / Shall… bee freed…" (6, 1–3). This is the most significant change in grammatical function occurring in any of the repeated lines, and it reflects how the momentum of the sequence is moving towards change and renewal. As various critics have noted, the same words that were a prayer at the end of the fifth sonnet show in the sixth that the prayer has been answered.[38] This extends the potential for punning and double meaning that has been at work throughout the sequence, and in some way prepares for the last two sonnets, both of which have a double function. They fulfil their place in concluding the sequence of scenes from Christ's life, representing, as the traditionally assigned titles tell us, the "Resurrection" and the "Ascension", but both are equally concerned with the end of the speaker's – or mankind's – earthly life, contemplating the resurrection of the flesh and the day of the Last Judgement almost more than they do Christ's own resurrection and ascension. The paradox of Christ's death killing death itself is worked out in a dense repetition of the word "death" in the sixth sonnet, as the speaker contemplates his own death and looks forward to the time when he "agayne risen maye, / Salute the last, and Euerlasting Day" (6, 13–14).

Either the Ascension or the Last Judgement, the twin subjects of the seventh sonnet, may be found occupying the final place in series of scenes from the New Testament. This may account for Gardner's comparison of the sequence to a series of stained-glass windows, or to the mystery plays. Yet it is this final sonnet that reinforces the formal circular structure of "La Corona". Indeed to describe it as "final" rather works against the logic of the sequence. It is the "final" sonnet if we read the sequence as linear and teleological – as indeed it appears on the page. But the seventh sonnet is in many ways, as Margaret Maurer has put it, "no end at all but a prelude to the

[38] O'Connell, "La Corona", p. 127. See also Judah Stampfer, *John Donne and the Metaphysical Gesture* (New York: Simon and Schuster, 1971), p. 238.

articulation of the problem in the opening sonnet".[39] It manages to occupy a place that is both first and last, and it draws, once again, on a very visual vocabulary in order to achieve this effect.

The "Ascension" sonnet is built upon expectation, beginning with the anticipatory imperative of its opening line: "Salute the last and Euerlasting Day" (7, 1). It is full of vocabulary of upward and forward movement: "th'vprising of thys Sunne, and Sonne;" "parting hence away" and "Ascending" to "first enter the way". The promise of "Light in darke" (2, 13) evoked in the second sonnet is here fulfilled in the image of the "Highest... lighten[ing] the darke Clouds" (7, 5). This detail, reminiscent of the visual tradition, is what prompts Patterson to identify Donne's sonnet as "a virtual ekphrasis" of Worthington's "The rosarie of our Ladie".[40] The language of light and dark does seem to invite visualisation, and the sestet develops this sense of invitation. The path to heaven is "mark'd" with Christ's blood, and seems to shine in welcome: "Bright Torche, which shinst, that I the way may see" (7, 11). This final "appeal to visualisation" beckons the reader onward, but at the last minute, as the upward and forward momentum of the poem prepares us for the final step – "if thy holy Spirrit, my Muse did rayse" (7, 13) – the last line of the poem is the first line of the sequence, so we come full circle, and the face of Christ in glory is kept from us. It is the frustration of the forward momentum of the poem that seems to generate the closing line and the return to the opening sonnet. Specifically, it is the anticipation of the "appeal to visualisation" that is thwarted, as in the earlier sonnets, and it is precisely this movement that takes us back to the beginning again.

Thus the corona shape of the sequence is created not only by the formal requirement of its repeated lines, but also by this motion away from the visual. The movement is similar to what Gilman describes in "Satyre 3", where the speaker "approaches, but then swerves away from, [the] idolatrous prospect, evoking but then effacing the picture behind his text".[41] I have suggested that this is a particularly apt description of Donne's attitude to images in his poems generally, where he frequently seems to simultaneously propose and withhold the possibility of putting a picture to his words. This dynamic of encouraging visualisation yet at the same time making it difficult has been at work throughout "La Corona", and in the seventh sonnet the "swerve away" from any kind of ekphrasis or pictorial description in the final sonnet is part of the pattern that allows

[39] Margaret Maurer, "The Circular Argument of Donne's 'La Corona'", *Studies in English Literature, 1500–1900* 22 (1982): 51–68 (p. 68).
[40] Patterson, "Re-formed", p. 85.
[41] Gilman, *Iconoclasm*, p. 117; p. 213n.2. Discussed in Introduction, pp. 16–18.

the circle to be completed – a "first last End" (1, 11) that seals the circle of the "Croune of Prayer and Prayse".

Of the many crowns mentioned in the opening sonnet of "La Corona", the first to be evoked is this textual "Croune of Prayer and Prayse" of the sequence itself. The poetic crown is vile, fraile and unworthy, yet it aspires to represent both the infinite divine and its circumscription, and it is the very process of verbal weaving that allows it to do to. The speaker who performs the delicate action of weaving the sequence is foregrounded by the poetic prize of the laurel wreath, even though this is rejected as a "Vile Crowne of frayle Bayes" (1, 5) in favour of the two crowns of Christ. The speaker, who, as we have seen, shifts his address from the Virgin to his soul, to Joseph, to Christ himself, is also, at the same time, speaking to the poem's readers, and this results in a very self-conscious and dramatised poet-persona.

The identification of "La Corona" with the iconography of devotional art has led different critics to seek visual parallels for its speaker. Martin Elsky compares him to the "interlocuter" or *Sprecher* figure of mannerist art. This figure looks out of the painting while pointing at a person or event within it, inviting the spectator to participate in the space of the artwork.[42] Elsky reads the poem as being as strongly influenced by the meditative practice of Ignatius of Loyola's *Spiritual Exercises*, equating the third sonnet's "fayths Eyes" with Ignatius's recommendation to "see … with the *mind's eye* the physical place where the object that we wish to contemplate is present".[43] For him the "meditator" of the poem, as he terms the speaker, like the mannerist interlocuter, functions as a bridge between the past space and time occupied by the biblical figures and the present moment of meditation, particularly in the final sonnet where, according to him, the "meditator [changes] position from a spectator to an interlocutor inside the represented sacred scene, inviting others to see, as he has done, with 'faiths eyes.' He has, so to speak, passed over to the other side of the painting".[44] Despite the limitations of the kind of interart comparison

[42] Martin Elsky, "Donne's La Corona", pp. 5–6.

[43] Quoted in Elsky, "Donne's La Corona", p. 3, my emphasis; *The Spiritual Exercises of St. Ignatius*, tr. Anthony Mottola (Garden City, NY: Doubleday, 1964), p. 54.

[44] Elsky, "Donne's La Corona", p. 9. Cf. Murray Roston who makes a similar comparison in *The Soul of Wit*, pp. 167-168, though discussing the Holy Sonnets rather than "La Corona": "[In *HSSpit*] the scene, in fact, just as in the religious paintings we have examined, is being viewed through the eyes of a speaker (or Sprecher) writhing in the foreground of the picture as he visualizes upon his own flesh the agony of the martyr … Within one quatrain, Donne has brilliantly constructed the literary parallel to that mannerist scene. There is the initial shock of revelation with its inversion of traditional values, the sudden dematerialization of actuality as the figure of Jesus merges into that of the speaker, and finally the establishment of a

proposed by Wylie Sypher,[45] Elsky's analysis here touches on something essential to the way "La Corona" works. His insight that "the events of *La Corona* do not occupy an unambiguous, rationally constructed space but instead take place in a space of transcendence" bears developed comparison with the mannerist paintings by Pontormo and Parmigianino that he cites, and echoes the claims made by Arasse regarding the space of painted Annunciations.[46]

Patterson, on the other hand, suggests that the speaking voice in Donne's Annunciation sonnet "could be either the poet or the archangel".[47] Placing the sonnet side by side with traditional Annunciation paintings certainly highlights the absence of one of the event's principal actors: the angel, the divine messenger. If the voice that announces and then enacts the circumscription of Christ has taken the place of the angel of the Annunciation, he is encroaching on divine territory. The first sonnet, though, makes quite clear that the poet who shapes the sonnet sequence in his "lowe deuoute Melancholye" (1, 2) is human, unlike the angel of the Annunciation, who represents the direct link to the divine. What Patterson's and Elsky's identifications of the poet-speaker both highlight is that he is somehow both inside and outside the crown that he weaves. The poem presents both his meditation on the divine and his craft in creating it. The intermedial comparisons that it sparks highlight the sequence's own place as a created work of art, and the fact that the comparisons often do not quite work has the effect, as we have seen, of driving the poem onwards.

"A CIRCLE… WHOSE FIRST AND LAST CONCURRE"

Rather like Donne's simile of "Painters that doe take / Delight, not in made worke, but whiles they make",[48] "La Corona" highlights the method and process of the poet's craft, making it a work perpetually in process rather than a finished artefact to be contemplated. It opens with a crown that is in process, a crown "Weau'd in … lowe deuoute Melancholye" (1, 2). But by the end of the octave, the speaker envisages "a Crowne of Glory which doth flowre alwayes" (1, 8), an endless circle, a crown that comes from God. Donne puns insistently on "end" and "endless" in the sonnet's sestet: "The Ends crowne our workes, but Thou crounst our Ends, / For at our End,

powerful bond between persona and reader to create a mood of brooding yet urgent introspection" (p. 168).

[45] Sypher, *Four Stages of Renaissance Style*. See discussion in the introduction to this book, pp. 4–7.
[46] Elsky, "Donne's La Corona", p. 6.
[47] Patterson, "Re-formed", p. 83.
[48] "The Expostulation", ll. 57–58.

beginns our Endles rest" (1, 9–10). His wordplay draws attention to the fact that the very crown he is weaving is itself a kind of pun, its different meanings co-existing simultaneously, an appropriately polyvalent symbol for the sequence's meditation on the mystery of the Incarnation.[49]

The potential of the circle to signify more than one thing at once clearly attracts Donne. His famous conceit of the compass in "A Valediction: Forbidding Mourning" illustrates how the lovers' souls may be "one" and "two" at the same time, and the action of the compass generates two reassuring yet incompatible images: the feet of the compass which will be brought together again, and the circle that will be completed only if the roaming foot remains separate:

> And though it in the Center sitt,
> Yet when the other farr doth rome,
> It leanes, and hearkens after it,
> And growes erect as it comes home.
> Such wilt thou bee to mee, whoe must,
> Like th'other foot obliquelie runn
> Thy firmness makes my circle Iust,
> And makes mee end, where I begun. (ll. 29–36)[50]

The conceit in the Valediction poem depends on the logic of the circle working in two ways at once, and a similar logic is at work in the circles Donne uses in his divine poems. In "La Corona", the potential of the circle to signify more than one thing simultaneously is another kind of visual and spatial logic working alongside the paradoxes of containment. The geometrical conceit reimagines and rearticulates the circumscription of Christ, and the relationship between human and divine. Donne is aware of its history, making oblique references, once again, to the work of Nicholas of Cusa as he elaborates his idea of the doubled circle in other divine poems and in his sermons.

In a sermon preached on Easter Day 1619, "when the king was seriously ill", Donne uses the double circle to describe the deaths of the martyrs and their rebirth into God's glory:

> Their death was a birth to them into another life, into the glory of God; It ended one circle, and created another; for immortality, and eternity is a Circle too; not a Circle where two points meet, but a Circle made at once;

[49] As Maurer observes in her detailed discussion of the circularity of Donne's sequence, "The circle as shape and motion is an emblem of the paradoxes of Christianity [and] thus especially appropriate to the story on which 'La Corona' is based: the matter of the poem admits the full wealth of the circle's symbolic potential". Maurer, "Circular Argument", p. 54.

[50] Johnson *et al.*, eds., *Variorum 4.2: Songs and Sonnets*, p. 51.

> This life is a Circle, made with a Compasse, that passes from point to point; That life is a Circle stamped with a print, an endlesse, and perfect Circle, as soone as it begins. Of this Circle, the Mathematician is our great and good God; The other Circle we make up ourselves; we bring the Cradle, and Grave together by a course of nature ... (2: 200)

These two circles, drawn on paper, recall the compass conceit of "A Valediction: Forbidding Mourning", as well as the textual crowns of "La Corona". The "thorny crowne" of Christ's Passion and Crucifixion in the first sonnet of the sequence corresponds to the circle "that passes from point to point", the circle of human life, while the "crown of glory that doth flower always", matches the "Circle stamped with a print, [the] endlesse, and perfect Circle" of eternity.

Donne explicitly invokes this double meaning of the circle in his other extended poem on the Annunciation, "Upon the Annunciation, when Good-friday fell upon the same daye", a liturgical coincidence that functions as another pun of sorts:

> Tamely fraile body, abstaine to daye; to daye
> My soule eats twice, Christ hether and away.
> Shee sees him man, soe like God made in this,
> That of them both a Circle Embleme is
> Whose first, and last concurre ... (ll. 1–5)[51]

This poem combines reference to *seeing* and the visual tradition with the geometrical conceit of the circle. Here again is the "circle where two points meet", this time functioning as a kind of shorthand for the liturgical conjunction of the beginning and the end of Christ's human life. In more detail, those events are then described in visual terms that recall paintings of both Annunciation and Crucifixion. There is an insistent "appeal to visualisation" at work here that is comparable to "La Corona", and once again it is "my soule" who sees Christ made man: [52]

> *My soule* eats twice ...
> Shee *sees* at once the Virgin Mother staye
> Reclus'd at home, publique at Golgotha.
> Sad, and Rejoyc'd; shees *seene* at once, and *seene*
> At almost fifty, and at scarce fifteene. (ll. 2; 11–14; my emphasis)

The fact that it is the soul that sees suggests that the act of seeing here goes beyond the "illusory realism of physical sight", to use Cunnar's term.[53] Nonetheless, the insistence on the physical image of Mary "at scarce fifteen" and at the foot of the cross "at almost fifty", cannot help but recall the

[51] Johnson *et al.* eds., *Variorum 7.2: Divine Poems*, pp. 133–134 (p. 133).
[52] Cf. Patterson, "Re-formed", pp. 82–83.
[53] Cunnar, "Illusion and Spiritual Perception", p. 325.

painted tradition. The Virgin Annunciata is described as "reclus'd", echoing the sequence's themes of interiority and enclosure. The focus here, though, is on the two faces of Mary, which are superimposed upon each other, "seene at once" (13) in a technique similar to that which Donne employs with the faces of Christ Judge and Christ crucified in the Holy Sonnet "What if this present were the world's last night".[54] The face of the young Mary marks the moment of "th'Angells *Ave*" of the Annunciation, as the older face witnesses his death on the cross, Mary once more performing her enclosing and containing role, "abridging" Christ's human life to its beginning and its end. But the "Abbridgement of Christs storie" (l. 20) is also verbal: circumscribed in this poem not only by the two faces of Mary but also by the words spoken at his conception and his death, "th'Angells Ave, and Consummatum est" (l. 22). Although the immediate impression here is of a simpler and more conventional iconography than that presented in "La Corona", the reflection Donne constructs around the liturgical coincidence of the two dates and the insistence on the circle as emblem of both man and God highlights the same Christological paradoxes as the sequence.

In the 1624 Christmas Day sermon that echoes so much of the language and imagery of "La Corona", Donne again develops the symbolic potential of the circle, describing it thus: "One of the most convenient Hieroglyphicks of God, is a Circle; and a Circle is endlesse; whom God loves, hee loves to the end" (6: 173). He opens the sermon by quoting St Bernard on the "remarkable conjunctions [of] this Day" (6: 168). If Donne's poem on the Annunciation and the Passion seems to approve the Church's symbolism in "letting those days join" (l. 33), in the sermon he follows Bernard in describing Christmas Day as a day that holds many conjunctions within itself: of God and man; of maid and mother; of faith and reason, a day that joins God's anger and His mercy (6: 168). The circle, that "convenient Hieroglyphick", is part of the conjunctive force of the day, and again Donne evokes its simultaneously divine and human meaning:

> God is a circle himselfe, and he will make thee one; Goe not thou about to square eyther circle, to bring that which is equall in it selfe, to Angles, and Corners, into dark and sad suspicions of God, or of thy selfe, that God can give, or that thou canst receive no more Mercy, than thou hast had already.
>
> This then is the course of Gods mercy. He proceeds as he begun … It is always in motion, and always moving towards *All*, alwaies perpendicular, right over every one of us, and always circular, always communicable to all … (6: 175)

[54] See Richard Strier, "John Donne Awry and Squint: The 'Holy Sonnets,' 1608–1610", *Modern Philology* 86 (1989): 357–384 (p. 380); see also Chapter 4 of this book, pp. 128–130.

In constructing this image of the geometry of God's mercy Donne makes a passing reference to another geometrical metaphor for the divine and human understanding of it, the squaring of the circle. He uses the same idea in another of his occasional divine poems, "Upon the translation of the Psalms by Sir Philip Sydney, and the Countesse of Pembroke his Sister".

> Eternall God, (For whome who ever dare
> Seeke new expressions, doe the circle square,
> And thrust into strayt Corners of poore witt
> Thee who art cornerlesse and infinite)
> I would but blesse thy name, not name thee now. (ll. 1–5)[55]

The idea of squaring the circle – or rather, of the impossibility of squaring the circle – is drawn from the thinking of Nicholas Cusanus. It is outlined in detail in his *De docta ignorantia*. Cusanus's proof of the mathematical impossibility of a polygon ever covering exactly the same area as a circle is claimed as a significant advance in the development of modern mathematics.[56] But the mathematical proof is only one step in his argument – a metaphor to express the inability of the human intellect to grasp the divine.

> The finite intellect, therefore, cannot know the truth of things with any exactitude by means of similarity, no matter how great. For the truth is neither more or less, since it is something indivisible... The intellect is to truth as the polygon is to the circle: just as the polygon, the more sides and angles it has, approximates but never becomes a circle, even if one lets the sides and angles multiply infinitely, so we know of the truth no more than that we cannot grasp it as it is with any true precision.[57]

Donne's parenthesis in "Upon the translation" closely follows Cusanus's logic. His repeated reference to the squaring of the circle is just one of his oblique allusions to the German thinker's metaphors, which will be discussed in more detail in the next chapters.[58] For Ernst Cassirer, what

[55] Johnson et al. eds., *Variorum 7.2: Divine Poems*, pp. 201-202 (p. 201). Robin Robbins cites the parallel between the 1624 sermon and the squaring of the circle in the *Sidney* poem, *The Poems of John Donne*. Longman Annotated English Poets (Harlow: Pearson, 2008), 2: p. 120. See also Donne's sermon preached to the King at Whitehall, April 1, 1627: "God hath wrapped up all things in Circles, and then a Circle hath no *Angles;* there are no *Corners* in a Circle" (7: 396-397).

[56] On Cusanus and mathematics see, Jean-Michel Counet, *Mathématiques et dialectique chez Nicolas de Cuse* (Paris: Vrin, 2000).

[57] *De docta ignorantia* i. 3. fol. 2f. Translation taken from Ernst Cassirer, *The Individual and the Cosmos in Renaissance Philosophy*, trans. Mario Domandi. (New York and Evanston: Harper Torchbooks, 1963), p. 22.

[58] Cf. the discussion of Cusanus' *De Visione Dei* in Chapter 2, pp. 54-57. The uses Donne makes of Cusanus's ideas will be discussed in more detail in Chapter 4.

makes Nicholas Cusanus "the first modern thinker" is that, in developing his theological reflection, "his first step consists in asking not about God, but about the possibility of knowledge about God".[59] Donne's nod at Cusanus's metaphor, though, asks more about the possibility of *representing* God. The "Strayt Corners of poore witt" in his poem on the psalms corresponds neatly to Nicholas of Cusa's polygon metaphor for the "finite intellect", but also points to the specifically verbal sense of *wit*, the "new expressions" that might attempt to contain the "cornerlesse and infinite" divine.

In the 1624 sermon, too, Donne's reference to Cusanus's squaring of the circle is oblique. By alluding, even in passing, to Cusanus's thought, he establishes the context of using geometrical metaphors to describe the divine, but he is much more interested in developing his own metaphor of the "convenient Hieroglyphick of God" (6: 173) which brings two circles together. Man is "made like God" in "Vppon the Annunciation", and God will make man into a circle like Himself, in the 1624 Christmas sermon (6: 175). Where Cusanus's analogy is based on incommensurability, Donne's is concerned with conjunction. The point of his "convenient hieroglyphic" is that it can represent God *and* man. In contrast to the squaring of the circle, Donne's two circles can be superimposed, allowing the human to approach the infinite. In "La Corona" this happens through the "thorny crowne" of Christ's Crucifixion, which allows the speaker to hope he too might aspire to "a Crowne of Glory which doth flowre alwayes" (1,8).

John of Damascus and the Byzantine iconodules held that the Incarnation legitimated religious art and the representation of the divine; indeed that the visual representation of Christ was essential to fully acknowledge and honour the mystery of the Incarnation. "La Corona" seems to reflect the complexities of this position. Its figures and forms of enclosure, combined with its insistent spatial paradoxes, are what make the Incarnation present. To quote O'Connell, "the paradox of the Incarnation, God in human flesh, undergirds the paradox of religious poetry, the Word in human words. Because the Almighty humbled himself to such an extent as to become human, he can be brought within the confines of human words and art".[60] Donne's sequence meditates on the *possibility* of circumscribing the divine in human words, and confronts the anxiety expressed by the speaker of "Upon the Translation of the Psalms" at the enormity of representing the "Eternal God". The echoes of religious painting which so many readers and critics have picked up on are not random or inconsequential, because those fleeting resemblances to visual art, nearly able to be pictured but not quite, underscore the elusive quality of what is being represented. But the

[59] Cassirer, *Individual and the Cosmos*, p. 10.
[60] O'Connell, "La Corona", p. 124.

comparisons to be made between Donne's Corona and Christian visual art prove to be far more complex than any superficial analogy to a specific artwork, as its recurrent "appeals to visualisation" are continually thwarted. The paradoxes and the conjunctions Donne sets before our "faith's eyes" meditate on the very possibility of representation in sacred art, and foreground the task of the divine poet or artist. His poems on the mystery of the Incarnation reflect the very essence of that mystery, representing the nature of Christ while simultaneously keeping it hidden. The circles woven by his poet-speaker encompass multiple ways in which religious art, verbal and visual, simultaneously holds out and withholds the possibility of ever comprehending the divine.

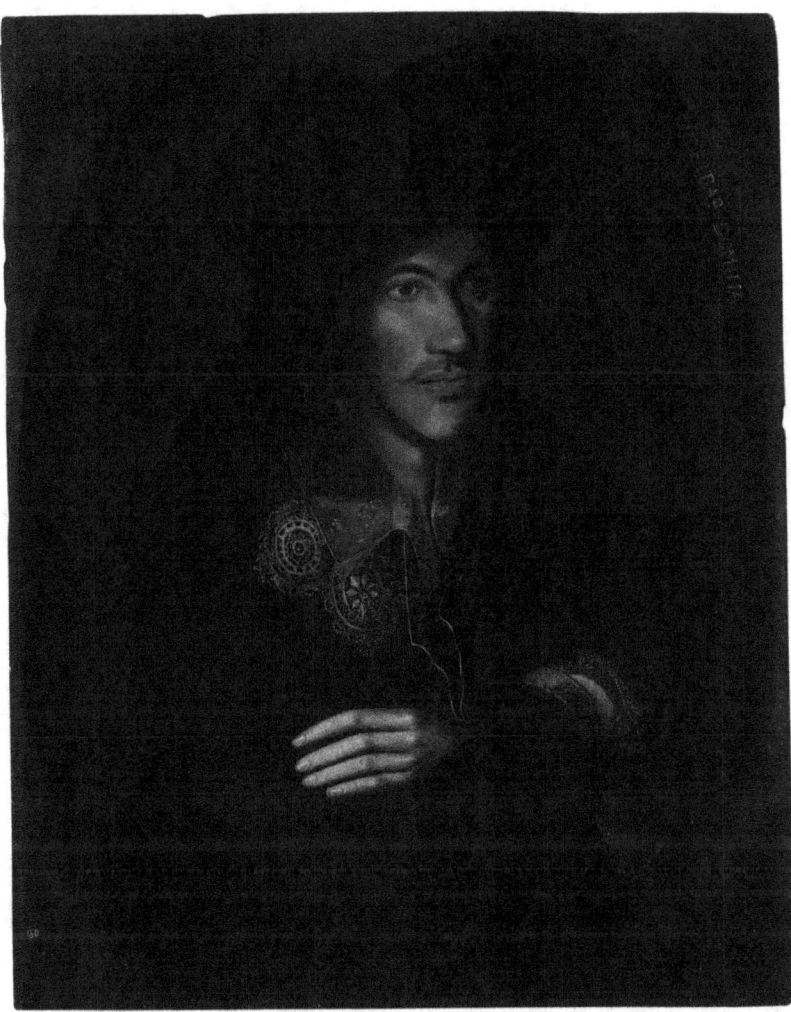

Figure 1. John Donne, by Unknown English Artist. ("The Lothian Portrait") c. 1595. Oil on Panel. NPG 6790, © National Portrait Gallery, London.

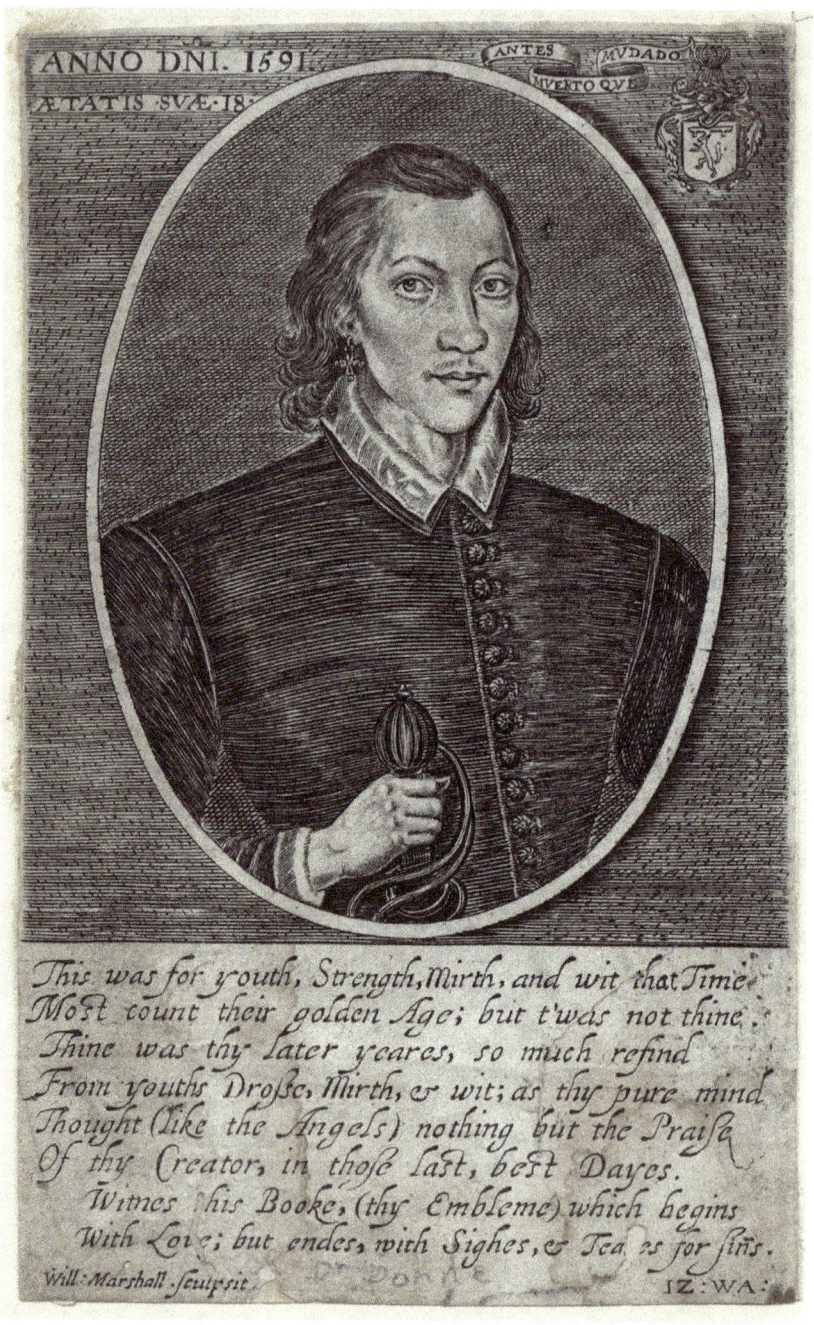

Figure 2. Portrait of Dr. Donne, by William Marshall. Print used as frontispiece to various editions of his poems, 1635–1650. D25490, © National Portrait Gallery, London.

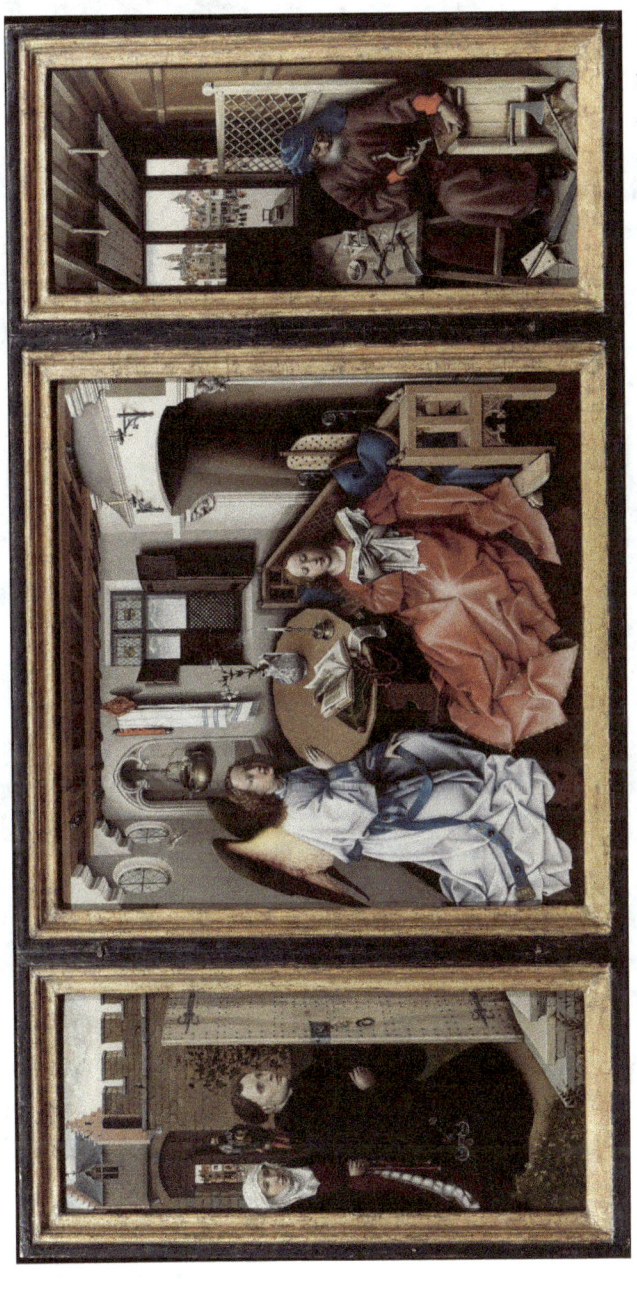

Figure 3. Annunciation Triptych (Merode Altarpiece). Workshop of Robert Campin. c. 1427–1432. Oil on oak. The Cloisters Collection. Metropolitan Museum of Art, New York.

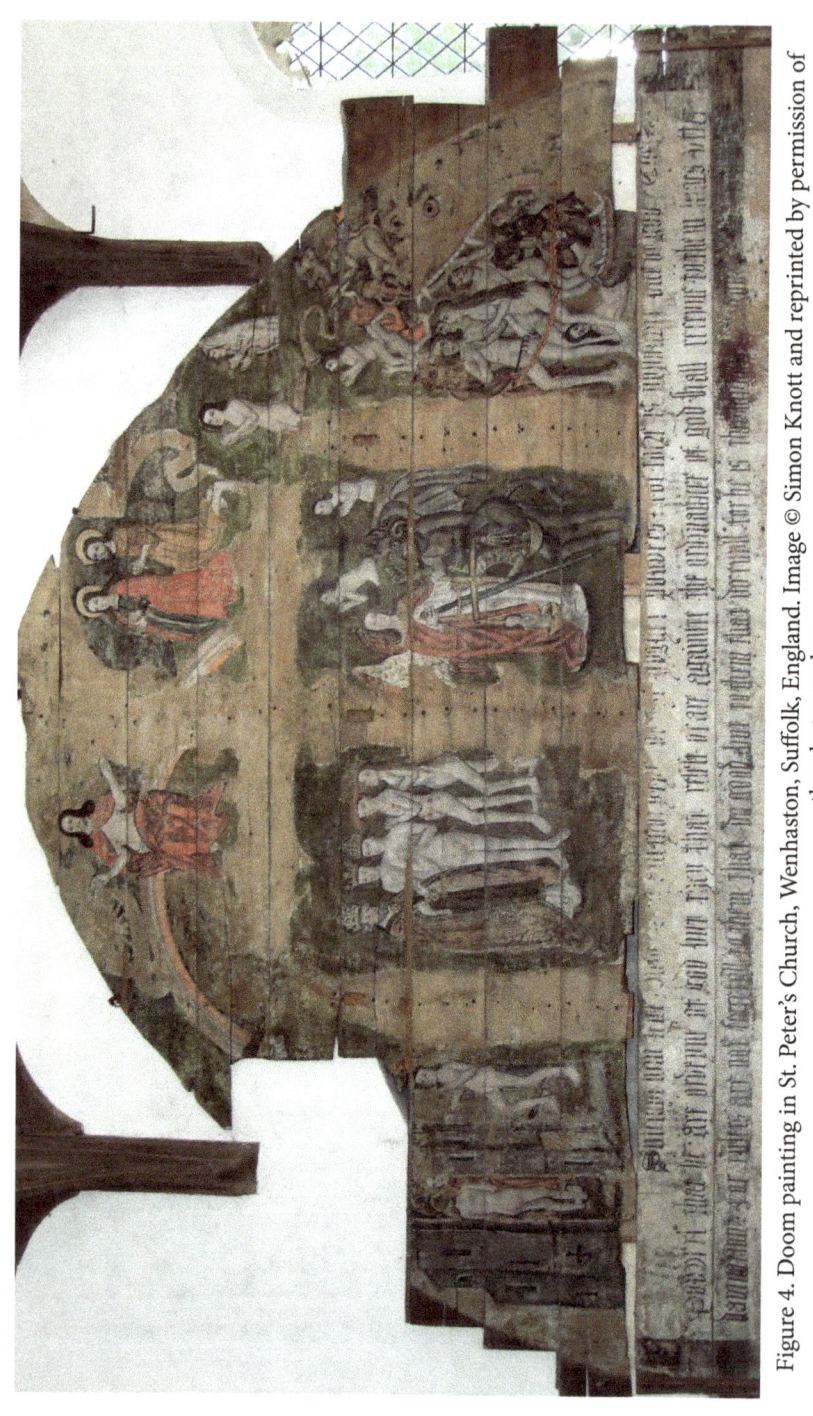

Figure 4. Doom painting in St. Peter's Church, Wenhaston, Suffolk, England. Image © Simon Knott and reprinted by permission of the photographer.

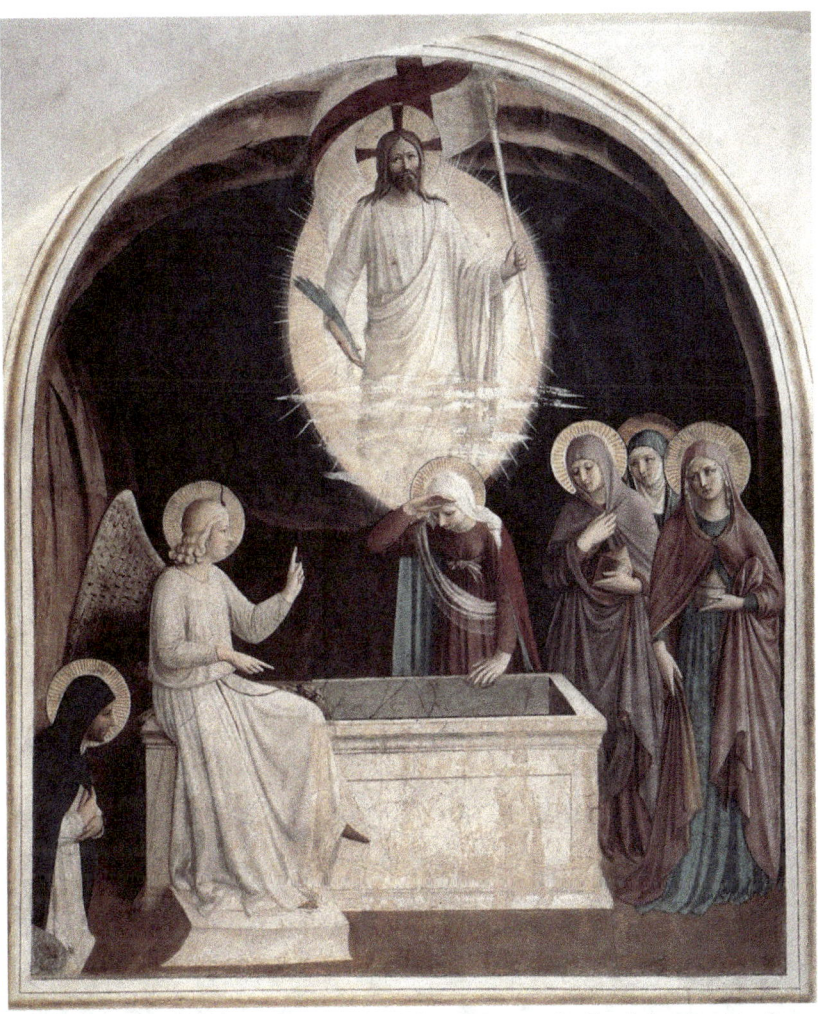

Figure 5. *The Resurrection of Christ and the Women at the Tomb,* by Fra Angelico. c. 1439–1443. Fresco. Ministero per i Beni e le Attività Culturali, Polo Museale della Toscana, Museo di San Marco, Firenze.

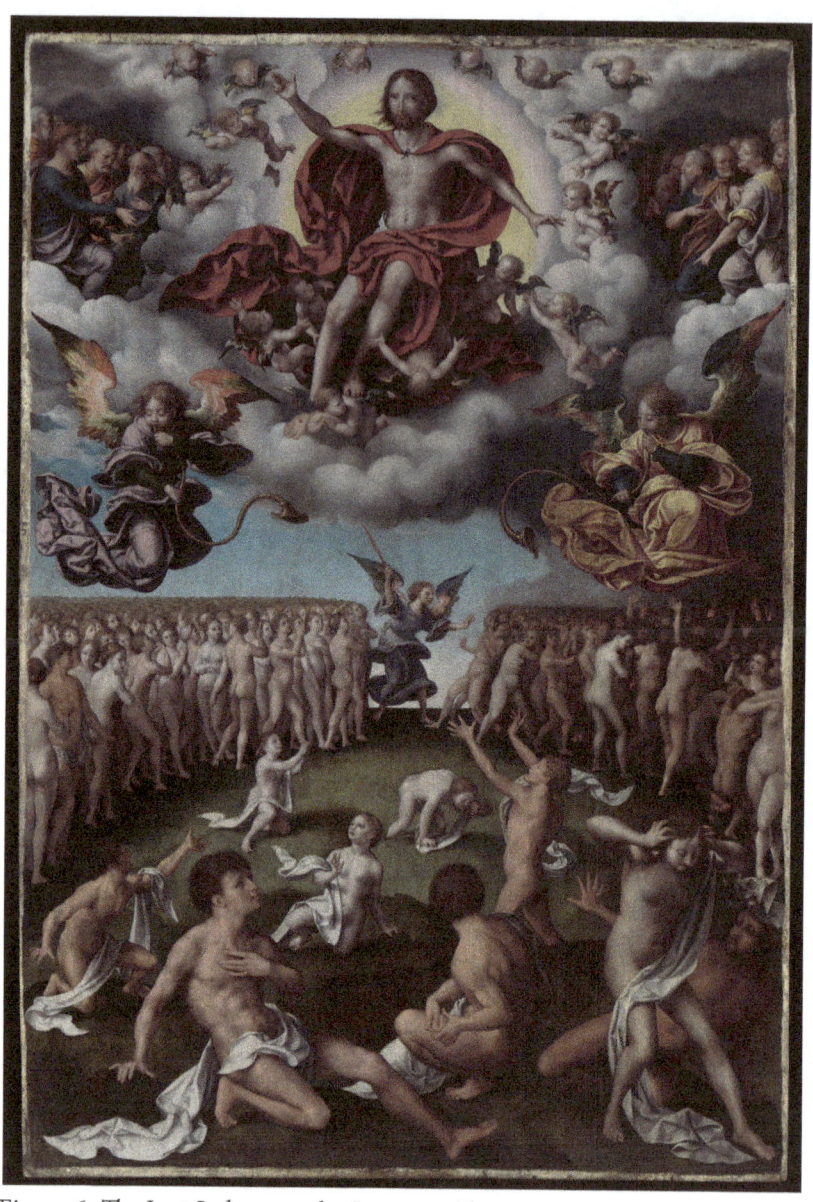

Figure 6. *The Last Judgement*, by Joos van Cleve. c. 1525–1530. Oil on wood. Metropolitan Museum of Art, New York.

Chapter 4

CRUCIFIXION

Christ's cross is the central image of Western Christian iconography, yet perhaps no image is more contested. So it is perhaps not surprising that in his poems on the cross Donne most pointedly highlights the conflicting discourses of iconolatry and iconoclasm. We have already seen that his treatment of the scene of the Crucifixion, in the context of his Annunciation poems, is far from straightforward. In "La Corona", he represents the Crucifixion in terms of spatial paradox rather than describing it visually, and in "Upon the Annunciation", despite the poem's insistence on "seeing", the soul contemplates only the fringes of the scene of the Passion through the figure of the Virgin Mary without confronting the Crucifixion head-on. Donne repeatedly highlights and problematises the status of the cross as a visual icon, and in the three poems that deal most explicitly with the topic, his approach continues to be oblique. In "Good friday, Made as I was Rideing westward, that daye"[1] the speaker is facing in the wrong direction to contemplate the "Spectacle" (ll. 15; 13) of "Christ, on this Cross", while in the Holy Sonnet "What if this present were the world's last night", the "picture of Christ crucified" (l. 3) is forced into conflict with the competing image of Christ at the Last Judgement. The vocabulary of the visual in these poems – the "spectacle", the "picture" – is also used in "The Crosse",[2] which opens with the "Image of his Crosse" (l. 2). But although this poem seems at first to be a relatively unproblematic celebration of the cruciform and its place in worship, the cross proves to be a slippery signifier. As in all of these poems, its status is far from simple. The anxiety about looking at the cross that Donne stages in these poems can be seen as an extension

[1] The title "Good friday, Made as I was Rideing westward, that daye" is the one used in the *Variorum* so I adopt it here. Hereafter in the chapter I will use the short form "Good friday", Johnson *et al.*, Variorum 7.2, pp. 147–148.

[2] Johnson *et al.*, eds., *Variorum 7.2: Divine Poems*, pp. 114–115. In *Variorum* the poem has the title "Of the Crosse", but I will use the shorter (and more familiar) version "The Crosse" throughout.

of his concern about representation in general, and representation of the divine in particular, as discussed in previous chapters. The contemplation of Christ's death, however, brings with it a special set of strictures and concerns. In both "Good friday" and "The Crosse", Donne parallels his problematic pictures of the cross with images drawn from mystical and apophatic theology. "The Crosse" makes use of a key metaphor also used by the sixth-century theologian Pseudo-Dionysius in his *The Mystical Theology*. Finally, however, the negative theology that enables his speakers to interact with the crosses and crucifixes in these poems is not so much Dionysian as Lutheran. Luther's "theology of the cross" provides an important context for the centrality of the cross to Donne's thinking, and his anti-iconoclastic writings also influence Donne's attitudes to religious iconography in his own iconoclastic society.

NEGATIVE THEOLOGY AND "THE CROSSE"

The crucifix had been a highly charged religious and political image in England since the 1540s when all church crucifixes were destroyed under Cranmer and Thomas Cromwell, following the Royal Injunctions of 1538. They were reinstated during Mary's reign, but many in a very temporary fashion, painted on canvas or on boards, only to be swept away again with the accession of Elizabeth to the throne in 1558.[3] In Donne's period, the crucifix was still a contested image. "The Crosse" is often read in this context as an anti-iconoclastic defence of the "image", the "picture", the physical crucifix, opening as it does, "Since Christ embraced the Crosse itt selfe, dare I / His image, th'image of his Crosse deny?" (ll. 1-2). Helen Gardner describes the poem as Donne "defending the cross as a pious and proper personal possession".[4] The opening part does insist on the physical form of the cross, yet this is qualified by the lines: "Materiall crosses, then, good Phisick bee, / And yett Spirituall haue cheefe dignitie; /... and cure mvch better" (ll. 25-26; 28). This shift to "spirituall" crosses is often used to link the poem's defence of the cross to the controversy surrounding the Puritan ministers' call to abolish the sign of the cross in baptism in 1603-1604.[5]

At the precise midpoint of the poem, however, in line 33, we find Donne evoking a visual artwork of quite a different sort:

[3] Eamon Duffy, *The Stripping of the Altars: Traditional Religion in England 1400–1580* (New Haven: Yale University Press, 1992), pp. 406–407; p. 454; Phillips, *Reformation of Images*, pp. 109–110. For an in-depth discuss of the place of the cross "at the heart of all iconoclastic controversy", see Aston, *Broken Idols*, pp. 707–882.
[4] Gardner, ed., *Divine Poems*, p. 92.
[5] William A. McQueen, "Donne's 'The Crosse'", *Explicator* 45, no. 3 (1987), 9. See also Lewalski, *Protestant Poetics*, p. 873 n. 508.

> As perchaunce Caruers doe not faces make,
> But that away, which hid them there, do take.
> Lett Crosses soe, take what hid Christ in thee,
> And bee his Image, or not his, butt Hee. (ll. 33–36)

This condensed, oblique reference to the sculptor's "substractive" practice of removing, rather than adding material from his medium to create the work of art has been paralleled with Michelangelo's evocation of the art of the sculptor in his Rima 151: "Non ha l'ottimo artista alcun concetto / c'un marmo solo in sé no circonscriva" ("The best of artists can no subject find / That is not in a single block of stone").[6] Having suggested the parallel, Mario Praz points out that at the moment of writing "The Crosse" Donne "could not have known of Michelangelo's sonnets, which were posthumously published in 1623".[7] However, as with his reference to the "Statuaries" who represent men "by Substraction" in his 1627 Trinity Sunday sermon (8: 54), the source seems likely to be Pseudo-Dionysius's use of the sculptor in the second chapter of his treatise *The Mystical Theology* to illustrate the *via negativa*.[8]

Here the mystical method of approaching God through acknowledgement of what he is not is compared to the practice of the sculptor who chips extraneous material away from the marble to reveal the work of art:

> For this would be really to see and to know: to praise the Transcendent One in a transcending way, namely through the denial of all beings. We would be like sculptors who set out to carve a statue. They remove every

[6] Michelangelo, *Poems and Letters*, trans. Anthony Mortimer (London: Penguin, 2007), p. 151.

[7] Mario Praz, *The Flaming Heart: Essays on Crashaw, Machiavelli and Other Studies of the Relation between Italian and English Literature from Chaucer to T. S. Eliot* (Gloucester, MA: Peter Smith, 1966), p. 203. This identification is also made by both Smith, ed., *Donne, Complete English Poems*, p. 648 and Alexander B. Chambers, *Transfigured Rites in Seventeenth-Century English Poetry* (Columbia: University of Missouri Press, 1992), p. 207.

[8] See Chapter 2 of this book, pp. 58–61. Robin Robbins identifies the parallel between the sermon passage and "The Crosse", though does not suggest Pseudo-Dionysius as a source, *Poems of John Donne*, 2: p. 11. Michael Martin finds a parallel between Donne's account of the affirmative way of representing God in the passage quoted above and the language used in another work of Dionysius', *The Divine Names*, which similarly describes humankind attributing human or physical forms to God: "they praise its eyes, ears, hair, face, hands, back, wings, and arms, a posterior, and feet", Pseudo-Dionysius, *Complete Works*, p. 57. Martin agrees that Donne "relies heavily on Dionysius" in the 1627 Trinity Sunday sermon, though he does not identify the statue imagery as originating with Dionysius. *Literature and the Encounter with God in Post-Reformation England* (Farnham: Ashgate, 2014), p. 65.

obstacle to the pure view of the hidden image, and simply by this act of clearing aside they show up the beauty which is hidden.[9]

Donne's concise reference to Pseudo-Dionysius's carver who removes rather than creating certainly evokes the *via negativa* of the mystics, but the way he develops it takes the principles of negation in quite a different direction.

In "The Crosse" Donne takes the negation, the subtraction, illustrated by the art of the carver or sculptor and applies it not to the knowledge of God but rather to the soul of man. His reinterpretation of the statue analogy is developed in the couplet "Lett Crosses soe, take what hid Christ in thee, / And bee his Image, or not his, but Hee" (ll. 35–36). The image in question is no longer – or not only – the image of Christ on the cross but the image of God in man that is to be revealed, and the cross takes on the role of the carver, or the carver's chisel, working on man in order to erase "what hid Christ in thee" (35). The internal idols that obscure the *imago Dei* are chipped away as "the Crosse of Christ work[s] fruitefullye / With in our Harts" (61–62). Donne uses a very similar image, though without the explicitly apophatic associations, in a sermon preached in 1620 to the Countess of Bedford:

> So then the children of God, are the *Marble*, and the *Ivory*, upon which he works; In them his purpose is, to re-engrave, and restore his Image; and affliction, and the *malignity of man*, and the *deceits of Heretiques*, and the *tentations of the Devill* him selfe, are but his instruments, his tools, to make his Image more discernable, and more durable in us. (9: 193)

The metaphor of the sculptor turns the cross from a passive icon of Christ into an active participant in the redemptive process. This brings it much closer to a Lutheran kind of apophatic theology than to the original Pseudo-Dionysian metaphor. And this metaphor at the midpoint of the poem transforms not only the cross but the direction of the poem itself.

At first sight, the opening of "The Crosse" seems to be an affirmation of the material cross rather than any kind of negation, with the list of crosses to be found in nature functioning to reinforce the visual validity of the "image of the cross". Yet although Donne's speaker asks "who can blott out the Crosse…?" (l. 15), the rapid succession of examples of naturally occurring cruciforms in lines 17–32 serves, if not exactly to blot out, certainly to blur the image of the crucifix. The first half of the poem also introduces the standard transferred use of "cross" to mean "affliction", and this double meaning contributes to the blurring repetition of the word, as the "crosses" borne by the Christian are celebrated alongside the array of manmade and natural crosses to be perceived in the world around us.

[9] Pseudo-Dionysius, *Complete Works*, p. 138.

This distorting multiplication of cross-like shapes leads into the "spirituall" and internal cross of the second part of the poem and prepares the reader for Donne's play with the word "cross", creating a much more complex engagement with the crucifix than the opening of the poem might lead us to expect. It is only in the second half of the poem, however, following the Pseudo-Dionysian sculptor metaphor of lines 33–34, that the cross itself is grammatically transformed from noun into verb and begins to act rather than simply being. The cross becomes the carver's tool that chips away to remove or scratch out "what hid Christ in thee". It does this by becoming a verb of negative action, taking on the meaning of *cancel* or *erase* (OED cross *v*. 4. a): "crosse / Your ioy in crosses (41–42); "crosse thy senses" (43); "Crosse the rest: / Make them indifferent" (47–48); "Crosse those deiections" (53); "Crosse, and correct Concupissence of witt" (58); "crosse thy selfe in all" (60).

The idea that the action of the cross will work on the sinner to reveal God's grace within him is very Lutheran, indeed the basis of Luther's theology of the cross. And Donne's move in this poem from the statue analogy to the action of the cross is highly reminiscent of Luther's own adaptation and appropriation of the terms of Pseudo-Dionysian apophatic theology. As Paul Rorem has shown, despite his statements rejecting negative theology as practised by Pseudo-Dionysius, "Luther explicitly moves from a Pseudo-Dionysian apophatic to a 'negative theology' of the cross".[10] Luther is fairly abrupt in dismissing Pseudo-Dionysius's ideas, writing in 1520 in the treatise *The Babylonian Captivity of the Church*, "So far, indeed, from learning Christ in [Pseudo-Dionysius's works], you will lose even what you already know of him. I speak from experience. Let us rather hear Paul, that we may learn Jesus Christ and him crucified."[11] Pseudo-Dionysius and Luther both reject intellectual or metaphysical knowledge as a way to approach the divine, and find God rather in darkness, although for Pseudo-Dionysius this means "plung[ing] into that darkness which is beyond intellect" to become "speechless and unknowing",[12] whereas for Luther the darkness is to be found in Christ's suffering on the cross. Some

[10] Paul Rorem, "Negative Theologies and The Cross", *Harvard Theological Review* 101, no. 3/4 (2008): 458–463 (p. 462).

[11] *Luther's Works*, ed. by Jaroslav Pelikan and Helmut T. Lehman, 55 vols (Philadelphia: Muehlenberg and Fortress, and St. Louis, MO: Concordia, 1955–1986), 36: 109 (hereafter LW). Luther's Latin reads, "*Christum ibi adeo non disces ut, si etiam scias, amittas. Expertus loquor. Paulum potius audiamus, ut Iesum Christum et hunc crucifixum discamus*". Luther, *Werke. Kritische Gesamtausgabe*, ed. by J. F. K. Knake, 67 vols (Weimar: Hermann Bohlaus Nachfolger, 1883–1997), 6:562.8-13 (hereafter WA = Weimarer Ausgabe).

[12] Pseudo-Dionysius, *Complete Works*, p. 139.

fifteen years later Luther explicitly moves from a dismissal of Pseudo-Dionysius into a reappropriation of the term "negative theology" in the light of the theology of the cross: "Therefore Dionysius, who wrote about 'negative theology' and 'affirmative theology', deserves to be ridiculed ... If we wish to give a true definition of "negative theology", we should say that it is the holy cross and the afflictions [attending it]."[13] Even the phrase that has become a kind of motto for Luther's theology of the cross, "Crux sola est nostra theologia", or "The Cross alone is our theology", comes from a passage in *Operationes in Psalmos* (1519–1521) where Luther disputes the mystical theologians' interpretation of "going into the darkness, ascending beyond being and non-being", adding, "truly I do not know whether they understand themselves, if they attribute it to [humanly] elicited acts and do not rather believe that the sufferings of the cross, death and hell are being signified. The CROSS alone is our theology."[14]

Such an "incarnational apophatic", as Rorem terms it, does not originate with Luther, but can be seen as part of a tradition that includes the writings of the seventh-century Byzantine theologian Maximus the Confessor and St Bonaventure in the thirteenth century.[15] What is more specifically Lutheran is the idea of the cross acting on man to improve him. As another Lutheran theologian puts it:

> Luther was an apophatic (negative) theologian of a different sort ... Luther did not understand the negation only as a moment in one's use of analogy to "unsay" what cannot rightly be said of an infinite being. Instead, the negation is always the act of God applying the cross to our very persons in this world.[16]

In a sermon preached at St Paul's Donne describes a similar shift from the desire for metaphysical knowledge of God to the knowledge that comes only from Christ's passion, insisting on the importance of applying this to the self.

[13] LW 13:110–111, quoted by Rorem, "Negative Theologies", p. 462 n. 51. "*Quare merito ridetur Dionysius, qui scripsit de Theologia Negativa et Affirmitiva.... Nos autem, si vere volumus Theologiam negativam definire, statuemus eam esse sanctam Crucem et tentationes, in quibus Deus quidem non cernitur, et tamen adest ille gemitus, de quo iam dixi*": Enarratio Psalmi 90 (1534/35 [1541]); Ps. 90:7 (WA, 40/3, p. 543.8–13).

[14] Rorem, "Negative Theologies", p. 462. "*Hunc ductum Theologici mystici vocant In tenebras ire, ascendere super ens et non ens. Verum nescio, an scipsos intelligant, si id actibuts elicitis tribuunt et non potius crucis, mortis infernique passiones significari credunt. CRUX sola est nostra Theologia*": Operationes in Psalmos (WA, 5, p. 176.27–33).

[15] Rorem, "Negative Theologies", pp. 460–461.

[16] Stephen D. Paulson, "Luther on the Hidden God", *Word and World* 19:4 (1999): 362–371 (p. 364).

He refers, like Luther, to Paul's words in 1 Corinthians 2: 2: "I determined not to know any thing among you, save Jesus Christ, and him crucified":

> I may have as much knowledge, as is presently necessary for my salvation, and yet have a restlesse and unsatisfied desire, to search into unprofitable curiosities, unrevealed mysteries, and inextricable perplexities: And, on the other side, a man may be satisfied, and thinke he knowes all, when, God knowes, he knowes nothing at all; for, I know nothing, if I know not Christ crucified, And I know not that, if I know not how to apply him to my selfe... (5:276)

It is precisely this shift from the Pseudo-Dionysian apophatic to the application of the cross that we see in Donne's poem, as "crosses" are applied to "take what hid Christ in thee" and reveal the image of God in man. This shift in the second part of "The Crosse" not only moves the poem away from being a defence of the cross as a physical, visual work of art to be looked at, but also strongly suggests that its corrective and erasing action is inherent to, indeed constitutive of, the cross itself. The poem splits precisely into two parts and the shift in focus is marked both by the introduction of the Pseudo-Dionysian carver and the printed cruciform letter x, which, as Theresa DiPasquale persuasively points out, appears at the poem's centre in the word "crucifix" at the end of line 32.[17] This central x is iconically appropriate since the change of direction in the second half of the poem is what gives it the form of the cross.

It is noteworthy that as "cross" becomes a verb and takes on this cancelling and corrective role, its corrective function is applied particularly to the sense of sight and the appreciation of icons – the appreciation of the cross itself – which is precisely what seemed to be celebrated in the first part of the poem:

> Therfore crosse
> Your ioy in crosses, els tis double losse;
> And crosse thy senses, els both they, and thou
> Must perish soone, and to destruction bowe.
> [...]
> But most the Eie needs crossing, that can rome,
> And move... (41–44; 49–50)

[17] Theresa M. DiPasquale, *Literature and Sacrament: The Sacred and the Secular in John Donne, Medieval and Renaissance Literary Studies (MRLS)* (Pittsburgh, PA: Duquesne University Press, 1999), p. 40. I find DiPasquale's point about the x marking the mid-point of the poem more persuasive if the word "crucifix" ends in "-x", as it does in just over a third of the extant manuscript versions of the poem. Other manuscript versions and all the early printed versions before 1669 have "crucifixe".

Significantly, while all the senses have to be checked, "the Eie needs crossing" most of all. While the first part of the poem established the cross as the "chosen Altar" (4) of Christ's sacrifice, and rhetorically demanded how it could be despised, the second part warns that in the case of an excessive "ioy in crosses", both idol and idolator will potentially perish.

Such an even-handed consideration of the image question is characteristic of Donne's judicious approach to the religious image throughout his work. As he puts it in "Satyre 3", "To'adore, or scorne an Image, or protest,/ May all be bad; doubt wisely; In strange way /To stand inquyring right, is not to stray" (ll. 76–78).[18] Indeed the move in "The Crosse", from an apparent criticism of iconoclasm to a warning about the dangers of idolatry, can be read as an inverted version of his later, much-quoted, balanced take on the image question in a sermon of 1627:

> Væ Idolalatris, woe to such advancers of Images, as would throw down Christ, rather then his Image: But Væ Iconoclastis too, woe to such peremptory abhorrers of Pictures, and to such uncharitable condemners of all those who admit any use of them, as had rather throw down a Church, than let a Picture stand. (7:433)

If our eyes cannot distinguish good crosses from bad, the speaker of "The Crosse" continues, we should treat them all as "indifferent" – "Make them indifferent" (48) – an expression which, in this context, refers clearly to the debates of the iconoclastic controversy and Luther's identification of images and other contentious rituals as "adiaphora": neither essential to salvation nor harmful.[19]

Just as the cross – like "The Crosse" – contains the potential for both idolatry and iconoclasm, the crosses of the first half of the poem, both material images and afflictions, are "crossed" – cancelled or erased – by the second half of the poem. Indeed, the second half of the poem can be seen to correct the first half in more ways than one, calling into question not only the speaker's initial defiant justification of the physical image but also his somewhat self-flagellating pleasure in tribulation. "Better were worse", the speaker asserts in the first half of the poem, "for no affliction, / No crosse is soe extreame as to haue none" (13–14), which reads almost as a caricature of a Christian willing acceptance of suffering, and recalls the similarly ambiguous lines on martyrdom in "A Litany": "oh, to some, / Not to bee Martyres, ys a Martyrdome" (89–90). The second half of "The Crosse", in contrast, warns against the risks of undue pleasure in adversity: "so may a selfe despising, gett selfe loue … Soe is Pride issued from

[18] Stringer et al., eds., Variorum 3: Satyres, p. 92.
[19] Koerner, Reformation of the Image, p. 157.

hvmilitie" (38, 40). This "ioy in crosses", too, must be "crossed". The heart must also be crossed, "for that in Mann alone / Poynts downewardes, and hath Palpitation" (51–52). These lines have been interpreted as referring to lusts and base desires,[20] but the following lines gloss this downward tendency of the heart as "deiections", which are as potentially dangerous to its owner as upward aspirations to "forbidden heights" (54). This again corrects the rather self-aggrandising image of the speaker in the first half of the poem stretching his arms to become his own cross: "Who can deny mee power, and liberty / To strech myne Armes, and myne owne Crosse to bee?" (17–18).

The contradictory, cancelling logic that opposes the first half of the poem to the second half is what turns it into a "Crosse", just as a cross is made of one line crossing out another. The first half which asserts the primacy of the material image is simultaneously present and cancelled out by the second half, an act of erasure in the Heideggerean or Derridean sense of the term.[21] The two halves of the poem intersect at the central statue image drawn from Pseudo-Dionysius' *Mystical Theology*, which appears to generate Donne's play with the word *cross* that permits the cancelling action of the verb. The cross both visually and verbally carries within itself the erasing and destructive action that Donne's poem wittily mimics, and so is an apt sign for the paradoxical nature of Christ's sacrifice, a paradox that is contained within Luther's theology of the cross, where God is both revealed and, paradoxically, hidden in the cross of Christ.[22]

THE *DEUS ABSCONDITUS* AND THE CROSS IN DONNE'S GOOD FRIDAY POEM

In "Good friday, Made as I was Rideing westward, that daye", a similar tension between the present and the absent cross is spatially enacted in the conceit of the speaker being "carried towards the west / ... when [his] soules forme, bends towards the East" (ll. 9–10). The verbal paradoxes of the "Sun by ryseing sett" (11) or "Christ, on this Cross [who] did rise and fall" (13) suggest a similarly cruciform logic. As in "The Crosse", the 1613 poem signals and then adapts an apophatic context. Its geographical conceit superimposes the metaphor of life running from east to west onto the spatial symbolism of medieval church architecture in which the crucifix

[20] See, e.g., *The Complete Poems of John Donne*, ed. by Robin Robbins (New York: Routledge, 2014), p. 473.

[21] See Jacques Derrida, *Of Grammatology*, trans. Gayatri Chakravorty Spivak (Baltimore and London: Johns Hopkins University Press, 1976), pp. 60–61, and Spivak's translator's introduction to the same volume, pp. xv–xviii.

[22] Alister E. McGrath, *Luther's Theology of the Cross* (Oxford: Blackwell, 2011), p. 149.

was traditionally hung over the altar in the east of the building. The speaker, "whirl'd" westwards for business or for pleasure, does not contemplate the crucifix, and admits to being "glad" that he "doe[s] not see / That Spectacle, of too much weight for mee" (ll. 15–16), continuing "Whoe sees Gods face, that is self life, must dye; / What a death were it then to see God dye?" (ll. 17–18). As most of the poem's commentators note, line 17 is a direct reference to God's words to Moses in Exodus 33: 20: "You cannot see my face; for no one shall see me and live", the scriptural basis for the idea of the hidden God or *Deus absconditus*. But Donne adapts the warning in Exodus 33 by adding his own: "What a death were it then to see God dye?", thus rhetorically, at least, placing the sight of the Crucifixion in the same category as the unimaginable, uncontemplable sight of God's face in glory.

This juxtaposition of the hidden revelation of Exodus 33 with the Crucifixion is also central to Luther's theology of the cross, as laid out in the theses of the Heidelberg Disputation of 1518. Theses 19 and 20 are of particular interest as they contain key statements highlighting the centrality of *how we look at God*:

> 19. *Non ille digne Theologus dicitur, qui invisibilia Dei per ea, quae facta sunt, intellecta conspicit.* (Anyone who observes the invisible things of God, understood through those things that are created, does not deserve to be called a theologian.)
>
> 20. *Sed qui visibilia et posteriora Dei per passiones et crucem conspecta intelligit.* (But anyone who understands the visible rearward parts of God as observed in suffering and the cross does deserve to be called a theologian.)[23]

The English translation here is taken from Alister McGrath's *Luther's Theology of the Cross* because, as McGrath points out, Jaroslav Pelikan's standard English translation of thesis 20 does not highlight Luther's reference to a key moment of divine self-revelation.[24] McGrath argues that Luther's use of the word *posteriora* is a direct reference to the use of the word in God's warning to Moses at Sinai. Having told Moses "there shall no man see me, and live", God goes on to say, "Thou shalt see my back parts, but my face shall not be seen", which in the Vulgate is "*videbis posteriora mea faciem autem meam videre non poteris*" (Exodus 33: 23). McGrath's translation of *visibilia et posteriora Dei* as "visible rearward parts of God as observed in

[23] WA, 1, pp. 362–363; translation: McGrath, *Luther's Theology*, pp. 204–205.

[24] Jaroslav Pelikan's translation of Luther's twentieth Heidelberg thesis in *Luther's Works* is: "He deserves to be called a theologian, however, who comprehends the *visible and manifest things of God* seen through suffering and the cross" (LW 31:52; my emphasis).

suffering and the cross" (as opposed to Pelikan's "visible manifest things of God") insists on the reference to Exodus 33 and therefore on the fact that this is a *hidden* revelation. According to McGrath, "it is clear that this is precisely what Luther intended to convey by the phrase".[25] Luther's bringing together of the hidden revelation of Exodus 33 and Christ's suffering on the cross is central to his theology of the cross. For Luther, Christ's incarnation and specifically his suffering on the cross *is* the "back side of God" or the "visible rearward parts of God", and it is all we can see. McGrath also points out that the theological engagement implied in the theology of the cross is not merely rational but also visual. A theologian of the cross "understands what is seen" rather than "observing through what is understood".

The paraphrase of Exodus 33:20 in line 17 of "Good friday" – "Whoe sees Gods face, that is self life, must dye" – immediately followed by Donne's development of this – "What a death were it then to see God dye" – seems to invoke the logic of Luther's theology of the cross as expressed in his twentieth Heidelberg thesis. This reference to the *Deus absconditus* in the context of the Crucifixion highlights the opposition Luther makes between *seeing* God and *understanding* God as observed in suffering and the cross.

Recent scholarship has demonstrated that Donne's couplet referencing Exodus has a somewhat unstable status in the poem's history. The couplet (ll. 17–18) is not included in two manuscript versions of "Good friday" in the hand of Nathaniel Rich, discovered in the 1970s, one of which misses out the following couplet as well.[26] Although bibliographical evidence cannot conclusively determine whether the version of "Good friday" recorded in these two manuscript versions is the result of scribal error, or whether it records an earlier authorial version, various circumstances lead Margaret Maurer and Dennis Flynn to cautiously conclude that the Rich manuscripts record an earlier stage in the poem's composition, prior to the manuscript tradition recorded in the 1633 *Poems*. Donne's close relationship with the Rich family at this period reinforces this hypothesis, but the most compelling, though circumstantial, evidence that these manuscripts record an earlier "tentative authorial trial" is the internal coherence of the variant readings found in them: none of the "missing" couplets leads to an obviously faulty reading.[27]

Maurer and Flynn demonstrate how, if we accept this chronology of authorial revision, the addition of the reference to Exodus 33:20, combined

[25] McGrath, *Luther's Theology*, p. 204.
[26] Margaret Maurer and Dennis Flynn, "The text of *Goodf* and Donne's Itinerary in April 1613", in *Textual Cultures: Texts, Contexts, Interpretation* 8, no. 2 (2013): 50-94 (pp. 84-87). Beal, *Index*, DnJ 1430 (P2), in private hands; Beal, *Index*, DnJ 1431 (PT2), Robert Taylor Collection, Princeton University Library.
[27] Maurer and Flynn, "Text of *Goodf*", p. 60; p. 66.

with other changes made to the poem, chart a shift from an earlier emphasis on the Crucifixion as a past, biblical event, to a revised version that recognises the Crucifixion as a "present possibility" in the life of the speaker.[28] This is most noticeable in a marked change of tense in line 15 (the couplet that would immediately precede the lines referencing Exodus 33), which in the earlier version of "Good friday", reads: "Yett am I almost glad, I *did* not see / That spectacle, of too much weight for me" (P2, 15–16). In the later canonical version the couplet is: "Yet dare I almost bee glad, I *doe* not see / That Spectacle of too much weight for mee" (ll. 15–16; my emphasis). The poem, Maurer and Flynn argue, thus emphasises the life-journey of the speaker as "a mortal being" – a mortality which is emphasised by the "dye / dye" rhyme of the added couplet – who, though constrained by life's duties to pursue business or pleasure, "can only trust that God's grace will find in time some means to restore God's image in him for that final reckoning".[29] The juxtaposition of the present-tense "Spectacle" of the Crucifixion with the added reference to the divine self-revelation of Exodus 33 means that the poem progresses toward an assertion of the presence of the cross in the life of the speaker which corresponds closely to Luther's theology of the cross.

Yet, having apparently established this parallel between the *Deus absconditus* and the Crucifixion, Donne immediately goes in another direction. The fact that his speaker is "almost … glad" *not* to "see / That Spectacle …" (ll. 15–16) seems to run counter to the logic of Luther's twentieth thesis. While for Luther, God is "hidden" in the Crucifixion and so the Crucifixion with all its suffering must be observed, Donne's speaker in "Good friday" seems to shy away from looking at the cross. God seems to be "hidden" in Donne's poem because the speaker does not engage visually with the Crucifixion. He does, however, engage with the Crucifixion through the faculty of memory: "these things … are present yet vnto my Memorie" (ll. 33–34). As Maurer and Flynn highlight, the speaker of the revised version of the poem "takes comfort in an assured assertion that … the faculty of memory has been and will always be available to assist his meditation on that event".[30] Read in the context of Donne's fascination with memory in his sermons, the insistence on memory in "Good friday" may point toward a new way of understanding the *posteriora Dei*, the visible rearward parts of God.[31]

[28] Maurer and Flynn, "Text of *Goodf*", p. 77.
[29] Maurer and Flynn, "Text of *Goodf*", p. 82.
[30] Maurer and Flynn, "Text of *Goodf*", p. 8.
[31] On memory and salvation in Donne, see Achsah Guibbory, "John Donne and Memory as the 'Art of Salvation'", *Huntington Library Quarterly* 43, no. 4 (1980):

Donne's sermon preached at Hanworth to James Hay, Earl of Carlisle and company in 1622, already briefly discussed in Chapter 2, contains many parallels to his Good Friday poem, and particularly illuminates the role played by the memory in this scheme of salvation. The Hanworth sermon is an important part of the network of texts reflecting Donne's thinking on negative theology and the hidden God. In this sermon, as in "The Crosse", Donne evokes some of the ideas of mystical theology only to adapt them to a more Christological kind of negative theology. The sermon opens by juxtaposing two verses from the Psalms – "God hath made darknesse his secret place" (Ps. 18.11) and "God covers himself with light as with a garment" (Ps. 104.2) – in order to oppose darkness and light as ways of seeing God (*Sermons* 4:164). While the first part of the sermon rejects the idea that God is only to be found in darkness (4: 168–169), the second part proposes darkness as a corrective to our sight and a means to prepare for the vision of God in glory. This paradox sounds like textbook mystical theology, but Donne is not referring to the mystical darkness of unknowing and the *via negativa*, or at least not directly. Rather, by darkness he means affliction or suffering, which, he explains, in a complicated chain of medicinal metaphors, is the corrective "eye-salve", or the corrective "spectacles" that will improve our spiritual sight. Just as in "The Crosse", afflictions, or crosses, proved to be "good Phisick" (l. 25), here Donne similarly merges the lexical fields of vision and affliction, in order to develop this very specific medicinal metaphor: "God made the Sun, and Moon, and Stars, glorious lights for man to see by; but man's infirmity requires *spectacles*, and affliction does that office" (4: 171).

Affliction is the corrective glass through which man must look in order to prepare to see God, and Donne develops his theme of the spectacles of affliction in a passage that strongly evokes the rhetoric of mystical theology, but uses this language to shift to a focus on the sufferings of Christ:

> Man *sees* best in the *light*, but *meditates* best in the *darke*; for our sight of God, it is enough, that God gives the light of *nature*; to behold him so, as to fixe upon him in meditation, God benights us, or eclipses us, or casts a cloud of medicinall afflications, and wholsome corrections upon us. ... that man, who through his owne *red glasse*, can see Christ, in that colour too, through his own miseries, can see Christ Jesus in his blood, that through the calumnies that have been put upon himself, can see the revilings that were multiplied upon Christ, that in his own imprisonment, can see Christ in the grave, and in his owne enlargement, Christ in his resurrection, this man ... beholds God... (4: 174–175)

261–274, and Donald M. Friedman, "Memory and the Art of Salvation in Donne's Goodfriday Poem", *English Literary Renaissance* 3, no. 3 (1973): 418–422.

The reference to the "red glass" here, drawn from Nicholas of Cusa's *De Visione Dei*,[32] while still used in the context of man's vision of God, is given a much more Christological focus, just as the language of the opening sentence here, so reminiscent of the mystical darkness of Pseudo-Dionysius and Nicholas of Cusa, quickly resolves itself into the idea of darkness as affliction. As in "The Crosse", a visual metaphor explaining the mystical project of going beyond human knowledge in order to see God is subtly altered to acquire a much more Christological perspective. While for Cusanus the image illustrated the way in which, just as the "bodily eye, looking through a red glass, judges as red whatever it sees", or can visualise God only in human terms, the "red glass" in Donne's sermon is adapted to signify the passion and blood of Christ. Mystical theology continues to provide Donne with metaphors and analogies that feed into his fascination with how we see the world and try to see God. The insistence of mystical writers such as Pseudo-Dionysius and Nicholas of Cusa that we have to move beyond the material is well adapted to the Reformation climate of suspicion of idolatry. But in the cases of both the Dionysian statue and the Cusean red glass Donne transposes the mystical metaphor in such a way that is at once more human and rooted in the theology of the incarnation.

While the language of crosses and afflictions used here strongly echoes "The Crosse", Donne goes on in the passage immediately following to develop the sight of "Christ Jesus in his blood" into a vision of God that has many linguistic and thematic parallels with "Good friday", including an explicit reference to the hidden God of Exodus 33:23:

> he hath manifested himselfe to me in his Sonne, being mounted, and raised by dwelling in his Church, being made like unto him, in suffering, as he suffered, I can see round about me, even to the *Horizon*, and beyond it, I can see *both Hemispheres* at once, God in this, God in the next world too. I can see him, in the *Zenith*, in the highest point ... and I can see him in the *Nadir*, in the lowest dejection; I can see him in the *East,* see how mercifully he brought the *Christian Religion* amongst us, and see him in the *West,* see how justly he might remove that againe... I can see him in all angles, in all postures; ... *Abraham* saw God *coming* [to him]; *Moses* saw God *going,* his glory passing by; he saw *posteriora*, his *hinder parts*; so I can see God in the memory of his blessings formerly conferred on me. (4: 175)

The way that this passage situates the crucified Christ visually in space, in the Zenith and the Nadir, in the East and in the West, parallels it both iconographically and linguistically with "Good friday". In the poem, the

[32] See Chapter 2, pp. 65–67.

speaker contemplates the cross through a series of questions, an approach that is apophatic in the rhetorical as well as the theological sense:

> Could I behold those hands which span the Poles,
> And turne all Spheres at once pierc'd with those holes?
> Could I behold that endless height, which is
> Zenith to vs...?" (ll. 21–24)

In the sermon, however, Donne confidently asserts, "I can see him, in the *Zenith* ... I can see him in the *East* ... and see him in the *West* ... I can see him in all angles." Poem and sermon, though, come to the same point, asserting that the sight of God is to be found in the memory. In the poem this is what resolves the problem of not seeing, or of looking in the wrong direction: "Though these things as I ride bee from mine eye, / They'are present yet vnto my Memorie" (ll. 33–34). And in the sermon the realisation that "I can see God in the memory of his blessings formerly conferred on me" is directly paralleled with the hidden revelation of Exodus 33.23. Like Luther in his twentieth thesis, Donne quotes the Vulgate's "*posteriora*", translating it himself as "hinder parts": "*Moses* saw God *going*, his glory passing by; he saw *posteriora*, his *hinder parts*; so I can see God in the memory of his blessings."

This paralleling of Moses's vision of God's hinder parts and God as seen in the memory of his blessings may be related to the theory, to be found in the writings of Galen and Avicenna, that the memory is anatomically located in the rearmost chamber or "ventricle" of the brain.[33] Donne himself refers to this tradition when he preaches on memory in his "Sermon of Valediction at my going into Germany" on April 18, 1619, another of the sermons that contains imagery drawn from Nicholas of Cusa's *De Visione Dei*: "Remember therefore, and remember now, though the Memory be placed in the hindermost part of the brain, defer not thou thy remembring to the hindermost part of thy life, but doe that now *in die*, in the day, whil'st thou hast light" (2:235). The association of the memory with the hinder parts (of the brain, of God) helps to resolve what might seem to be a contradiction in Donne's Good Friday poem. Although a Lutheran interpretation of Exodus 33:20 implies that the only way to approach God would be through the contemplation of Christ's suffering on the cross, the speaker of "Good friday" seems to turn away from a Lutheran theology of the cross as he shies away from the Crucifixion, "glad [not to] see / That Spectacle, of too much weight for mee" (15–16). But if we read the poem in the light of the Hanworth sermon and the revelation that looking backward in time, into

[33] See Andrew Hiscock, *Reading Memory in Early Modern Literature* (Cambridge: Cambridge University Press, 2011), pp. 28–30; p. 183.

the memory, may be equated to Moses looking at God from behind, then the speaker's convoluted refusal to look at the scene of the Crucifixion reveals a new understanding of the *Deus absconditus*. The memory represents the *posteriora Dei* and it is there that the sight of Christ's passion is located.

This apparent reversal of the Lutheran contemplation of Christ crucified and the replacement of the eye by the memory is illustrated by the almost chiasmic structure of line 35. The lack of a perfect chiasmus, in fact, shows the imperfection of sinful man's attempt to contemplate God. The act of looking is strangely deferred: "that" (his memory) looks towards "them" ("these things", images of God). God's gaze is much simpler and more direct: "*thou* look'st towards *mee*", and yet the speaker seems to be in some doubt as to whether God will "know" him (l. 42).

Donne's reinterpretation of Exodus 33:23 is marked by a pointed reversal of the dynamics of the Exodus verse: whereas God showed Moses his back, in the poem it is the speaker, the sinner, who turns his back to God "to receiue / Corrections" (ll. 37–38), asking the Saviour to "Burne off my Rusts, and my deformitye, / Restore thine Image" (ll. 40–41). This corrective and corrosive action of the crucifix at the end of "Good friday" can be directly paralleled with the application of the cross to the person of the sinner to remove "what hid Christ in thee" in "The Crosse" (l. 35). The negative, erasing action of the cross in both poems is ultimately positive, creative like the sculptor's tool as it restores the *imago Dei*.

THE "PICTURE OF CHRIST CRUCIFIED"

Donne's balanced approach to the question of images in both of these poems is characteristic of his negotiation between the extremes of idolatry and iconoclasm which is to be found in both his sermons and his poetry. Writing as he was in a society that found the material image highly suspect, one of his apophatic moves in both "The Crosse" and "Good friday" is to replace the crucifix as a material devotional image with an internal crucifix that works on man to reveal the image of God within him. Both poems confront the potentially idolatrous status of the crucifix as a visual work of art, and redeem or rehabilitate it. In both cases the crucifix is internalised, but despite this process of internalisation the two crosses do not lose their associations with the material, physical world of the visual artwork. The very idea of an internalised image of the Crucifixion itself also has Lutheran echoes, as Luther evoked an internal crucifix in his anti-iconoclastic pamphlet *Wider die himmlischen Propheten, von den Bildern und Sakrament* (1525) (Against the heavenly prophets in the matter of images and sacraments). Many of Donne's sermons preaching

moderation on the question of images use language that suggests he is advocating a Lutheran approach to images.

In his 1627 sermon on Hosea 3:4 preached at Paul's Cross, Donne lays out his balanced approach to the image question. He cites Calvin, who argues that (in Donne's words), "where there is a frequent preaching, there is *no necessity* of pictures" but qualifies this with "but will not every man adde this, That if the true use of Pictures bee preached unto them, there is *no danger* of an abuse". He continues:

> And since, by being taught the right use of these pictures, in our preaching, no man amongst us, is any more enclined, or endangered to worship a picture in a Wall or Window of the Church, then if he saw it in a Gallery, were it onely for a reverent adorning of the place, they may bee retained here, as they are in the greatest part of the *Reformed* Church, and in all that, that is *properly Protestant*. (7: 432)

Louis Martz argues that Donne is using the term *Protestant* here "with strict etymological, legal and historical accuracy to designate the Lutherans, the original *protestantes*". He parallels this instance of Donne's use of the word with the lines from Satyre 3, some twenty years previously: "To'adore, or scorne an Image, or protest, / May all be bad" (ll. 76–77). Here too, Martz claims, Donne is using the very precise definition of the term "protest". He continues:

> As the *OED* explains, "in the sixteenth century the name *Protestant* was generally taken in Germany by the Lutherans, while the Swiss and French called themselves *Reformed*". [...] Here Donne is treating the *Reformed* Church as larger than strict Calvin and distinguishing the *Reformed* from the Lutheran – those *properly* called *Protestant*, who retained much of the old imagery and ritual.[34]

Elsewhere in the *Sermons* Donne uses the terms Reformed and Protestant more loosely, for example in another 1627 sermon where he speaks of practices "in the *Reformed* Churches, in both sub-divisions, Lutheran and Calvinist" (8: 105). However in the particular sermon on images, where Reformed and Protestant appear in the same sentence and are contrasted, it seems legitimate to read them as Martz suggests. It is also worth noting that on both the occasions that Donne seems to use *Protestant* to mean Lutheran, he is discussing images.

[34] Louis M. Martz, "Donne, Herbert and the Worm of Controversy", in *Wrestling with God: Literature and Theology in the English Renaissance: Essays to Honour Paul Grant Stanwood*, ed. by Mary Ellen Henley and W. Speed Hill, *Early Modern Literary Studies*, Special Issue 7 (2001): 1–28 (pp. 22–23).

Donne's ambivalence in these sermons in many ways echoes that of Luther himself. For while Luther had condemned the abuse of images, particularly in the context of the system of patronage whereby wealthy donors were rewarded with indulgences, he took great exception to a spate of iconoclasm that took place in Wittenberg in January and February 1522, and Karlstadt's continuing iconoclastic preaching in the following years. In early 1522, while Luther was still in the Wartburg, the castle where he went into hiding following his excommunication, there was an outbreak of iconoclasm in Wittenberg (and in Eilenburg) that was legitimated by a council order stating that images and altars should be removed from churches. Luther returned from his exile in time to halt the worst excesses of iconoclasm,[35] and preached a series of anti-iconoclastic sermons, eventually published the pamphlet *Wider die himmlischen Propheten* (1525).

In "The Crosse" and "Good friday" we saw Donne engaging with contemporary anxieties about image worship while using visual and physical metaphors to insist on the material, corrective effects of the cross working within the heart. A similar interaction of image and iconoclasm animates his Holy Sonnet "What if this present were the world's last night", and this poem too can be read in the context of Luther's theology of the cross and his writings on iconoclasm. Specifically, *Wider die himmlischen Propheten*, with its evocation of a crucifix in the heart, sheds some light on the "picture of Christ crucified", "marked in the heart" in Donne's highly complex sonnet, and helps to situate it at the centre of the English iconoclastic controversy.

The sonnet starts not with the Crucifixion but with the thought of the Last Judgement:

> What if this present were the worlds last night?
> Mark in my hart Ô Soule where thou dost dwell,
> The Picture of Christ crucified, and tell
> Whether that countenance can thee affright… (ll. 1–4)[36]

The vertical juxtaposition of "the worlds last night" with "the Picture of Christ crucified" evokes the traditional pairing of the Crucifixion with the Last Judgement in the rood screens of pre-Reformation churches, very few of which survived the iconoclasm of the sixteenth century. Diarmaid MacCulloch opens his study of the Reformation in Europe with an example

[35] See Sergiusz Michalski, *The Reformation and the Visual Arts: The Protestant Image Question in Western and Central Europe* (London and New York: Routledge, 1993), pp. 17–31; Koerner, *Reformation of the Image*, pp. 159–164.

[36] Holy Sonnet 9, Revised Sequence, Stringer *et al.*, eds., *Variorum 7.1: Holy Sonnets*, p. 25.

of one such rood screen, the Wenhaston Doom in Suffolk (fig. 4),[37] which proves curiously appropriate as an introduction to Donne's sonnet. St Peter Wenhaston's surviving early sixteenth-century tympanum showing the Last Judgement is vividly coloured, and would have filled the top of the chancel arch of the church. The great rood, or crucifix, which would more often have hung below the Judgement tympanum, was in this case superimposed on it. MacCulloch focuses on this particular example because of the iconoclasm it endured and, incredibly, survived. The Wenhaston image was defaced in the 1540s and the rood and the figures surrounding it ripped off, but the outlines of the crucifix and the figures of Mary and John are still clearly visible as blank spaces on the doom painting which would have been behind them, both present and absent in the image.[38] Paradoxically, the iconoclasm of the 1540s also ensured the preservation of the partial image, since the doom painting was whitewashed over and replaced with the royal coat of arms. It stayed in this state until the discovery of the underpainting during the renovation of the church in 1894.

Like the ghost of the crucifix in the Doom painting, the crucifix in Donne's sonnet is poised between image and iconoclasm, between material object and memory. As in "The Crosse" and "Good friday", the vocabulary of the poem insists on the physical characteristics of this "*Picture* of Christ crucified", at the same time as "marking" it as an internal image in the speaker's heart. The description of the crucifix in the octave insists on the physical characteristics of the "picture", while the first line of the sestet introduces the notion of "Idolatrie" (l. 7), and the concluding line, "This beauteous forme assures a pitious minde" (l. 14), seems to privilege the visual form, rather than the word, as evidence. The sestet's vocabulary of beauty and idolatry offers a key to reading the sonnet as a whole. While the very use of the term idolatry calls images into question, and raises the spectre of iconoclasm, it is not the picture of Christ crucified that is the most immediately controversial image. The crucifix is summoned up in order to counter the image of the Last Judgement that opens the sonnet. For the speaker of this sonnet, it is the Judgement, rather than the crucifix, that is problematic. The sonnet opposes two conflicting images of Christ, Christ Judge and Christ-Redeemer, which, it seems, are not only incompatible but locked in conflict.

The impression of a potentially idolatrous image in the heart resonates with much of the rhetoric for and against images in the 1520s in Wittenberg. Much debate focused on whether idolatry was located in the eye or in

[37] Diarmaid MacCulloch, *Reformation: Europe's House Divided 1490–1700* (Harmondsworth: Penguin, 2004), pp. 6–7.
[38] St Peter Wenhaston http://www.suffolkchurches.co.uk/wenhaston.html.

the heart. Luther stated in 1529 that images were not the problem, because true idolatry was in the heart, not in the eye: "vera idolatria est in corde" (WA, 27, p. 586), while the iconoclast argument can be summed up in the words of Zwingli, "ab Auge, ab Herz": once images were removed from the eye, they would be removed from the heart. In *Wider die himmlischen Propheten*, Luther reproached Karlstadt with removing images from the eye but not from the heart, and, in a passage with many similarities to Donne's "What if this present", he argued that it might be natural to have an image of Christ in our hearts, and therefore why should it be a sin to have such an image before our eyes?

> So weys ich aus gewiss, das Gott wil haben, man solle seyne werck hören und lesen, sonderlich das leyden Christi. Soll ichs aber hören odder gedencken, so ist myrs unmüglich, das ich nicht ynn meym hertzen sollt bilde davon machen, denn ich wolle, odder wolle nicht, wenn ich Christum hore, so entwirfft sich ynn meym hertzen eyn mans bilde, das am creuze henget, gleich als sich meyn andlitz naturlich entwirfft yns wasser, wenn ich dreyn sehe. Ists nu nicht sunde sondern gut, das ich Christus bilde ym hertze habe, warumb sollts sunde seyn, wenn ichs ynn augen habe?

> [I know for certain that God desires that one should hear and read his work, and especially the passion of Christ. But if I am to hear and think, then it is impossible for me not to make images of this within my heart, for whether I want to or not, when I hear the word Christ, there delineates itself in my heart the picture of a man who hangs on the cross, just as my face naturally delineates itself on the water, when I look into it. If it is not a sin, but a good thing, that I have Christ's image in my heart, why then should it be sinful to have it before my eyes?][39]

There is no evidence that Donne read this passage by Luther, particularly since it does not seem to have been translated into Latin or English in the sixteenth century, but Luther's idea of the inner crucifix became "canonical" and widely disseminated in Lutheran circles.[40]

Donne's internal crucifix resembles Luther's in many ways. Both have a highly ambivalent status. Luther's crucifix is explicitly inspired by the word, by his hearing the word "Christ". In the hierarchy of words and images, words clearly come first, although the two are "naturally" connected. Words, once internalised, become pictures, but, as Luther makes clear, there is no question of will or agency on the part of the listener: "whether I want to or not, when I hear the word Christ, there delineates itself in my heart the

[39] WA, 18, p. 83; translation LW 40: 99–100.
[40] Koerner, *Reformation*, p. 56.

picture of a man who hangs on the cross ..." Joseph Leo Koerner discusses Luther's use of the verb *entwerfen* (to delineate) "to name this generation of pictures by words". The verb was generally used in Middle and Early New High German to refer to an artist's preliminary sketch. Luther's reflexive use of the verb highlights the idea that the listener does not consciously visualise the image of the crucifix; it "delineates itself" (*entwirft sich*). Koerner deconstructs the word to suggest that since *entwerfen* derives from the verb *werfen* (to throw), *entwerfen* might be associated with the Latin *proicere* (project, literally to throw forward). Thus "Christ's picture 'projects itself' in the heart in the way an object casts a shadow. Automatically, as if due to natural conditions, words generate pictures".[41] Yet Koerner's deconstruction of *entwerfen* reveals an uncertainty regarding the genesis of the internal crucifix which Luther's use of the word *natürlich* sought to dispel. Luther's image of the man on the cross is curiously suspended between the reflected and the projected, the natural and the created.

The status of Donne's image is equally conflicted, and this ambiguity centres on the verb "mark" which begins the second line of the sonnet. The persona instructs his "soule" to "mark in [his] heart ... the picture of Christ crucified". Earlier manuscript versions have a variant of this line: "Looke in my heart, O Soule...", and the Variorum edition of the Holy Sonnets attests that "mark" is an authorial correction.[42] While the earlier "looke in my heart", with its echoes of Sidney's *Astrophel and Stella*,[43] denotes quite simply the contemplation of the crucifix (already a problematic act), the change to "mark" opens up other connotations. For while "mark" may indeed mean "to take notice of mentally; to consider; to give one's attention to" (OED) in the sense of "mark well", the word also has the sense of "making a mark on something by drawing, stamping, branding, cutting, staining, etc". (OED). These two potential meanings of "mark" give two opposed interpretations of the status of the image in the persona's heart: either the picture of Christ crucified is already there and the soul is merely being instructed to meditate on it, or the soul actively inscribes the image in the heart. Yet another meaning of the word "mark" may further complicate the sonnet: an older denotation in the OED has "to make the sign of the cross upon (a person, a person's heart, forehead, etc.)". The connotations of "mark" then range from mental contemplation to the very physical actions of stamping, branding and cutting. The change from "look" to "mark" suggests that the act of looking at images contains within it the possibility of making images.

[41] Koerner, *Reformation*, p. 161.
[42] Stringer *et al.*, eds., *Variorum 7.1: Holy Sonnets*, p. 88.
[43] "Foole, said my muse to me, looke in thy heart and write", Philip Sidney, *Astrophel and Stella* in *The Countesse of Pembrokes Arcadia, Written by Sir Philip Sidney Knight* (William Ponsonbie, 1598), pp. 519–569 (p. 519).

As with Luther's argument that the formation of a mental picture justifies the contemplation of an actual picture, here the mental image evokes the existence of a physical crucifix.

Very different critics of this sonnet have reacted to the physicality of the description of the crucifix by picturing a physical crucifix and indeed situating it in a particular school of art. Stevie Davies reads this particular sonnet as an example of Donne's "mannerist perspective [...] contracting the conflict of the Passion into one line". Her identification of Donne with the Baroque and Mannerist tradition echoes R. V. Young's suggestion that Donne's "graphic image of the Crucifixion suggest[s] a Spanish baroque painting", and his proposal of a contemporary "visual analogue" in Velázquez's *Christ on the Cross* (1599–1600).[44] The association with the baroque relates directly to the sonnet's insistence on both the "beauteous forme" and the suffering body of Christ. The blood and tears of the crucified Christ function as the subjects of the verbs "fills" (l. 6) and "quench" (l. 5) respectively, and these physical details become particularly important when we consider that Donne's crucifix is raised in the second line of the sonnet as a preferable alternative to the image of the Last Judgement, which was evoked in the first line with the phrase "the worlds last night". The introduction of the crucifix challenges the authority of the image of Christ as Judge, causing the speaker to demand "whether that countenance can thee affright?" The following lines move between iconographic details of Christ's face in both Crucifixion and Judgement, from the "tears in the eyes" of Christ crucified to the "amazing light" in the eyes of the Judge; from the bloody brow of the suffering Christ to the frown of the Judge; from the condemnation of the Judge to the forgiveness of the Saviour. Christ's "countenance" is divided into two, and the speaker of the sonnet oscillates between these two, apparently incompatible, faces of Christ.

Like his internal crucifix, Donne's simultaneous attraction to and rejection of Judgement has parallels in Luther's writings. Luther repeatedly objects strongly both to the iconography and the doctrinal implications of the Last Judgement. He evokes the rainbow, the lily and the sword of judgement paintings, only to argue that these constitute a false view of Christ.[45] Luther rejects the fear that the Last Judgement was intended to instil in the faithful, and argues that if we have faith, we have no need to fear Christ (WA, 47, p. 102). Salvation, according to Luther, can only be achieved through Christ and the cross, and therefore Judgement, which implies the

[44] Stevie Davies, *John Donne* (Plymouth: Northcote House, 1994), p. 25; Young, *Doctrine and Devotion*, pp. 24–25.

[45] WA, 8, pp. 677–678; WA, 33, pp. 538–539; WA, 45, p. 482, and in many other places. For an anthology of Luther's remarks about the iconography of the Last Judgement, see Hans Preuss, *Martin Luther der Kunstler* (Güttersloh, 1931), pp. 35–37.

weighing of men's acts and works during their lives, is part of the older system of belief which must be rejected. Luther approves of the Gospel of John, particularly the verse "For God sent not his Son into the world to condemn the world; but that the world through him might be saved" (Jn 3:17), and comments that indeed man should not regard Christ as a Judge or a terrible Lord, but rather as a Saviour and a friend (WA, 48, p. 135). In another commentary on John's Gospel, Luther states: "therefore you must have a picture of Christ that is different from the one you were taught; you must not look upon him as a judge ... No, if you have sinned, He is the Light of the World and judges no-one" (LW, 23, p. 337).[46] We must, Luther says, find another mental picture of Christ to replace the image of Christ in Judgement that we have inherited from the Papacy. And in a sermon preached in 1519 on "preparing to die" Luther states that Christ on the cross prepared himself as "*ein dreyfeltig bild*" (a three-fold picture) for us, with which we could drive out the "*gegen bild*" (counterpictures) of death, sin and hell, all of which Luther associated with the Last Judgement (WA, 2, p. 691; p. 695; LW, 42, p. 106; p. 111).

Luther's language here suggests the idea of images in competition with each other: the good image of the Crucifixion can counter its opposite, the image of death, sin and hell united in the Last Judgement. A very similar process takes place in Donne's sonnet, as the image of Christ in Judgement is replaced by its opposite, the "Picture of Christ crucified". The last two lines of the octave explain the doctrinal problem behind the iconographic confusion: how can Christ both condemn and forgive? How can Saviour and Judge be the same person? Luther's objection to the iconography of the Last Judgement was that anyone who truly had faith had nothing to fear from Judgement, because salvation could only be achieved through faith in Christ. By establishing the Lutheran image of the internal crucifix in his heart, the speaker of this sonnet attempts to place all his faith in the salvatory power of the Crucifixion, and in doing so, to blot out his fear of Judgement.

Although in the first three lines of the sonnet there is a clear distinction between two different images – "the worlds last night" and "Christ crucified" – from line 4 onwards, they begin to merge. It is difficult to distinguish which "countenance" (l. 4) is being described, as iconographic details from the picture of Christ crucified are superimposed on those of Christ in Judgement in the space of single lines. The tears of Christ crucified "quench" the light from the eyes of Christ in Judgement; the blood from the

[46] "*Darumb bilde dir Christum anders fur, denn sie gelereret haben, nicht als einen Richter [...] sondern hast du gesundiget, so ist er das Liecht der Welt, er richtet niemand*" (WA, 33, p. 542).

wounds of the Saviour "fills" the frowns of the Judge. The image of Christ the Judge is extinguished and smoothed out by the physical effluence from the body of Christ crucified. In a sonnet which explicitly evokes "idolatrie" and the iconoclastic controversy, the image of Christ Judge is erased by the image of Christ Saviour. The picture of Christ crucified, itself the victim of so many iconoclastic attacks, here performs an act of iconoclasm, effacing – or even defacing – the image of the "worlds last night". The image of Christ's divinity is replaced by Christ's humanity. The ambiguity surrounding the word "mark", however, means that it remains unclear whether this internal iconoclasm is an action willed by the speaker of the poem, or whether he is merely the witness of it.

THIS BEAUTEOUS FORME

Koerner points out the irony inherent in the iconoclastic defacement of the crucifix. He argues that the crucifix is itself already an image of defacement, and the emphasis laid on the scourging and piercing of the body of Christ in meditations on the Passion foreshadows the defacement of the crucifix by the iconoclasts.[47] Passion plays rigorously re-enacted Christ's flagellation and torture, and in some pre-Reformation Crucifixion images it is difficult to distinguish the body of Christ behind the blood that covers it. The blood of Christ already serves to hide his body from view, rather as, in our sonnet, the blood of the crucified Christ serves to fill in and smooth out the frowns of Christ the Judge. The final effect of the practice of affective piety, "this exercise of achieving a mental picture of the ruination of a body" was, in Koerner's words, "the recognition that what we end up seeing, in our head, in the painting, is also everything Christ is *not*".[48] In other words, Christ's divinity is concealed by the extreme humanity of his Crucifixion, the humility and the ugliness of it. As prophesised in Isaiah, "he hath no form nor comeliness, and when we shall see him there is no beauty that we should desire him. He is … a man of sorrows, and acquainted with grief" (Isa. 53: 2–3).

The verse from Isaiah contextualises, but also problematises, Donne's language in the sestet of the sonnet and particularly its closing lines. The "beauteous forme" of the last line seems to deliberately counter the man of sorrows verse, with its insistence that Christ will have "no form … no beauty". Critics have dealt with this by claiming that the beauty of the last line refers to the "ethical beauty" of Christ's act of redemption, in which

[47] Koerner, *Reformation*, p. 109–111.
[48] Koerner, *Reformation*, p. 126.

the "event becomes beautiful".⁴⁹ We might, though, be tempted to read the "beauteous" Christ of the last line as the Christ Judge, revealed in glory. It may have been temporarily erased, or concealed, by the picture of Christ crucified in the octave, but at the end of the sestet, Christ's divine beauty seems to reassert itself. It is as if the act of iconoclasm attempted in the octave, the erasure of Christ Judge by Christ crucified, has not entirely succeeded. If the erasure of the octave worked by superimposing the picture of Christ crucified on top of the picture of Christ Judge, concealing but not destroying it, perhaps the two overlaid pictures can be seen as a kind of palimpsest. The scene of Judgement and Christ's divine beauty are temporarily concealed, but in time begin to show through again, the "amazeing light" once more penetrating the mess of blood and tears which obscured it.⁵⁰

However this reading is not entirely satisfactory because it does not take into account the other elements in the sestet that further complicate the images of the octave. The sestet has proved consistently problematic for critics, partly because of the intrusion of Donne's "profane mistresses" into the sacred territory of the sonnet, and partly because of an uneasiness regarding the logic of the context in which they appear. The argument that emerges from Donne's tortured syntax uses an analogy from the profane world to assuage his spiritual doubts. Donne's persona used to flatter and seduce his mistresses with the argument that a beautiful woman would take pity on her lover and succumb to his advances, while a less beautiful woman would maintain an unfeeling "rigour". The spurious logic of this then appears to be transferred to the contemplation of the image of Christ: "so I say to thee" the persona addresses (presumably) his soul, "To wicked spirits are horrid shapes assign'd / This beauteous forme assures a piteous minde." It is the unhelpful juxtaposition of the profane and the sacred in the sestet, as well as its faulty logic, that has caused such a strong critical reaction. Martz finds the sonnet's sestet "unworthy of [the] opening: the

⁴⁹ Doniphan Louthan, *The Poetry of John Donne: A Study in Explication* (New York: Bookman Associates, 1951), p. 122; Paul W. Harland, "'A True Transubstantiation': Donne, Self-love, and the Passion", in *John Donne's Religious Imagination: Essays in Honor of John T. Shawcross*, ed. by Raymond-Jean Frontain and Frances M. Malpezzi (Conway, AR: UCA Press, 1995), pp. 162–180 (p. 167).

⁵⁰ Catherine Gimelli Martin also sees a "palimpsest" in this sonnet, although for her it is "a two-sided scroll or palimpsest reflecting the two opposing images of God: on the one side beauty and pity, on the other duplicity and death". "Unmeete Contraryes: The Reformed Subject and the Triangulation of Religious Desire in Donne's *Anniversaries* and *Holy Sonnets*", in *John Donne and the Protestant Reformation*, ed. by Mary Arshagouni Papazian (Detroit: Wayne State University Press, 2003), pp. 193–220 (p. 209).

reference to 'all my profane mistresses' is in the worst of taste: there is almost a tone of bragging here", and Richard Gill, too, comments on the possibly "boastful" recollections of his profane mistresses.[51] John Carey goes further, describing the sestet as "blasphemous" and continuing:

> He contemplates the Saviour's bloody face, and searches for some argument that will assure him of salvation. But all he can find among the dazed, licentious thoughts that have become habitual to him is the hideous piffle about pity and pretty faces which the last six lines throw up.[52]

The perceived bragging and blasphemy of the sestet, however, do not invalidate the power of the octave. The mention of the mistresses, and particularly their qualification as "profane", has the effect of bringing the sonnet firmly back down to earth and reminds us that the word "beauty" may be used in many contexts.

The whole sonnet has been following a downward trajectory, in a sense, from the "last night" suspended above the Crucifixion as in a pre-Reformation church, through the increasingly human and bloody depiction of the crucified Christ. Coming immediately after the octave's images in conflict, the mention of "idolatrie" in line 9 reinserts us in the iconophobic context of Donne's time with a pertinent reminder of the potential result of relying too strongly on "pictures". This is followed by the dissonance caused by the introduction of the profane mistresses and the "piffle" of the speaker's spurious analogy, which forcefully reminds us of physical, worldly beauty and its effect on the sinful self. The evocation of idolatry and of the mistresses combined have the effect of calling into question the meaning of the word "beauty" at the same time as the syntax of the poem leaves the reader in some doubt as to whose mind is "piteous". Thomas O. Sloane points out that, depending on how we understand the word "piteous", the "piteous minde" could belong to the speaker or the reader as much as to Christ: "'Piteous' means both full of pity, or compassionate (in which case the 'minde' is Christ's), and pitiful, or moving to compassion (in which case the 'minde' is the speaker's, and ours)".[53] For Paul W. Harland, "because the speaker is able to identify the Crucifixion as 'beauteous,' he demonstrates his own 'piteous mind.' The reader is thus able to recognise the transformation that has taken place in the speaker."[54] If the referent of "piteous minde" is thus uncertain, so too is that of the "beauteous forme", which by this

[51] Martz, *Poetry of Meditation*, p. 84; Richard Gill, *John Donne: Selected Poems* (Oxford and New York: Oxford University Press, 1990), p. 10.
[52] Carey, *John Donne*, p. 47.
[53] Thomas O. Sloane, *Donne, Milton, and the End of Humanist Rhetoric* (Berkeley : University of California Press, 1985), p. 206.
[54] Harland, "True Transubstantiation", p. 167.

point could refer to Christ in judgement, or Christ crucified, to the "profane mistress" or, arguably, to the speaker himself.

The speaker is, in Harland's term, "transformed" by the action of the "picture of Christ crucified" within his heart. Like the cross as sculptor's chisel, "work[ing] fruitefullye / With in our Harts" (Crosse, ll. 61-62), the crucifix here, too, works correctively within the heart to "take what hid Christ in thee" (Crosse, l. 35). In "The Crosse" Donne played with the potentially destructive or erasing capabilities contained within both the name and the simple form of the cross. In "What if this present" that logic is extended to the defacement that is already contained within the image of the crucified Christ. The blood that fills and the tears that quench are the aspects of the "picture" that performed the "erasure" or "iconoclasm" in the octave of the sonnet, and these are the same elements that appeal to affective piety and provoke pity in the spectator. The "picture of Christ crucified" effaces the image of the judging Christ in glory, but the ultimate effect of this act of erasure, as in "The Crosse" and "Good friday", is on the heart of man himself. The contemplation of the Crucifixion generates the pity that works within man to reveal the hidden beauty of the *imago Dei* in his heart, "burn[ing] off ... rusts and ... deformity" in order to "restore thine Image" (*Goodf*, ll. 40-41). In this sense, the "beauteous forme assures a piteous mind".

In all three of these poems Donne restores the crucifix as the central, inevitable and active focus of the Christian faith. Just as the speaker of "The Crosse" sees crosses everywhere, so Donne seems to be able to find, in widely different sources, language and imagery that reinforces his vision. The lexical fields of church-worship, of negative theology, and of Luther's theology of the cross come together to support his celebration of the Crucifixion. All of these poems stage a cross that is in some way difficult to look at, described in language that recalls the context of iconoclastic controversy. But Donne does not turn away from visual culture in order to reinstate the cross. Although his crosses work internally – in the heart, in the memory – they acquire their power from his appropriation of the vocabulary of both image worship and iconoclasm to describe their effects. The crucifix, as Koerner puts it, is already an image of defacement. The cross is formed by one line striking out another. It is precisely this paradoxical and oppositional energy that Donne draws on to construct his crosses, transforming the doubt and anxiety attached to a contested material icon into a powerful affirmation of the cross as a dynamic force working to reveal the divine image in man.

Chapter 5

JUDGEMENT

> Truly, the *Creation* and the *last Judgement*, are the *Diluculum* and *Crepusculum*, the *Morning* and the *Evening* twi-lights of the long day of this world. Which times, though they be not utterly dark, yet they are but of uncertain, doubtfull, and conjecturall light. ... the birth of the world [is] more discernable than the death, because upon this God hath cast more clouds...[1]

Like "La Corona", Donne's sequence of Holy Sonnets seems to invite comparison with visual art, and Louis Martz finds the sonnets exemplary of the "graphically imaged openings" that he considers characteristic of the metaphysical poets.[2] Looking forward to the end of time and the moment of the Last Judgement, the sequence is read by Helen Gardner as a "meditation designed to deepen religious fear" completed by a "meditation to awaken love".[3] The sonnets explicitly devoted to the last things, which Gardner describes as the "core" of the sequence, receive particular mention from Martz, as he evokes "those grand and passionate openings ... where the moment of death, or the Passion of Christ, or the Day of Doom is there, now, before the eyes of the writer, brought home to the soul by vivid 'similitudes'".[4] For Martz, as for Gardner, these "vivid similitudes" derive from the prescribed pattern of meditation in the *Spiritual Exercises* of St Ignatius of Loyola (1548), with its insistence on clearly visualising the object of meditation.[5] But as in "La Corona", the apparent invitation to read the

[1] Simpson, ed., *Essays in Divinity*, p. 19.
[2] Martz, *Poetry of Meditation*, p. 31.
[3] Gardner, ed., *Divine Poems*, p. xlii.
[4] Martz, *Poetry of Meditation*, p. 31.
[5] Martz, *Poetry of Meditation*, pp. 43–53; Helen Gardner, "Introduction", *Divine Poems*, pp. l–lv. Martz and Gardner claim to have come to their conclusions regarding the "Holy Sonnets" independently almost simultaneously. Martz first developed the connection between Donne and the *Spiritual Exercises* with reference to Donne's *Anniversaries* in "John Donne in Meditation: the Anniversaries", *ELH* (1947).

sequence visually is the first step towards a much more complex reflexion on what it means to look at Judgement – or to look at all. The Holy Sonnets form a twelve-sonnet sequence, but two distinct versions of the sequence exist, and the revised version sees whole sonnets cut and added as well as some reordering of those that remain.[6] This evident authorial revision and re-thinking reflects a theme that is prominent in the sonnets themselves, the painstaking questioning and reassessment of how to approach God. Although the Revised Sequence retains the central focus on the last things, the way of approaching that final moment is literally revised.[7] In a sequence that is very concerned about what way to look, Donne makes some crucial changes to his *ways of seeing* in the later version of the Holy Sonnets, and qualifies the metaphors of seeing and visual art that characterise his imagining of the divine up in other poems. The circumscription and spatial paradox of "La Corona" are poetic and human solutions that highlight Christ's humanity and the mystery of the Incarnation. Contemplation of Christ after his death and Resurrection, and contemplation of what comes after the General Resurrection and the Last Judgement, move the representational problems Donne addresses on to a new level. In the divine poems that approach these mysteries – the Holy Sonnets but also "Resurrection. Imperfect" – the attempt to imagine Christ in glory is deferred and circumvented, and it is in the sonnet sequence that we understand most clearly the correspondences that Donne establishes between the limits of visual representation and the limits of his own, verbal, representation.

The contemplation of the cross discussed in the previous chapter already illustrates to what extent Donne insists that looking is problematic. "Most the Eie needs crossing", he writes in "Of the Crosse" (l. 49), qualifying the insistence in the first half of the poem that by looking at nature we can somehow approach knowledge of Christ. "The picture of Christ crucified" (l. 3) invoked in the Holy Sonnet "What if this present were the world's last night", as we have seen, is far from simple, and is summoned up to counter

Gardner notes that: "It was after I had come to my own conclusions on the 'Holy Sonnets' that I read the article. It was encouraging to find we had independently arrived at the same conclusion". *Divine Poems*, p. liv, n. 1. Martz for his part states "…I learned from Miss Helen Gardner that she was well advanced in the preparation of an edition of Donne's *Divine Poems*, […] and studying the order, dating, and significance of the 'Holy Sonnets' from a standpoint similar to my own". *Poetry of Meditation*, p. vii.

[6] Stringer *et al.* eds., *Variorum 7.1: Holy Sonnets*, pp. lx–lxxi. Discussed further on p. 147 ff.

[7] For Gardner, "The core of the two sets [of sonnet sequences] is the six sonnets on the Last Things (1–6 of *1633*). These appear in the same order in each set, although in Group III other sonnets are interspersed among them". *Divine Poems*, p. xlii. See further discussion this chapter, p. 147.

the even more problematic vision of the Last Judgement in the poem's opening line. The problem with the scene of Judgement is both personal and doctrinal as well as representational. The personal fear of contemplating that irreversible judgement and the doctrinal concern that salvation rather than judgement should be emphasised are brought together in the problem of how to represent that moment at all – how to represent Christ, the Judge, in glory. The representational and theological problem around depictions of Christ after his Crucifixion and death is concisely expressed by Hegel in his *Lectures on Fine Art*:

> ... the means at the disposal of painting, the human figure and its colour, the flash and glance of the eye, are insufficient in themselves to give perfect expression to what is implicit in Christ in situations like these. Least of all can the forms of classical beauty suffice. In particular, the Resurrection, Transfiguration, and Ascension, and in general all the scenes in the life of Christ when, after the Crucifixion and his death, he has withdrawn from immediate existence as simply this individual man and is on the way to return to his father, demand in Christ himself a higher expression of Divinity than painting is completely able to give to him; for its proper means for portraying him, namely human individuality and its external form, it should expunge here and glorify him in a purer light.[8]

It is the flip side of the argument put forward by John of Damascus, that the Incarnation meant that Christ could be depicted by human means, though John also acknowledged that "it is impossible to depict one who is incorporeal and formless, invisible and uncircumscribable".[9] But the moments mentioned by Hegel, when Christ is in human form, seen by the apostles and yet seen differently, pose a particular kind of representational problem. The human form and, specifically, human individuality, cease to be adequate means for representing Christ, who is "on the way to return to his Father", on a trajectory out of representatable space. The images of Christ's feet disappearing out of the top of the frame which are an iconographic staple of paintings of the Ascension may appear comic but they illustrate the point nicely – they capture the moment beyond which the pictorial space will no longer be able to contain Christ.

Hegel uses a lexicon of light – "a purer light" – to indicate the difference between the resurrected and glorified Christ and the Christ who could be represented as a simple human figure. In doing so he may be drawing on the

[8] Georg Wilhelm Friedrich Hegel, *Aesthetics: Lectures on Fine Art*, trans. T. M. Knox. (Oxford: Oxford University Press, 1975), vol 2, p. 822.

[9] St John of Damascus, *Oratio apologetica*, III, 2 (and II, 5), PG 94: p. 1320. Translation in St John of Damascus, *Three Treatises on the Divine Images*, ed. by Andrew Louth (Crestwood, NY: St Vladimir's Seminary Press, 2003), p. 82. See Chapter 2 p. 87.

description of the Transfiguration in the three synoptic gospels, where the change in Christ is described in terms of light and whiteness: "his face did shine as the sun, and his raiment was white as the light" (Matt. 17.2), though Luke also adds "the fashion of his countenance was altered" (Lk. 9.29). Light functions to blot out the body that cannot be represented visually or verbally. Donne too draws on the Transfiguration's vocabulary of light when he addresses the same representational problem, which he does in a sermon preached at Lincoln's Inn in 1620. Taking as his text 1 Cor. 15.50, he explores "*the qualities of bodies in the resurrection*", (117), and evokes the Transfiguration as a type of the Resurrection (both Christ's Resurrection and the General Resurrection), describing it as "the best glasse to see this resurrection, and state of glory in". Donne refers to St Jerome's translation in order to describe the vision of the transfigured Christ, and, although he picks up on the language of the gospels, he discusses not the appearance of Christ himself so much as the effect upon the apostles' *sight* of him:

> We content our selves with Saint *Hieromes* expressing of it, *non pristinam amisit veritatem, vel formam corporis;* Christ had still the same true, and reall body, and he had the same forme, and proportion, and lineaments, and dimensions of his body, in it selfe. *Transfiguratio non faciem subtraxit, sed splendorem additit,* says he; It gave him not another face, but it super-immitted such a light, such an illustration upon him, as, by that irradiation, that coruscation, the beames of their eys were scatterd, and disgregated, dissipated so, as that they could not collect them, as at other times, nor constantly, and confidently discerne him.[10]

Donne develops the idea of addition to something already perfect through his accumulation of light-words: light illuminating, sending out rays, sparkling. In her biography of Donne, *Super-Infinite,* Katherine Rundell makes much of Donne's use of the prefix "super-", claiming that "he loved to coin formations with the *super-* prefix: super-edifications, super-exaltation, super-dying, super-universal, super-miraculous. It was part of his bid to invent a language that would reach beyond language, because infinite wasn't enough: both in heaven, but also here and now on earth, Donne wanted to know something larger than infinity."[11] Virtually all of her examples refer to the unimaginable divine. "Super-miraculous" and "super-exaltation" come from his final sermon, "Deaths Duell", and describe the enormity of the fact that Christ must die. As in the "super-imitted" of our passage on the Transfiguration, Donne uses the prefix very precisely to indicate what is beyond description, and what might even seem contradictory – "super-infinite"

[10] Potter and Simpson, eds., *Sermons,* 3, p. 118.
[11] Katherine Rundell, *Super-Infinite: The Transformations of John Donne* (London: Faber & Faber, 2022), p. 14.

being a case in point. The Transfiguration not only adds but *super*-adds something unviewable, undiscernable, to the apostles' knowledge of Christ: "a higher expression of Divinity", as Hegel expressed it, "than painting is completely able to give to him".

In the sermon, Donne highlights that it is not that the face of Christ in glory has changed beyond recognition, rather, the change lies in the fact that it is now impossible to contemplate. His image of the "scatterd" eye-beams of the apostles is like a reversal of the lovers' eye-beams "twisted and thred[ed] upon one double stringe" in "The Ecstasy".[12] The visual and human connection between the ecstatic lovers is not possible between the apostles and Christ when they witness Him transfigured. While Donne insists on the fact that Christ manifested himself to "naturall men", he also emphasises the connection between the impossibility of seeing the transfigured Christ and the impossibility of communicating the nature of the transfigured Christ – or any resurrected body – in words:

> remember that in this *reall parable*, in this Type of the Resurrection, the transfiguration of Christ, it is said that *even Peter himself wist not what to say* [Mark 9:6]; and remember too, That Christ himself forbad them to say anything at all of it, till his Resurrection. Till our Resurrection, we cannot know clearly, we should not speak *boldly*, of the glory of the Saints of God, nor of our blessed endowments in that state. (3: 122; emphasis in original)

This shift from seeing to speaking, or rather from the impossibility of seeing to the impossibility of putting into words, is fundamental to Donne's engagement with the representation of the divine – and with representation more generally. He emphasises here that we will neither be able to *know* nor to to *speak* of Christ or the Saints in glory, or of the General Resurrection, until our own resurrection. The Transfiguration is a type of that moment, prefigures it, but it is nonetheless a "parable" of not seeing and not speaking, a moment that encapsulates the distance in understanding between *now* and *then*.

The scriptural touchstone for the opposition of human knowledge now and the knowledge of the world to come is 1 Corinthians 13:12, "For now we see through a glasse darkly, but then face to face; now I know in part, but then I shall know even as I am knowne", and Donne's description of the Transfiguration as "the best glasse to see this resurrection … in" seems to echo that famous passage. His sermon on 1 Corinthians 13:12, preached at St Paul's on Easter Sunday 1628, opens by explicating the epistemological and the temporal implications of the verse:

[12] "Extasie", ll. 7–8. Johnson *et al.* eds., *Variorum 4.3: Songs and Sonnets*, p. 106.

These two termes in our Text, *Nunc* and *Tunc*, *Now* and *Then*, *Now in a glasse*, *Then face to face*, Now in part, Then in perfection, these two secular termes, of which, one designes the whole Age of this world from the Creation, to the dissolution thereof (for, all that is comprehended in this word, *Now*) And the other designes the everlastingnesse of the next world, (for that incomprehensiblenesse is comprehended in the other word, *Then*). (8: 219)

The contraction of the span of human time into the incomprehensible moment of Judgement and Resurrection fascinates Donne, and becomes a recurrent motif in his Holy Sonnets. The word *Now* encapsulates all of human time from Creation to the end of time; this is opposed to the ungraspable, incomprehensible "everlastingnesse of the next world". These two ages, he says in this sermon, "are now met in one Day; in this Day in which we celebrate all Resurrections in the roote" (219). In preaching a sermon about the day of Judgement (when we shall see face to face, and know as we are known) on Easter Day, Donne deliberately conflates Christ's Resurrection with the General Resurrection. Christ's Resurrection is the root of all resurrections because it is the sign of redemption and it prefigures the resurrection of all flesh on the "last and everlasting day" (*Corona* 6, 14). But he also describes *Now* in more immediately graspable terms: it describes "that very act, that we do now at this present, the Ministry of the Gospell, of declaring God in his Ordinance, of Preaching his word". He tells his congregation that "now (now in this Preaching) you have some sight, and then, ... you shall have a perfect sight of all" (219–220).

Knowledge of God, described in visual terms, is transmitted, imperfectly, through the word preached, a slippage between the visual and the word that continues throughout the sermon. Although early on he states, supported by Augustine, that "sight is so much the Noblest of all the senses, as that it is all the senses" (221),[13] by the mid-point of the sermon he is celebrating the power of hearing the word of God over the dangers associated with sight: "The eye is the devils doore, before the eare: for, though he doe enter at the eare, by wanton discourse, yet he was at the eye before..." (228). The sermon places the eye-ear opposition in the context of controversy surrounding ritual in the Church:

[13] Ettenhuber identifies the source of this as Augustine's Sermon on Luke 14: 16–24, ch. 6; *PL* 38.646, in *Donne's Augustine*, p. 223, n. 60. This idea of sight englobing all the senses is one of Donne's recurring snippets in his meditations on sight in the *Sermons*: it also occurs, as Ettenhuber mentions, in his Candlemas sermon of 1627 (7: 346), and a Whitehall sermon from 1625 (6: 235–236). It also seems to be a favourite with Augustine himself: he refers to it in Chapter 10 of the *Confessions* (X. xxxv (54)). St Augustine, *Confessions*, trans. and intro. Henry Chadwick (Oxford: Oxford University Press, 1998), p. 211.

The eare is the Holy Ghosts first door, He assists us with Rituall and Ceremoniall things, which we see in the Church; but Ceremonies have their right use, when their right use hath been first taught by preaching. (228)

Donne's ambivalence about the eye, his swerving away from putting trust in the visual, is once more on display. But while the preacher's words may provide some stability and guidance in this example, words in general prove no more reliable than the visual when it comes to approaching the divine.

This idea persists throughout his works that confront the difficulty of representing – of understanding – the Resurrection: both Christ's Resurrection and the general resurrection of the Last Judgement. Anxiety about looking, about how to look, and specifically how to look at God, permeates the Holy Sonnets in ways that recall the *now in a glass; then face to face* of 1 Corinthians 13:12. Donne's only occasional poem on Christ's Resurrection can be seen as acting out the difficulty experienced by the apostles at the type of the Resurrection, the Transfiguration – "even Peter himself wist not what to say". He seems to suggest that the figurative means at the disposal of the poet will be equally insufficient as those of the painter.

RESURRECTION. IMPERFECT

"Resurrection. Imperfect", the title given to Donne's resurrection poem, has generally been understood to indicate that the poem is unfinished, an impression reinforced by the Latin tag "Desunt Cætera" (the rest is lacking) appended to it in the 1633 *Poems*.[14] More recent critics have cast doubt on this assumption though, and in various ways have suggested that the "imperfection" of the poem may be thematic and not simply textual.[15] My

[14] Only one manuscript witness (WN1) includes the subscription "*Desunt Cætera*", and this is reproduced in the 1633 *Poems* and throughout the early print tradition. Johnson *et al.* eds., *Variorum 7.2: Divine Poems*, p. 166.

[15] Ruth Falk has suggested that the additions of "imperfect" and "*Desunt cætera*" were Donne's own, and a commentary on the fact that the work begun by the Resurrection remains "incomplete, unfinished" until the end of the world and the general resurrection. "Donne's 'Resurrection, Imperfect'", *Explicator* 17 (1958), item 24. More recently, Kate Frost has persuasively argued that the poem is complete, and provided a numerological interpretation of it which can only work if "*Desunt cætera*" is counted as a numbered line of the poem as written by Donne. Kate Frost, "Magnus Pan Mortuus Est: A Subtextual and Contextual Reading of Donne's 'Resurrection, imperfect'", in *John Donne's Religious Imagination: Essays in Honour of John T. Shawcross*, ed. by Raymond-Jean Frontain and Frances M. Malpezzi (Conway: UCA Press, 1995), pp. 231–261 (pp. 250–251). Lara Crowley has argued that "*Desunt cætera*" is highly unlikely to be authorial, since it does not appear in all the manuscript versions of the poem. Lara M. Crowley, "A Text of 'Resurrection. Imperfect'", *John Donne Journal* 9 (2010): 185–198 (p. 196).

purpose here is not to determine whether the poem is unfinished, but rather to argue that, finished or not, there is an "imperfection" in Donne's Resurrection poem that is a deliberate artistic decision, reflecting an inability to come to terms with the poem's theme. This imperfection is to be found less in the poem's unfinished appearance, than in the way that its metaphors fail to hit home. Rather as in "Sappho to Philaenis" we saw a breakdown of poetic language as simile turned into tautology,[16] the successive metaphors of "Resurrection. Imperfect" seem similarly unfit for purpose. *Ut pictura poesis*: as in painting, the poem's figurative language enacts the impossibility of "giving perfect expression" to what is implicit in the Resurrection of Christ.

It is not quite clear who the speaker of Donne's poem is, but he is a potential witness of Christ's empty tomb on the morning of Easter Sunday.

> Sleep sleep old Sunne, thou canst not have repast
> As yett the wound, thou took'st on Frydaie last.
> Sleepe then and rest: the world may beare thy staie
> A better Sun rose before thee to daie. (ll. 1–4)

The advice to the sun to remain asleep irresistably recalls "The Sun Rising", as well as the sun/son pun in "Good friday". But besides the figurative significance of the sun highlighted by the pun, it is also a literal presence in most of the gospel versions: the holy women enter the sepulchre at "the rising of the sun" (Mark 16:2); "as it began to dawn" (Matthew 28:1); "very early in the morning" (Luke 24:1); cf. "when it was yet dark" (John 20:1). Donne's speaker may identify himself with the holy women as they discover the empty tomb, or may even pre-empt them, since his "old Svnne" (l. 1) is still sleeping. Yet unlike the holy women he approaches the tomb with some knowledge: he *knows* that "a better Sun" (l. 4) has risen, whereas in the gospel accounts the absence is not immediately translated into a sign of a presence. Donne's speaker then goes one step further, to attempt to imagine what the moment of Resurrection *might* have been like.

The earliest visual representations of the Resurrection highlight the problem that the gospel descriptions narrate only an absence: the discovery of the empty tomb. The simplest image of Christ's Resurrection is the symbolic Resurrection – the empty cross (*crux nuda*), and early Resurrection paintings, like medieval mystery plays, stay close to the gospels by showing the moment of the holy women's discovery of the tomb. The depiction of the Resurrection becomes more interesting – but more problematic – when painters begin to represent the actual moment of Christ's Resurrection. The problem is double-edged. On the one hand, representing Christ as

[16] See Chapter 1, pp. 46–48.

an "individual man", to return to Hegel's term, is no longer adequate since Christ's figure demands a "higher expression of divinity". On the other hand, the version of the tradition that shows a transfigured Christ, floating above the tomb, is problematic in the other direction. Christ is still wholly man and wholly God, and a representation that departs too far from the human is not acceptable either. A further detail that contradicts the gospel descriptions and poses an additional visual problem is the tradition that one of the soldiers guarding the tomb witnesses the risen Christ departing from the tomb.[17] A more nuanced version of this floating resurrected Christ which goes some way towards resolving these problems is to be found in Fra Angelico's "Resurrection" in the Convento di San Marco in Florence (1440–1441) (fig. 5). This fresco illustrates the gospel moment of the holy women finding the empty tomb, yet shows Christ floating above their heads (unseen by them) on another plane of existence, surrounded by a luminous mandorla, showing by his invisible presence what the absence of the empty tomb signifies.

Sketching out the various solutions found in visual art for the representation of the Resurrection – none of them fully satisfactory – provides a context for Donne's verbal attempt to convey the same scene. His Resurrection poem begins with the moment of discovery, but attempts to fill the empty space of the tomb with words to illustrate what that absence means. As Donne's speaker approaches the empty tomb, he turns to figurative language to illustrate that absent presence, but ultimately all of his attempts fail.

He works through three figures. The first is the opening invocation of the sun, with its inherent associations with the Son of God. In the sermon where Donne describes the Transfiguration he points out that in Matthew's gospel, the face of the transfigured Christ is described as shining like the sun (Matt 17:2), and he connects this with the General Resurrection, as Matthew's gospel also says "then shall the righteous shine forth as the sun in the kingdom of their father" (Matt 13:43) (*Sermons* 2:120). In the poem the "better Sun" (Christ) is superior to the "old Svnne", and a direct simile is established in line 8 with the contrast between the light of the sun and fire/candlelight: "As att thy presence here our fires grow pale"(l. 8). This

[17] In his *Iconographie de l'art chrétien*, Louis Réau gives a list painterly solutions to the Christological conundrum of how to represent Christ leaving the tomb: 1) Christ in the tomb ("Christus in sepulcrum"); 2) Christ with one foot on the edge of the tomb; 3) Christ in the act of stepping out, with one foot in and one out of the tomb ("Christus uno pede extra sepulcrum"); 4) Christ standing in front of the tomb ("Christus extra sepulcrum") and finally 5) Christ standing on the flat stone lid of the tomb ("Christus supra sepulcrum"). Réau, *Iconographie*, p. 545.

detail is something of a commonplace in visual art,[18] transliterated here into a somewhat flat simile, but even this flatness reinforces the impossibility of seeing, never mind representing the glorified Christ. The inadequacy of human vision, and human language, is made plain.

And so he passes to a second figure, in which the risen Christ is described using the language of alchemy. Christ becomes the philosopher's stone, the tincture which can transmute other metals to gold.[19] In Donne's poem we are told that after his entombment Christ would "for these three daies become A Mynerall" (l. 12); this seems to reference the philosophers' stone, and the following lines about gold and tincture provide a gloss of the word "Mynerall": "Hee was all Gould, when hee lay downe, but rose / All tincture" (ll. 13–14).[20] These lines can be read, as Kate Frost has read them, as a clear reference to the different stages of the alchemical process:

> In the threefold transmutative process the base matter was gradually albified by heating, dissolution, and coction. From the fire emerged the tincture, a white powder, often called the Philosopher's Gold, which imparts its whiteness to everything it is mixed with, purifying and transmuting. In spiritual alchemy, the stage of spiritual gold was achieved by union with Christ, the white tincture.[21]

The comparison between the alchemical process and redemption through Christ is not Donne's conceit; the most in-depth introduction to "spiritual alchemy" remains Evelyn Underhill's *Mysticism* (1911).[22] Yet Donne's description of Christ lying down "all Gould" and rising "*all* tincture" poses certain problems. The metaphor marks the difference between Christ's resurrected body and all other bodies. But through this figure the body becomes almost *not* a body. To be all tincture is a move towards the spiritual and ethereal, away from the physical. And a similar problem haunts the poem's third metaphor, which compares the body of the resurrected Christ

[18] See Maille S. Hutterer, "Illuminating the Sunbeam through Glass Motif", *Word & Image*, 38:4 (2022): 407–434 (pp. 424–425). The source for this imagery is probably the *Revelations* of St Bridget of Sweden.

[19] The alchemical context is explained in great detail in Frost, "Magnus Pan", pp. 239–242.

[20] The first definition of "mineral" in the OED, now obsolete, is "1. *Alchemy*. According to certain writers: that variety of the philosophers' stone which was responsible for the purification of metals".

[21] Frost, "Magnus Pan", p. 242.

[22] Evelyn Underhill, *Mysticism* (London: Methuen, 1911), pp. 140 ff. Quoting Jacob Boehme, she states: "… the indwelling Christ, the 'Corner Stone', the Sun of Righteousness, became, for many of the Christian alchemists, identified with the *Lapis Philosophorum* and with Sol … His spirit was the 'noble tincture' which 'can bring that which is lowest in the death to its highest ornament or glory'" (p. 144).

to the soul leaving the dying body. In order to do so, Donne's speaker posits a hypothetical witness to the Resurrection, which reminds us of the absence of witnesses in the gospel accounts and raises the question of the potential visualising of the Resurrection. The speaker speculates:

> *Had* one of those whose credulous Pietie
> Thought, that A Soule, one might discerne, and see
> Go from a Bodie, att this Sepulcher benn,
> Hee *would haue* Iustly thought his bodie a Soule
> If not of any Man, yett of the whole. (ll. 17–22; my emphasis)

This hypothetical witness is distanced from us by being described as "one of those", further distanced by his "credulous Pietie" (l. 17) and by the conditional framing of what he might have seen and might have believed. On one level this hypothetical witness must be wrong. If he interprets the sight of Christ's resurrected body as a soul, he misses the point of the bodily Resurrection of Christ, who remained wholly man. Like the tincture metaphor, it risks representing Christ as too ethereal. Such metaphors resemble the choice made by painters of the Resurrection to show Christ ethereally floating in the air, rather than with feet solidly on the ground.

On some level though, the poem suggests, Christ's body can be "*Iustly* thought ... a Soule" (my emphasis), because it is the only way to express the difference of Christ's glorified body from the whole body of mankind. Like the mandorla in paintings of the Resurrection and the Transfiguration, it marks the attempt to articulate that difference. This attempt to contemplate, to conceive of, Christ's resurrected body governs the three metaphors of "Resurrection, imperfect", and ultimately ends in the poem's failure (rhetorical or otherwise). The body-soul metaphor is somehow both adequate and inadequate, right and wrong, and a similar doubleness applies to all of the poem's figurative language. Metaphor is essential, because it seems we can only see or imagine Christ's body if we describe it as something else. And yet metaphor is always inadequate, because like the "eye-beames" of the apostles at the Transfiguration in Donne's sermon, the full picture is "scatterd ... dissipated", always at one remove from what we want to see.

The sun-son pun recalls that of "Good friday", where the speaker "should see a Sun by ryseing set, / And by that setting endless day begett" (ll. 11–12). Yet the eye-beams in "Resurrection. Imperfect" are going in very different directions from Donne's Crucifixion poem. In "Good friday", the speaker knows where he *should* be looking, but is unable to do so. In the Resurrection poem, he looks in the right direction, but cannot see. With the holy women, or before them, Donne's speaker approaches the empty sepulchre, and attempts to fill it with words turning absence into the sign of a living presence. At the centre of the poem, as Frost points out, are the words "fill

all" (l. 11).[23] Donne does not try to fill in the empty space with a picture of the resurrected Christ; rather, he acknowledges that it is a space, which can only be filled with attempts to imagine the resurrected Christ. But how to imagine, how to put words to, that glorified body? The space, of the sepulchre, and of the poem, is filled with three imperfect images for the body of the resurrected Christ.

THE FACE OF GOD IN THE HOLY SONNETS

If Donne's occasional poem on the Resurrection remains "imperfect", his "Resurrection" sonnet in "La Corona" sidesteps the representation of Christ's Resurrection almost entirely. Apart from the oblique reference in the phrase "Death, whom thy death slue" (6, 6), the speaker is much more concerned with imagining his own resurrection on "the last, and everlasting day" (Corona 6: 14), rather as Donne's Easter 1628 sermon on 1 Corinthians 13:12 describes "this Day in which we celebrate all Resurrections in the roote" (8: 219). The moment of the Last Judgement, just as much as that of the Resurrection, poses problems of imagination and visualisation, but, unlike the Resurrection, it is a moment that Donne revisits again and again, in his sequence of "Holy Sonnets". As discussed in the Introduction, the speaker of the Holy Sonnets appears to desire the moment of face-to-face encounter with God, the *Then* of 1 Corinthians 13:12, but also works to maintain a distance, spatially and temporally, between *Now* and *Then*. The moment of Judgement is repeatedly summoned up only to be somehow circumvented. John Carey provides a biographical interpretation of this ambivalent fascination with Judgement: "Dead, he will at last know whether or not he is saved. Though terrified by the Last Judgement, he is also impatient for it".[24] Yet Donne's ambivalence concerning Judgement need not be read only in the light of his anxiety about his own personal salvation. It also illuminates his persistent anxiety about representation. The question of salvation becomes inextricably linked with the questions of sight and representation that continue to preoccupy him. As already discussed in the context of "La Corona", the Last Judgement was often the last in a series of scenes from the New Testament, marking the final scene in the life of Christ just as it is the inevitable end of all human existence.[25] It is also the inevitable end-site of all Donne's mixed metaphors, arguments and equivocations surrounding the representation of the divine.

[23] Frost, "Magnus Pan", p. 244.
[24] Carey, *Donne*, p. 202.
[25] Cf. Chapter 3, p. 91.

Judgement

The simultaneous fascination with Judgement and refusal to contemplate it head on run through the whole sequence of Holy Sonnets, as Gardner recognises when she identifies "the core of the two sets [of sonnet sequences]" as "the six sonnets on the Last Things (1–6 of *1633*)", adding that "these appear in the same order in each set…".[26] Her mention of the two different "sets" of the sonnet sequence foreshadows the importance of the revision of the Holy Sonnets – a revision that significantly changes the speaker's attitude to Judgement and to the (endlessly deferred) sight of the face of God. Gardner and earlier editors were of course aware that there existed two different orderings of the Holy Sonnets, and that the variation was not only between 1633 and 1635 editions of Donne's *Poems* but was also to be found in the manuscript tradition. The bibliographical work of the Variorum edition of the Holy Sonnets in 2005 provides the first comprehensive theory of the relationship between the two sets of sonnets, identifying an "original sequence" of twelve and a "revised" sequence (corresponding to the twelve published in the 1633 *Poems*), and substantial authorial corrections of individual sonnets.[27] The editors' identification of the revision as authorial means that the reordering of the sequence itself feeds into the interpretation of the sonnets. Charting the two sequences' differing perspectives on Judgement and the anticipation of the sight of God involves observing the very different ways they treat visual perception.

Of Gardner's six "core" Holy Sonnets on the last things, only three project the moment of Judgement as such: "This is my Playes last Scene", "At the round Earths imagin'd corners", and "What if this present were the worlds last night?" All of these establish the scene of Judgement as a spectacle, a site defined in specifically spatial and visual terms, yet in all three the speaker's vision is limited and problematic. In the previous chapter we saw how the the speaker of "What if this present" turns away from the scene of Judgement to find another devotional image, seeking to obscure the visual details of the face of Christ the Judge with the merciful face of Christ crucified.[28] The two other Judgement sonnets similarly insist on the vision of Judgement, while in various ways interrupting or disrupting that vision. Just as in "What if this present", it is the sight of Christ's face that is incomplete, *imperfect* or otherwise disrupted, and this is highlighted in different ways. In the Introduction to this book I discussed the "swerving

[26] Gardner, ed., *Divine Poems*, p. xlii. The six sonnets in question are: HSDue, HSBlack, HSScene, HSRound, HSMin and HSDeath. HSWhat is not included in this group, presumably because it is one of the sonnets added in the Revised Sequence and thus not included in the original.

[27] Stringer *et al.* eds., *Variorum 7.1: Holy Sonnets*, pp. lx–lxxi.

[28] Cf. Chapter 4, pp. 128–130.

away" that, I argue, characterises Donne's engagement with images.[29] "At the round Earths imagin'd corners" is a key text in establishing this pattern, with its abrupt turn away from the scene of Judgement in the sonnet's sestet, prompted, it seems, by the very mention of "God's face".

IMAGINED CORNERS

In "At the round Earths imagin'd corners", the representation of the last day is sustained for the entire octave of the sonnet, including many iconographic details that correspond to the visual tradition. The two-tier structure of most Last Judgements mimics the presumed vertical relation of heaven and earth. The figure of Christ as Judge, flanked by the intercessors and cohorts of apostles and saints, generally occupies the upper deck of the picture, while the numberless bodies of the Resurrected clambering out of the earth are on the lower level, as in Joos van Cleve's Last Judgement (fig. 6). While the bodies of the Resurrected occupying the narrative, temporal, horizontal axis are placed in a horizontal relationship with each other, they are all individually in a vertical relationship with the Judge. The transition from the temporal sphere to the eternal sphere is thus represented spatially and vertically; the moment of Judgement occurs on the vertical, divine axis.[30] In Donne's sonnet, the angels blowing their trumpets in the opening lines belong to the heavenly, vertical axis, and this vertical movement is emphasised semantically by the repetition of "arise, arise" at the end of line two, and also aurally by the string of marked enjambments in the first three lines, which generate a rising tone, rather than the falling tone of an end-stopped line.

Visually, the Last Judgement functions through a moral mapping, a spatial system which conveys, and at the same time simplifies, the eschatological drama. While heaven and earth are established as up and down, the fixed ordering of space in Last Judgement paintings also attaches iconographic significance to right and left, based on the biblical text "And he shall set the sheep on his right hand, but the goats on the left" (Matt. 25:33). This dictates the second dimension of the basic layout of almost all Last Judgement paintings, which is particularly accommodated by the form of the triptych: heaven is on the left (our left as we look at the painting, and therefore Christ's right) while hell is on the right. It is within this strict moral

[29] Cf. Introduction, p. 17.
[30] The terms vertical and horizontal to describe the Last Judgement are used by John Collins in his "Apocalyptic Eschatology as the Transcendence of Death", *Catholic Biblical Quarterly* xxxvi (1974), pp. 21–43 (p. 37). Collins' use of the terms is taken up by Bernard McGinn in *Visions of the End: Apocalyptic Traditions in the Middle Ages* (New York: Columbia University Press, 1998), p. 9.

spatial mapping that the chaos of the numberless bodies of the Resurrected multiplies. Although the act of judgement occurs on the vertical axis – the vertical relationship between Christ as judge and the individual Resurrected – it overlaps with the multiple bodies of the Resurrected, who are still emerging from the earth, and therefore still part of the horizontal and temporal axis.

The spatial mapping of the octave of "At the round Earths imagin'd corners" echoes this temporal and spatial logic, with the first quatrain functioning vertically and the second horizontally. In the first quatrain the speaker of the sonnet seems to be hastening the moment of Judgement. His use of imperatives in the opening lines – "blowe / Your Trumpets, Angells, and arise, arise from death" (1–3) – seems to urge the inevitable to happen more quickly, and the repeated enjambments give the impression of time's inexorable rush towards its end. In another sermon preached at St Paul's, Donne asks whether, "if [...] the great and generall Judgement should begin now at this *his house*, and that the first should be taken up in the clouds, to meet the Lord Jesus, should be we, that are met now in this his house, would we be glad of that acceleration, or would we thank him for that haste? Men *of little faith*, I feare we would not" (10: 106). Here, as in the sonnet, temporal "acceleration" and "haste" are associated with vertical transition ("up in the clouds"). And just as this sermon articulates man's fear of the Last Judgement, so the second quatrain of the sonnet puts a brake on this rapid vertical acceleration with its list of paralleled ways of dying which emphasises the horizontal relationship between the bodies of the Resurrected: the democracy of death in the last moment. Each of those resurrected bodies has an individual story, but now all narratives are converging and coming to an end, because time will cease to exist. The form of the list with its many heavy stresses, enumerating the many ways to die, slows down the reading of the poem, and, rather as in "This is my Playes last Scene", postpones the inevitable transition to another kind of existence.

All these thematic and structural similarities to painted Last Judgements, making the octave of the sonnet almost a Last Judgement in miniature, may distract from the surprising absence of what should be central: the figure of the Judge. Despite the iconographic detail, corresponding indeed to Martz's "graphically imaged openings", it is only at the end of the octave that the eye of the beholder is introduced, with the promise of the inevitable vision of God in judgement. But the eye is thwarted at the last minute and the sonnet's sestet reveals another moment. Here we are placed firmly on the horizontal, temporal plane, "here on this lowly ground", at a remove from the final and terrifying vertical transition, a spatial opposition made clear by the "there; here" caesura in line 12. Having contemplated the terrifying last moment, Donne rejects the scene of Judgement and prays for the continuation of

narrative time: "let them sleepe, Lord, and me mourne a space". This need for time is marked by the very temporal "Tis *late* to ask abundance of thy grace / *When* we are there" (ll. 10–11, my emphasis). Time must continue, because time is what he needs in order to make amends.

But the speaker has a very different relationship to God in the sestet. The "God" whose face is not seen in line 8 is vertically juxtaposed with the "Lord" addressed so familiarly in line 9. Rather than being addressed within the vertical logic of the Last Judgement of the octave, here God is confronted and addressed more intimately. The personal relationship of the individual to God in the sestet, contrasted with the crowded octave, and the emphasis placed on individual repentance, set up a very different form of Judgement. By reproducing the overall logic of the Last Judgement but omitting the Judge, Donne's octave highlights problems with this fixed and static version of Judgement. In the horizontal paradigm established in the sestet of the sonnet this is replaced by a much closer, and oral, face-to-face relationship to God. And the shift from vertical to horizontal means that Judgement is no longer something which occurs at one moment out of time, but which is continuous throughout narrative time. The sestet, rather than being a meditation on (and therefore, implicitly, a reinforcement of) the octave's "composition of place", works against it by proposing an alternative version of Judgement. It swerves away from the vision of Judgement as iconic, limited and rigidly mapped and replaces it with a personal judgement of the individual.

VISION AND REVISION

The very form of the sonnet provides an apt vehicle for the limitations of fallen man's knowledge. In "At the round earth's imagined corners" the metre strains to accommodate the description of the innumerable bodies of the resurrected. In "La Corona", the containment of both individual sonnet and cycle manage to provide a somewhat reassuring justification of the representation of Christ's life, but in the Holy Sonnets the form of the sonnet seems to strain at the seams under the pressure of the speaker's awareness of what lies beyond human comprehension. And the sequence as a whole not only frames but also structures the speaker's anxiety and speculation as it acts out the opposition between "now" and "then" of 1 Corinthians 13.12: "For now we see through a glass, darkly; but then face to face: now I know in part; but then shall I know even as also I am known". The most condensed reiteration of the structure comes in the sestet of "At the round earth's imagined corners", where the "there; here" caesura of line 12 – "'Tis late to ask abundance of thy grace, / When we are there; here on this lowly ground / Teach me howe to repent..."

(ll. 11–13) – encapsulates the opposition between the imagined future confrontation and the present fear and doubt.

This moment of anxiety, where looking becomes problematic, seems to lie behind other kinds of shift in the sequence. The whole sequence, particularly in its original version, can be seen as opposing the "now" designating all time from the Creation to the incomprehensible "then" of the dissolution of the world. But tracking the changes Donne made to these sonnets as he revised the whole sequence is also revealing. His anxiety is expressed, particularly in the "original" sequence, in visual terms which are reminiscent of his painterly and visual analogies for the relationship between man and God in the sermons. Yet this foregrounding of the speaker's visual anxieties undergoes a significant shift with the revision of the sequence. Not only does the reordering of the overall sequence cast individual sonnets in a different perspective, but the substantive changes at the level of vocabulary and syntax frequently occur at points where the dynamic of looking at / looking away is at work.

One of these revisions occurs in "What if this present", at the very moment that the speaker seeks to replace the image of the scene of Judgement with the face of Christ on the cross. In an earlier version of the sonnet, recorded in the "Westmoreland Sequence",[31] the speaker invites his soul to "*Looke* in my heart, the picture of Christ crucified" (l. 2, my emphasis). In the version that makes it into the Revised Sequence, this has become "*Mark* in my hart the picture …".[32] This change, as previously observed, brings the act of looking closer to the act of physically producing images while reinforcing the idea that looking is somehow problematic.

Another substantial revision in the sonnet sequence compounds this impression. "This is my plays last Scene" contains the most notable substantive change in any one sonnet, and once more this occurs in the context of seeing the face of Christ. The crux occurs near the end of the octave, in line 7. In the Original Sequence, the speaker desires the moment of "face to face" encounter with God, but that moment remains shrouded in doubt:

> This is my Playes last scene, here heav'ns appoint
> My Pilgrimages last mile, and my race
> Idly, yet quickly runne, hath this last pace,
> My spans last inch, my minuts latest point,
> And gluttonous Death will instantly vnjoynt
> My body and my soule, and I shall sleepe a space,
> Or presently, (I knowe not) see that face,

[31] See Stringer *et al.* eds., *Variorum 7.1: Holy Sonnets*, pp. lxvii–lxx for discussion of the place of the Westmoreland Sequence (NY3) in the evolution of the sequence.
[32] Stringer *et al.* eds., *Variorum 7.1: Holy Sonnets*, pp. 18 and 25.

> Whose feare already shakes me euery ioynt. (HSScene, Original Sequence, ll. 1–8)

The uncertainty and fear attached to the anticipated sight of God's face are made explicit in both the "Or" and the parenthesis "(I knowe not)" of line 7.[33]. When the sequence is revised, this is the line that comes in for significant alteration. Lines 6–8 in the Revised Sequence version of the sonnet assert, much more confidently: "And I shall sleepe a space / But *my ever wakeing part shall see* that face / Whose feare already shakes my every joynt" (my emphasis). The editors of the *Donne Variorum* identify the revision as authorial,[34] as does Gardner in her 1952 *Divine Poems*. On one hand, the chronology of revision seems to chart a progression from doubt to confidence. But the very co-existence of these variants has the effect of reinforcing the hesitation around seeing "that face".

Gardner's own editorial commentary captures that hesitation. She privileges the later variant, but acknowledges that the "I knowe not" of the first variant "must be the original reading" and finds its "deliberate expression of doubt [to be] the more impressive, in that the sestet assumes that the second alternative [seeing the face] is the true one, and makes the soul receive its final judgement at death".[35] The original variant, as Thomas Hester puts it, "evokes so well the limitations of the speaker's view of the afterlife… the essential liminations of fallen man who, as sinner, actually 'knows' only 'not' – whose vision in this case is capable of 'seeing' the eternal only as the absence of the physical".[36] The brisk confidence of the revised version is somehow less convincing than the way the possibility of face-to-face confrontation with God is deferred in the original. The (paradoxically) long-drawn-out syllables of "presently", combined with the parenthesis "(I knowe not)" have the effect of slowing down the metre and suspending the moment, so that overall the line helps to delay even mentioning the sight of God's face.

In marked contrast with this drawing out of the final moment, the octave begins by imagining the end of life as a rapid contraction of space and time. The space within which the speaker is contained narrows towards the point

[33] "Or presently (I knowe not) see that face …" (l. 7) has been read as expressing the "mortalist heresy" that between the death of the body and the Last Judgement the soul is uncomprehending or asleep. See discussion in Stringer *et al.* eds., *Variorum 7.1: Holy Sonnets*, pp. xcviii–xcix.

[34] Stringer *et al.* eds., *Variorum 7.1: Holy Sonnets*, p. 67.

[35] Gardner, ed., *Divine Poems*, p. xlv.

[36] M. Thomas Hester, "'Impute this idle talke': the 'leaven' body of Donne's 'Holy Sonnet III'", in *Praise Disjoined: Changing Patterns of Salvation in 17th-Century English Literature*, ed. by William P. Shaw (New York: Peter Lang, 1991), pp. 175–190 (p. 178 n. 5).

where the contemplation of Judgement will be inevitable. The list of "last things" – the last scene of the play, last mile of a pilgrimage, last step of a race – are established metaphors for the end of life, but it is their concatenation that creates the impression of constriction in this sonnet, as the relatively wide expanse of the "last scene" or "last mile" becomes a "pace", an "inch", a "point". The octave's rather awkward A-rhymes emphasise this sense of contraction. Each initial word rhymes with a reduced version of itself, as "appointe" (l. 1) is reduced to "point" (l. 4) and "unjoynt"(l. 5) to "joint" (l. 8). If the opening line of the sonnet recalls the theatrical metaphor of God's Creation that structures Donne's Easter 1628 sermon, that expansive vision of *now* is contracted into the unknowable perspective of an imminent *then*.

UT PICTURA POESIS

A similar kind of spatial logic is to be found throughout the sequence, particularly the "Original Sequence", which is framed by God's Creation of man in his own image and the place of that creation in the world.[37] Alongside this insistence on the language of craft and visual art in the sonnets, the sense of sight is recurrently called into question. The "Revised Sequence", despite containing many of the same sonnets, shifts the emphasis considerably, from visual to verbal, from sight to interpretation. Although the anticipated meeting between the speaker and God in the moment of Judgement remains, arguably, the "core" of both the Original and the Revised Sequences, the nature of that relationship and the terms of that judgement alter significantly.

The first sonnet in the Original Sequence opens with the line "Thou hast made me, and shall thy worke decay?" (HSMade, l. 1) and the final sonnet of that sequence ends "'Twas much that man was made like God before, / But that God should be made like man, much more" (HSWilt, ll. 13–14), neatly moving from the *imago Dei* to the related notion of Christ as "image of the invisible God" (Col. 1:15). Man as God's masterpiece, made by his hand, opens and closes the sequence, and the idea is reinforced by the recurrent references to images, made and decaying, throughout. In the second sonnet the "made / decay'de" rhyme in the first quatrain emphasises the point: "first I was made / By thee [...] and when I was decay'de..." (HSDue, ll. 2–3); in the seventh sonnet the speaker states that he, "a little World, made cunningly" "must be burnt" (HSLittle, ll. 1; 10). Sinful man has tarnished God's image within him, which is why, like the speaker of "Good friday", the speaker of the Holy Sonnets must beg for the restoration of the *imago Dei*, so that it will be recognisable to and acceptable to God.

[37] "Original Sequence", Stringer *et al.* eds., *Variorum 7.1: Holy Sonnets*, pp. 5–10.

The first sonnet in the sequence is the speaker's plea for God to pay attention to him. But the speaker himself finds his vision paralysed:

> I dare not moue my dimme eyes any way,
> Despaire behind, and Death before doth cast
> Such terrour, and my feebled flesh doth wast
> By sinne in it, which it t'wards Hell doth weigh;
> Only thou art aboue, and when t'wards thee
> By thy leaue I can looke, I rise againe ... (HSMade, ll. 5–10)

The paralysed spectator who opens the sequence announces that the Holy Sonnets are an attempt to see God, to picture God, a negotiation between the earthly space in which the persona finds himself and the divine image he aspires to. But, surrounded by images of despair and death, he does not dare to look. He maps out his location in relation to his fears: "Despaire *behind*, Death *before* ... *towards* Hell ... only thou art *above*", a succession of prepositions that recalls the more profane spatial orientation "Behind, before, above, betweene, below" of "Elegy 8: On his mistris going to bed".[38] "Between" is the missing term in the first Holy Sonnet, but that is exactly where the speaker finds himself, between despair and death, heaven and hell. There is only one direction in which it would be safe to look, which is up, but the speaker doubts his ability to do so. This is far removed from the reassuring reciprocal gaze that Donne describes in the sermons when he appropriates Nicholas of Cusa's "omnivoyant image" and reiterates the message that "God upon whom thou keepest thine eye, will keep his Eye upon thee" (4: 130). [39]

In the Holy Sonnets, looking up towards God seems to depend on some kind of permission: "when t'wards thee / By thy leave I can looke ..." (HSMade, ll. 9–10), and the speaker's eyes are often obscured, usually by tears. The "dimme eyes" of the first sonnet are reinforced by the "shoures of rayne / [that] Mine eyes did wast" in the "Idolatry" of the third sonnet (HSSighs, ll. 5–6), and the reiteration of "Idolatrous Lovers" who "weepe and mourne" in sonnet ten (HSSouls, l. 9). The tears can also serve to cleanse the eyes, as in the seventh sonnet: "Pour new seas in mine eyes" (HSLittle, l. 7) and the ninth: "teares make a heav'nly Lethean floud / And drowne in it my sinnes blacke memory ..." (HSMin, ll. 11–12), but even in these cases the cleansing does not seem to lead directly to vision.

Yet the closing sonnet of the Original Sequence reiterates the opening sonnet's insistence on *making*. Its opening lines seem designed as a conclusion: "Wilt thou loue God, as he thee? then digest, / My soule, this

[38] "Elegy 8. To his Mistress going to bed", l. 26. Stringer *et al.* eds., *Variorum 2: Elegies*, pp. 163–164 (p. 163).

[39] Donne, *Sermons*, 2: 237; 4: 130; 5: 299; 9: 368. See Chapter 2, pp. 52–56.

wholesome meditation" (HSWilt, ll. 1–2). And if the sequence opened with a question – "Thou hast made me, and shall thy work decay?" (HSMade, l. 1) – the closing couplet of the final sonnet seems to provide an answer to it: "'Twas much that man was made like God before / But that God should be made like man, much more" (HSWilt, ll. 13–14). The Original Sequence is thus framed with ideas we have observed Donne developing elsewhere, the idea of making, the idea of God as craftsman and man as the *imago Dei*. Despite the paralysis that overcomes the speaker and the tears and doubts that he endures, the logic of making that frames the sequence reinforces the symmetry of man being made in God's image; Christ assuming man's image. It is part of a reassuring pattern of the possibility of salvation in that moment when man will find himself "face-to-face" with God, when he will "know, as [he] is known".

But the logic of making and craftsmanship that frames the original version of the sequence is less dominant when the sequence is revised. The revision foregrounds the written legal document rather than the made object. In the revised group of twelve sonnets, four of the original sonnets are omitted and four new ones are introduced, and there is also some reordering of the sequence. The sonnet that opened the Original Sequence, "Thou hast made me", is one of those omitted, so the sonnet that was previously second in the sequence, "As due by many titles", takes its place in the initial position. With its "made / decay'de" (ll. 2;3) rhyme in the first quatrain, this sonnet echoes many of the concerns of "Thou hast made me", and the speaker does describe himself as God's image in the seventh line. The opening conceit of the sonnet, though, is one of legal entitlement: "As due by many titles I resigne myself to thee" (l. 1) – and this idea is picked up again in the sestet with the line "Why does hee [the devil] steale, nay ravish that's thy *right*" (l. 10, my emphasis). And this legal language of ownership, of titles and rights, at the opening of the sequence, is picked up in "Father, part of his double interest", which moves from fourth place in the Original Sequence to become the closing sonnet of the revised one.[40]

Donne uses the line about "many titles" to describe man's relationship to God in an early sermon preached on April 30, 1615, and the passage in which it appears brings together the legal and the creative language that permeates the Holy Sonnets:

> before God, in whose jurisdiction we were by many titles, had forsaken us, or done any thing to make us forsake him. So that our action in selling our selves for nothing, hath this latitude, That man whom God hath dignified so much, as that in the Creation he imprinted his Image

[40] See Stringer *et al.*, *Variorum 7.1: Holy Sonnets*, p. lxii.

in him, and in the Redemption he assumed not the Image, but the very nature of man ... (*Sermons* 1: 153)

As in this sermon, in both versions of the sequence of Holy Sonnets the language of artistic creation and of legal documents meet and overlap. Since eight sonnets are common to both sequences, there is of course a continuity of themes and imagery. Yet the changes made to the order mean that there is a significant reframing of the concerns of the sequence. There is a clear shift from the original sequence, which is framed by God as maker, with man linked to God by the image of God within him, and God's *interest* in man tied to the fact that man is His work of art; to the Revised Sequence, which is framed by a far more legalistic conception of God and of man's links to God – man is linked to God by titles, legacies and by laws. As Theresa DiPasquale has observed, the idea of man as an artwork *made by* God shifts to the idea of man being *owned by* God.[41]

"Father, part of his double interest", which closes the Revised Sequence, is perhaps the least visual of all the Holy Sonnets. It does not start with one of Martz's "vividly dramatized, firmly established, graphically imaged openings".[42] The "titles" of the first sonnet of the Revised Sequence are multiplied in this closing sonnet in an accumulation of legal terminology that gives an impression of piles of written documents. The legal language of the octave is for the most part related to ownership or inheritance: the Father's "double interest"; the Son's "jointure" in the Trinity, the "wills" and "legacy" with which the Son "invests" his legatees. In the sestet the language is more that of legislation, evoking "laws", "statutes" to be "fulfilled", and one "last command". Greg Kneidel points out that the sonnet "invokes four different jurisprudences or forms of law" in its fourteen lines, two with a basis in scripture and two firmly based in English law.[43]

It is tempting to read the Revised Sequence, with its insistence on the written word, as a "Reformed" sequence, accommodating visual aids to devotion but ultimately privileging the word as the proper means of access to knowledge of God, rather as Donne often seems to do in his sermons. Yet the relationship between words and images – and between words and the representation of the divine – proves more complex than that. As Kneidel observes, the multiple forms of jurisdiction evoked in "Father, part of his

[41] Theresa DiPasquale, "A Tale of Two Sequences: Reading the Variorum Edition of the Holy Sonnets", Presidential address, Twenty-Second Annual John Donne Society Conference, Baton Rouge, February 17, 2007. Unpublished.
[42] Martz, *The Poetry of Meditation*, p. 31.
[43] Gregory Kneidel, "The Death of Christ in and as Secular Law", in *Political Theology and Early Modernity*, ed. by Graham Hamill and Julia Reinhard Lupton (Chicago: University of Chicago Press, 2012), p. 273.

double interest" mean that within the sonnet Christ occupies opposing, apparently incompatible roles as "legal actor": conqueror and yet sacrificial victim, but also joint-holder and testator.[44] These oppositions recall the very visual oscillation between the two faces of Christ Judge and Christ Saviour in "What if this present were the world's last night" – itself one of the sonnets that was added to the Revised Sequence. The legal documents thus provide another version of the doctrinal and Christological conflict represented in visual terms several sonnets previously.

The titles, laws and statutes highlighted in the Revised Sequence also recast the visual and spatial logic of earlier sonnets in other ways. The proliferation of legal documents and legal systems in the final sonnet of the sequence are reduced, in the closing couplet, to one: "Thy Lawes Abridgement, and thy last command / Is all but Loue, Oh lett that last will stand" (HSPart, ll. 13–14). As so often, we find an echo of the same idea in a sermon, preached in 1626 on Psalm 32:6. Like the sonnet, this sermon opens with legal vocabulary, and towards the end Donne, praising Christianity for being a "*Verbum abbreviatum*, a contracted religion", observes that God's law, already abridged into the ten commandments, is even further compressed:

> our blessed Saviour, though he would take away none of the burden ... was pleased to binde it in a less roome, and in a more portable forme, when he re-abridged that Abridgement, and recontracts that contracted doctrine in these two: Love God and Love thy Neighbour. (*Sermons*, 9. 323–324)

Donne seems to like this metaphor of a "more portable form", and employs it in his visually inspired imagery as well as in this legal, documentary context. He uses a very similar device in his much more visually-oriented valediction sermon preached in April 1619, where he refers to Nicholas of Cusa's metaphor of the omnivoyant image on the wall but allows that "every man hath a pocket picture about him, a manuall, a bosome book" to remind him of God's goodness (2: 237–238). Within the Holy Sonnets such an "abridgement" also recalls the way the end of life is imagined as contracting to a mile, a span, a point, in the earlier Holy Sonnet "This is my playes last scene." In all of these examples, visual, spatial and textual, Donne imagines a collapsing of space and knowledge down to one point – the point that represents the unimaginable end of what is humanly knowable, the moment of face-to-face confrontation with God.

The conflicting versions of Christ in "Father, part" and the contraction of the sonnet's closing couplet thus repeat patterns of imagery that were previously expressed through visual metaphor. The shift of focus to legal

[44] Kneidel, "Death of Christ", pp. 273–274.

vocabulary and an emphasis on the written word do not replace the metaphors of making and seeing, but rather reframe the sequence using terms drawn from another mode of representation. Whenever Donne engages with the production and appreciation of visual art, whether in his sermons, his secular poetry or his divine poetry, his recurrent theme is that the painting or sculpture can never adequately represent what it is supposed to signify. Portrait representations were already problematised and deconstructed in the love poetry; "La Corona" and other divine poems transferred the same anxieties to the representation of the incarnate Christ. The poems concerned with imagining the unrepresentable God take the same problem to its extreme. By shifting the source of the metaphor from visual art to the written word in the revision of the Holy Sonnets, Donne makes clear something that has been implicit in his treatment of visual representation all along: that his concern is with all forms of representation; that his recurrent problematisation of visual representation reflects back on his own verbal representation. Words prove just as inadequate to represent the divine, subject to the same distortions and contradictions.

It is perhaps appropriate that Donne's equation of visual with verbal representation is brought to the fore by the revision of the sequence of the Holy Sonnets. Not only does the restructuring foreground written texts as objects, from the "titles" of the first sonnet to the "abridgement" of the last couplet, but the authorial revision of the sequence also highlights the materiality of the sonnets themselves, combined and recombined to provide subtly different angles on the speaker's fear of death and judgement. If the circular form of *La Corona* holds out the possibility of representing the incarnate Christ, circumscribed in human form, the form of the Holy Sonnets – in both sequences – is fragmented and fraught. Each sonnet is an attempt to see and understand but they all point in different directions. In the sequence overall, vision is scattered, like the apostles' eye-beams in Donne's sermon on the Transfiguration. The Holy Sonnets provide a partial, fragmented, kaleidoscopic vision of the divine and of the moment of Judgement.[45] Like the imperfect and incompatible metaphors for the Resurrection of Christ in "Resurrection, imperfect" the *Holy Sonnets* can do no more than acknowledge the space that should be filled with the body or face of Christ, drawing attention to our inability to fill that space. They highlight the fact that any attempt – visual or verbal – to represent the divine is simply "look[ing] through a glass darkly": the text, like the image, is an imperfect, and human, vehicle.

[45] The term "kaleidoscopic" is taken from Deborah Shuger in *The Renaissance Bible: Scholarship, Sacrifice, and Subjectivity* (Berkeley: University of California Press, 1994) where she describes the "kaleidoscopic sequence of images used to portray the chimerical Christ" in Calvinist passion narratives (p. 113).

CONCLUSION

> Churches are best for Prayer that haue least light;
> To see God only, I goe out of sight:
> And to scape stormy dayes, I choose an everlasting Night.
>
> "A Hymne to Christ", ll. 26–28[1]

I claimed in the Introduction to this book that Donne might be more properly described as "painterly" than "pictorial": he is much less interested in "made work", than in the process of making, to use his phrase from "The Expostulation".[2] When he mentions "a Serpentine line, (as the Artists call it)" in a sermon from the 1620s, or "powders blue stains" in "Elegy: His Picture",[3] we see him referencing the materiality of the artwork and the craft and skill of the painter, rather than giving the kind of detailed ekphrastic information that could allow readers to visualise the painting's subject matter. I have argued that critics who seem determined to find visual analogues for Donne's images are setting off on the wrong foot, and risk imposing images on the poems. And yet this recurrent critical desire is understandable. The "appeal to visualization", to use Annabel Patterson's phrase, is undoubtedly there.

Patterson coins this phrase in her discussion of "La Corona" due to the many imperatives to "look!": "Seest thou, my Soule, with thy faiths eyes ..."; "See where your child doth sit".[4] Her observation could be extended to Donne's references to pictures more generally. Virtually every time he uses the word "picture" there is a pointed – one might say provocative – appeal to visualisation. Whether this is in the context of a secular portrait – "Here, take my picture... / 'Tis like me"; an internal devotional image – "Looke in my Hart ... the picture of Christ crucifyde"; or an external one – "Who

[1] "A Hymne to Christ", pp. 26–28, Johnson et al., eds., *Variorum 7.2: Divine Poems*, p. 147.
[2] "Elegy 16: The Expostulation", ll. 57–58. Stringer et al., eds., *Variorum 2: Elegies*, p. 370.
[3] Potter and Simpson, eds., *Sermons* 5, p. 347; Stringer et al., eds., *Variorum 2: Elegies*, p. 264.
[4] "La Corona", 3, l. 9; 4, l. 2. Johnson et al., eds., *Variorum 7.2: The Divine Poems*, pp. 5–7 (p. 6). Patterson, "Re-formed", p. 85. See Chapter 3, p. 80.

from the Picture would avert his eye"; each time the picture seems to be tantalisingly held out towards us.[5] Ernest Gilman observes acutely that "although Donne is typically not regarded as a 'visual' poet, his poems are nearly obsessed with the eye".[6] It is not surprising that every mention of a picture is accompanied by a mention of the eye or the act of looking. What is remarkable is that each time we accept the invitation to engage with it, the picture resists, frustrates, confounds and turns out to offer something much more problematic than visualisation.

I have appropriated from Gilman the notion of "swerv[ing] away ... evoking but then effacing the picture behind his text", which seems to me to have a much wider application than the interpretation of Satyre 3 from which it is taken.[7] The mechanism that Gilman identifies marks the limits of the pictures Donne does not describe, making us aware of the empty space that resists mimetic representation. We are repeatedly prompted to ask to what extent a picture can be "like me" or "like thee".[8] In "La Corona", even though there is no reference to a physical picture as such, the fleeting resemblances to visual art, inviting but resisting translation into image, underscore the elusive quality of what is being represented.

This mechanism of swerving away comes close to the apophatic moves of mystical theology, where the material and describable are evoked only to be surpassed. The importance of Donne's debt to the mystical theology of Pseudo-Dionysius, and by extension to Nicholas of Cusa's *De Visione Dei*, goes beyond the identification of the uncited sources. Without overstating the influence of mystical theology on his own theological position, it does seem that both Pseudo-Dionysius's sculptor image and the omnivoyant icon from *De Visione Dei* are crucial to understanding Donne's simultaneous reticence about and great interest in representational art. Donne highlights his own method when he refers, in both the sermons and in "Of the Crosse", to Pseudo-Dionysius's sculptor image, "tak[ing] away, par[ing] off some parts of that stone, or that timber, which they work upon" to illustrate the *via negativa*.[9] Donne too uses material metaphors to represent the path to the contemplation of the immaterial divine. But more to the point, time

[5] "Elegy 12. His Picture", ll. 1; 3, Stringer *et al.*, eds., *Variorum 2: Elegies*, p. 264; "What yf this present" (Westmoreland Sequence), ll. 2–3, Stringer *et al.*, *Variorum 7.1: Holy Sonnets*, p. 18; "Of the Crosse", l. 7, Johnson *et al.*, eds., *Variorum 7.2; The Divine Poems*, pp. 147–148 (p. 148).

[6] Gilman, *Iconoclasm*, p. 124.

[7] Gilman, *Iconoclasm*, p. 117; p. 213n. 2.

[8] "Elegy 12. His Picture", l. 3, Stringer *et al.*, eds., *Variorum 2: Elegies*, p. 264; "Phrine", l. 1., Stringer *et al.*, eds. *Variorum 8: Epigrams*, p. 11.

[9] *Sermons*, 8: 54 ; cf. "Of the Crosse", l. 33, Johnson *et al.*, eds. *Variorum 7.2: The Divine Poems*, pp. 147–148 (p. 147).

after time he evokes the possibility representing the self, or representing God, only to then take it away.

The recurrent references in the *Sermons* to Nicholas of Cusa's "omnivoyant icon" speaks to Donne's interest in the seeing of pictures as well as the making of them. It is, in the phrase he uses repeatedly, "a *well made*, and *well placed* picture" that "looks always upon him that looks upon it".[10] Donne's phrasing here insists on the painterly craft required to make the effect of the icon's reciprocal gaze to work, to make the eyes appear to follow you round the room. This reciprocity is crucial for the metaphor in *De Visione Dei*, and in Donne's extraction of it in his *Sermons*; it is also crucial when we apply it, as I think we can, to Donne's treatment of pictures more generally. As in the poetry, the act of looking at a "picture" is emphasised, but it is a picture that actively solicits the spectator's involvement, as all Donne's verbal pictures do.

I have suggested that Donne's problematising of visual art ultimately reflects on all representation and so, necessarily, on his own verbal art. Every time his poems swerve away from a picture, they draw attention to their own failure to represent. This is the paradox of all Christian art. As Joseph Koerner puts it, icons are "meant to train our eyes to see beyond the image, to cross it out",[11] and in his poetry Donne finds many ways to convey this paradox. As his poems swerve away from pictorialism or ekphrastic description they create other kinds of visual, or at least formal patterns, and this is particularly the case with his divine poems. The title and form of "La Corona" insist on the circle that encloses and circumscribes at the same time as representing infinity. The crosses of "Good Friday", "The Crosse" and some of the Holy Sonnets similarly function as formal paradoxes, creating meaning at the same time as they cross it out. Donne does not propose a word/image *paragone* that privileges the word, but rather suggests that all human production – all human perception – is necessarily circumscribed.

Donne's version of *ut pictura poesis* is that neither poetry nor visual art can hope to represent the divine. The human vehicles of text and image are circumscribed by the limits of human knowledge and ability. He explores this idea in the secular poetry too. In the concluding lines of "The Relique" the speaker states "All measure, and all language I should passe, / Should I tell what a Miracle shee was" (ll. 32–33). The "Paper" (l. 21) on which the poem is written can only go so far in using language to instruct a misbelieving age in miracles. Of course, in a certain sense, "The Relique" is a

[10] *Sermons*, 2: 237, my emphasis. This phrase does not come from the Latin of *De Visione Dei* – I still hope to identify a source, but perhaps it originates with Donne himself.

[11] Koerner, *Reformation of the Image*, p. 12.

kind of Last Judgement poem. Its imagining of the lovers' souls meeting "at the last busie Daye", united by their provident "Bracelet of bright haire about the bone", gestures towards the incomprehensible and unrepresentable moment of Judgement that Donne explores in the Holy Sonnets.[12] The Last Judgement sonnets are perhaps the most explicit of all Donne's poems in acknowledging that their subject matter is impossible to describe, and in the way that they bring together visual and verbal attempts to convey it. Beyond time, beyond human understanding, and yet endlessly imagined and re-imagined in both word and image, the Last Judgement sums up the paradox of human imagination of the divine.

One of Donne's Judgement sonnets was the spark that set me off on this project, so it is appropriate that the Holy Sonnets also conclude the book. The apophatic conclusion to the "Hymne to Christ", quoted as the epigraph to this chapter, provides one answer to the paradox: "To see God only, I goe out of sight". This is not the reciprocal gaze of Nicholas of Cusa's omnivoyant icon; rather, it suggests that God can only be properly seen when the human has been eclipsed. The speaking self of Donne's poem has to write himself out of the poem in order to approach God. This is a sleight of hand, because it is a resounding conclusion to the poem; by pretending not to represent the poem represents much more. But as in so many of Donne's image/texts it is in this moment poised between representation and the impossibility of representation that the work of art is generated.

[12] "The Relique", Jeffrey S. Johnson *et al.*, eds., *Variorum 4.3: Songs and Sonnets*, p. 186.

BIBLIOGRAPHY

Allen, D. C. "Donne's 'Sapho to Philaenis'", *English Language Notes* 1:3 (1964): 188-191.
Anderson, David K. "Internal Images: John Donne and the English Iconoclast Controversy", *Renaissance and Reformation/Renaissance et Réforme* 26:2 (Spring 2002): 23-42.
Arakawa, Mitsuo. *Shinpishiso to Keijijoshijintachi [Mystical Thought and Mystical Poets]*. Tokyo: Shohakusha, 1976.
Arasse, Daniel. *L'Annonciation italienne: une histoire de perspective*. Paris: Hazan, 1999.
Aston, Margaret. *Broken Idols of the English Reformation*. Cambridge Cambridge University Press, 2016.
———. *England's Iconoclasts: Volume 1: Laws against Images*. Oxford: Clarendon Press, 1988.
———. "Public Worship and Iconoclasm", in *The Archaeology of Reformation 1480-1580*, edited by D. Gaimster and R. Gilchrist. Leeds: Maney, 2003, pp. 9-28.
Augustine. *Confessions*. Translated by Henry Chadwick. Oxford: Oxford University Press, 1998.
Ayres, Philip J. "Donne's 'the Dampe', Engraved Hearts, and the 'Passion' of St. Clare of Montefalco", *English Language Notes* 13:3 (1976): 173-175.
Bald, R. C., and W. Milgate. *John Donne: A Life*. Oxford: Clarendon Press, 1970.
Bell, Ilona. "Women in the Lyric Dialogue of Courtship: Whitney's Admonition to Al Yong Gentilwomen and Donne's 'The Legacie'", in *Representing Women in Renaissance England*, edited by Claude J. Summers and Ted-Larry Pebworth. Columbia, MO: University of Missouri Press, 1997, pp. 76-92.
Bobo, Elizabeth. "'Chaf'd Muscatts Pores': The Not-So-Good Mistress in Donne's 'The Comparison'", *ANQ: A Quarterly Journal of Short Articles, Notes and Reviews* 25:3 (2012): 168-174.
Bryson, John. "Lost Portrait of Donne", *The Times*. (London), October 13, 1959.
Burton, Robert. *The Anatomy of Melancholy*. Oxford: John Lichfield and James Short, for Henry Cripps, 1621.
Calvin, John. *A Commentarie of Iohn Calvine vpon the first booke of Moses called Genesis*. Translated by Thomas Tymme. London: for John Harison and George Bishop, 1578.
———. *Institutes of the Christian Religion*, ed. John T. McNeill. Philadelphia: Westminster Press, 1960.
Carey, John. *John Donne: Life, Mind and Art*. New York: Oxford University Press, 1981.
Cassirer, Ernst. *The Individual and the Cosmos in Renaissance Philosophy*. New York and Evanston: Harper Torchbooks, 1963.

Certaine Sermons or Homilies. Gainsville, FL: Scholars' Facsimiles and Reprints, 1965.

Chambers, A. B. "The Meaning of the 'Temple' in Donne's La Corona", *Journal of English and Germanic Philology* 59:2 (1960): 212–217.

Chambers, Alexander B. *Transfigured Rites in Seventeenth-Century English Poetry.* Columbia: University of Missouri Press, 1992.

Chambers, E. K., ed. *Poems of John Donne.* London: A. H. Bullen, 1896.

Chevallier, Philippe, ed. *Dionysiaca.* Stuttgart-Bad Cannstatt: Frommann-Holzboog, 1989.

Clements, A. L., ed. *John Donne's Poetry: Authoritative Texts, Criticism*, Norton Critical Editions. New York: Norton, 1966.

Colclough, David, ed. *The Oxford Edition of the Sermons of John Donne, Vol. 3: Sermons Preached at the Court of Charles I.* Oxford: Oxford University Press, 2013.

Collins, John. "Apocalyptic Eschatology as the Transcendence of Death", *Catholic Biblical Quarterly* xxxvi (1974): 21–43.

Cooper, Tarnya. *Citizen Portrait: Portrait Painting and the Urban Elite of Tudor and Jacobean England and Wales.* New Haven and London: Yale University Press, 2012.

Correll, Barbara. "Symbolic Economies and Zero-Sum Erotics: Donne's 'Sapho to Philaenis'", *English Literary History* 62:3 (Fall 1995): 487–507.

Counet, Jean-Michel. *Mathématiques et dialectique chez Nicolas de Cuse.* Paris: Vrin, 2000.

Cousins, A. D. "The Coming of Mannerism: The Later Ralegh and the Early Donne", *English Literary Renaissance* 9:1 (1979): 86–107.

Cowley, Abraham. "On the Death of Sir Anthony Vandike, the Famous Painter", *Poems.* London: Humphrey Moseley, 1656, p. 9.

Cresswell, Catherine J. "Giving a Face to an Author: Reading Donne's Portraits and the 1635 Edition", *Texas Studies in Literature and Language* 37:1 (1995): 1–15.

Crowley, Lara M. "A Text of 'Resurrection. Imperfect'", *John Donne Journal* 29 (2010): 185–198.

Cunnar, Eugene R. "Illusion and Spiritual Perception in Donne's Poetry", in *Aesthetic Illusion: Theoretical and Historical Approaches*, edited by Frederick Burwick and Walter Pape. Berlin: de Gruyter, 1990, pp. 324–336.

Davies, Stevie. *John Donne.* Writers and Their Work. Plymouth: Northcote House, with British Council, 1994.

Davis, Walter R., and Richard Lanham, eds. *Sidney's Arcadia.* New Haven and London: Yale University Press, 1965.

Derrida, Jacques. *Of Grammatology.* Translated by Gayatri Chakravorty Spivak. Baltimore and London: Johns Hopkins University Press, 1976.

DiPasquale, Theresa M. *Literature and Sacrament: The Sacred and the Secular in John Donne.* Pittsburgh, PA: Duquesne University Press, 1999.

———. "A Tale of Two Sequences: Reading the Variorum Edition of the Holy Sonnets", Presidential Address, Twenty-Second Annual John Donne Society Conference, Baton Rouge, February 17, 2007. Unpublished.

Docherty, Thomas. *John Donne, Undone.* London: Methuen, 1986.

Dolce, Ludovico. *Aretin: A Dialogue on Painting. From the Italian of Ludovico Dolce.* London: P. Elmsley, 1770.

Donne, John. *Essays in Divinity*, edited by Evelyn M. Simpson. Oxford: Clarendon Press, 1952.
Donno, Elizabeth Story, ed. *Andrew Marvell: The Complete Poems*, London: Penguin, 1972.
Dowden, Edward. "The Poetry of John Donne", *The Fortnightly Review*, 232 (1890): 791–808.
Duffy, Eamon. *The Stripping of the Altars: Traditional Religion in England 1400–1580*. New Haven: Yale University Press, 1992.
Dyrness, William A. *Reformed Theology and Visual Culture: The Protestant Imagination from Calvin to Edwards*. Cambridge: Cambridge University Press, 2004.
Elsky, Martin. "John Donne's La Corona: Spatiality and Mannerist Painting", *Modern Language Studies* 13:2 (Spring 1983): 3–11.
Ettenhuber, Katrin. *Donne's Augustine: Renaissance Cultures of Interpretation*. Oxford: Oxford University Press, 2011.
Evett, David. *Literature and the Visual Arts in Tudor England*. Athens and London: University of Georgia Press, 1990.
Falk, Ruth E. "Donne's 'Resurrection, Imperfect'", *Explicator* 17 (1958).
Farmer, Norman. *Poets and the Visual Arts in Renaissance England*. Austin: University of Texas Press, 1984.
Flynn, Dennis. *John Donne and the Ancient Catholic Nobility*. Bloomington: Indiana University Press, 1995.
———. "John Donne's Titian: What Was It, How Did He Get It, and What Does It Mean for Us?" Unpublished.
Ford, Sean. "Nothing's Paradox in Donne's 'Negative Love' and 'A Nocturnal Upon S. Lucy's Day'", *Quidditas* 22 (2001): 99–113.
Fowler, Alastair. "Periodization and Interart Analogies", *New Literary History* 3:3 (1972): 487–509.
Friedman, Donald M. "Memory and the Art of Salvation in Donne's Good Friday Poem", *English Literary Renaissance* 3:3 (1973): 418–442.
Frochlich, Karlfried. "Pseudo-Dionysius and the Reformation of the Sixteenth Century", in Pseudo-Dionysius, *Complete Works*, Translated by Colm Luibheid. New York: Paulist Press, 1987, pp. 33–46.
Frost, Kate Gartner. "The Lothian Portrait: A New Description", *John Donne Journal* 13:1–2 (1994): 1–11.
———. "The Lothian Portrait: A Prologomenon", *John Donne Journal* 15 (1996): 95–125.
———. "Magnus Pan Mortuus Est: A Subtextual and Contextual Reading of Donne's 'Resurrection, Imperfect'", in *John Donne's Religious Imagination: Essays in Honor of John T. Shawcross*, edited by Raymond-Jean Frontain and Frances M. Malpezzi. Conway, AR: UCA, 1995, pp. 231–261.
Gardner, Helen, ed. *John Donne. The Divine Poems*. Oxford: Clarendon Press, 1952.
———., ed. *John Donne. The Elegies and the Songs and Sonnets*. Oxford: Clarendon Press, 1965.
Gee, Henry, and W. H. Hardy, eds. *Documents Illustrative of English Church History*. New York: Macmillan, 1896.
Gent, Lucy. *Picture and Poetry 1560–1620*. Leamington Spa: James Hall, 1981.
Gill, Richard, ed. *John Donne: Selected Poems*. Oxford: Oxford University Press, 1990.

Gilman, Ernest B. *Iconoclasm and Poetry in the English Reformation: Down Went Dagon*. Chicago and London: University of Chicago Press, 1986.

———. "'To Adore, or Scorne an Image': Donne and the Iconoclastic Controversy", *John Donne Journal: Studies in the Age of Donne* 5: 1–2 (1986): 62–100.

Grierson, Herbert J. C. *The Poems of John Donne*. 2 vols. Oxford: Clarendon Press, 1912.

Guibbory, Achsah. "John Donne and Memory as 'the Art of Salvation'", *Huntington Library Quarterly* 43:4 (1980): 261–274.

———. "'Oh, Let Mee Not Serve So': The Politics of Love in Donne's Elegies", *English Literary History* 57: 4 (Winter 1990): 811–833.

Hagstrum, Jean H. *The Sister Arts: The Tradition of Literary Pictorialism and English Poetry from Dryden to Gray*. Chicago and London: University of Chicago Press, 1958.

Harland, Paul W. "'A True Transubstantiation': Donne, Self-Love, and the Passion", in *John Donne's Religious Imagination: Essays in Honor of John T. Shawcross*, edited by Raymond-Jean Frontain and Frances M. Malpezzi. Conway, AR: UCA Press, 1995, pp. 162–180.

Harvey, Elizabeth D. "Ventriloquizing Sappho: Ovid, Donne, and the Erotics of the Feminine Voice", *Criticism* 31:2 (Spring 1989): 115–138.

Heffernan, James A. W. "Ekphrasis and Representation", *New Literary History* 22:2 (1991): 297–316.

———. *The Museum of Words: The Poetics of Ekphrasis from Homer to Ashbery*. Chicago: Chicago University Press, 2004.

Hegedüs, Kader. "Maps, Spheres and Places in Donnean Love. Donne's Spatial Representations in the 'Songs and Sonnets'", MA Thesis. University of Lausanne, 2012.

Hegel, Georg Wilhelm Friedrich. *Aesthetics: Lectures on Fine Art*. Translated by T. M. Knox. 2 vols. Oxford: Oxford University Press, 1975.

Hester, M. Thomas. "'Impute This Idle Talke': The 'Leaven' Body of Donne's 'Holy Sonnet III'", in *Praise Disjoined: Changing Patterns of Salvation in 17th-Century English Literature*, edited by William P. Shaw. New York: Peter Lang, 1991, pp. 175–190.

Hiscock, Andrew. *Reading Memory in Early Modern Literature*. Cambridge and New York: Cambridge University Press, 2011.

Hollander, John. "A Poetics of Ekphrasis", *Word & Image* 4:1 (1988): 209–219.

Holstun, James. "'Will You Rent Our Ancient Love Asunder?' Lesbian Elegy in Donne, Marvell, and Milton", *English Literary History* 54: 4 (Winter 1987): 835–867.

Hopkins, Jasper, ed. *Nicholas of Cusa's Dialectical Mysticism: Text, Translation, and Interpretive Study of De Visione Dei*. Second edition. Minneapolis: Arthur J. Banning, 1988.

Howard, Richard. "Giovanni da Fiesole on the Sublime, or Fra Angelico's Last Judgement." *Poetry* 114, October 1970.

Hurley, Ann Hollinshead. *John Donne's Poetry and Early Modern Visual Culture*. Selinsgrove, PA: Susquehanna University Press, 2005.

Hutterer, Maille S. "Illuminating the Sunbeam through Glass Motif", *Word & Image* 38:4 (2022): 407–434.

St John of Damascus. *Three Treatises on the Divine Images*. Crestwood, NY: St Vladimir's Seminary Press, 2003.

Johnson, Jeffrey S. *The Theology of John Donne*. Cambridge: D. S. Brewer, 1999.

———. et al., eds. *The Variorum Edition of the Poetry of John Donne*. Vols 4.2, 4.3, 5, 7.2. Bloomington and Indianapolis: Indiana University Press, 2019–2022. See also Stringer below.

Johnson, Kimberly. "Linear Perspective and the Renaissance Lyric", *PMLA* 134:2 (2019): 280–297.

Karim-Cooper, Farah. *Cosmetics in Shakespearean and Renaissance Drama*. Edinburgh: Edinburgh University Press, 2006.

Keynes, Geoffrey. *A Bibliography of Dr. John Donne, Dean of Saint Paul's*. Fourth edition. Oxford: Clarendon Press, 1973.

Kinney, Arthur F., and Linda Bradley Salamon, eds. *Nicholas Hilliard's Art of Limning*. Boston: Northeastern University Press, 1983.

Klawitter, George. "John Donne's Attitude toward the Virgin Mary: The Public Versus the Private Voice", in *John Donne's Religious Imagination: Essays in Honor of John T. Shawcross*, edited by Raymond-Jean Frontain and Frances M. Malpezzi. Conway, AR: UCA Press, 1995, pp. 122–140.

Knapp, James A. "Looking at and through Pictures in Donne's Lyrics", in *The Art of Picturing in Early Modern English Literature*, edited by Camilla Caporicci and Armelle Sabatier. New York and London: Routledge, 2019, pp. 33–49.

Kneidel, Gregory. "The Death of Christ in and as Secular Law", in *Political Theology and Early Modernity*, edited by Graham Hamill and Julia Reinhard Lupton. Chicago: University of Chicago Press, 2012, pp. 264–281.

Koerner, Joseph Leo. *The Reformation of the Image*. London: Reaktion, 2004.

Labriola, Albert C. "Iconographic Perspectives on Seventeenth-Century Religious Poetry", in *Approaches to Teaching the Metaphysical Poets*, edited by Sidney Gottlieb. New York: Modern Language Association of America, 1990, pp. 61–67.

Lederer, Josef. "John Donne and the Emblematic Practice", *Review of English Studies* 22:87 (1946). 182–200.

Lee, Rensselaer W. *Ut Pictura Poesis: The Humanistic Theory of Painting*. New York: Norton, 1967.

Legouis, Pierre. *Andrew Marvell: Poet, Puritan, Patriot*. Oxford: Clarendon Press, 1965.

Lessing, Gotthold Ephraim. *Laocoön: An Essay on the Limits of Painting and Poetry*. Translated by Edward Allen McCormick. Indianapolis and New York: Bobbs Merrill, 1962.

Lewalski, Barbara Kiefer. *Protestant Poetics and the Seventeenth-Century Religious Lyric*. Princeton: Princeton University Press, 1979.

Lomazzo, Giovanni Paolo. *A Tracte Containing the Artes of Curious Paintinge Caruinge Buildinge Written First in Italian by Io: Paul Lomatius Painter of Milan and Englished by R. H. Student in Physik*, 1598.

Louthan, Doniphan, ed. *The Poetry of John Donne: A Study in Explication*. New York: Bookman Associates, 1951.

Luther, Martin. *D. Martin Luther's Werke. Kritische Gesamtausgabe*, ed. J. F. K. Knake, 67 vols. Weimar: Hermann Bohlaus Nachfolger, 1883–1997.

———. *Luther's Works*, ed. Jaroslav Pelikan and Helmut T. Lehman, 55 vols. Philadelphia and St. Louis, MO: Muehlenberg and Fortress / Concordia, 1955–1986.

MacCulloch, Diarmaid. *Reformation: Europe's House Divided 1490-1700*. London: Allen Lane, 2003.

Martin, Catherine Gimelli. "Unmeete Contraryes: The Reformed Subject and the Triangulation of Religious Desire in Donne's Anniversaries and Holy Sonnets", in *John Donne and the Protestant Reformation: New Perspectives*, edited by Mary Arshagouni Papazian. Detroit, MI: Wayne State University Press, 2003, pp. 193-220.

Martin, Michael. *Literature and the Encounter with God in Post-Reformation England*. Farnham: Ashgate, 2014.

Martz, Louis L. "Donne, Herbert, and the Worm of Controversy", in *Wrestling with God: Literature and Theology in the English Renaissance: Essays to Honour Paul Grant Stanwood*, edited by Mary Ellen Henley, W. Speed Hill and R. G. Siemens. *Early Modern Literary Studies*, Special Issue 7 (2001): 1-28.

———. *From Renaissance to Baroque: Essays on Literature and Art*. University of Missouri Press, 1991.

———. *The Poetry of Meditation: A Study in English Religious Literature of the Seventeenth Century*. New Haven: Yale University Press, 1954.

Maurer, Margaret. "The Circular Argument of Donne's 'La Corona'", *SEL: Studies in English Literature, 1500-1900* 22:1 (Winter 1982): 51-68.

Maurer, Margaret, and Dennis Flynn. "The Text of *Goodf* and Donne's Itinerary in April 1613", *Textual Cultures: Texts, Contexts, Interpretation* 8:2 (2013): 50-94.

McCaffrey, Philip. "Painting the Shadow: (Self-)Portraits in Seventeenth Century Poetry", in *The Eye of the Poet: Studies in the Reciprocity of the Visual and Literary Arts from the Renaissance to the Present*, edited by Amy Golahny. Lewisberg: Bucknell University Press, 1996, pp. 179-195.

McGinn, Bernard. *Visions of the End: Apocalyptic Traditions in the Middle Ages*. New York: Columbia University Press, 1998.

McGrath, Alister E. *Luther's Theology of the Cross: Martin Luther's Theological Breakthrough*. Second edition. Oxford: Blackwell, 2011.

McQueen, William A. "Donne's 'The Crosse'", *Explicator* 45:3 (Spring 1987): 8-11.

Meier-Oeser, Stephan. "Die Cusanus-Rezeption Im Deutschen Renaissancehumanismus Des 16. Jahrhunderts", in *Nicolaus Cusanus Zwischen Deutschland Und Italien*, edited by Martin Thurner. Berlin: Akademie, 2002, pp. 617-632.

———. *Die Präsenz Des Vergessenen: Zur Rezeption Der Philosophie Des Nicolaus Cusanus Vom 15. Bis Zum 18. Jahrhundert*. Münster: Aschendorff, 1989.

Merrifield, Mary. *Original Treatises on the Arts of Painting* [1849]. New York: Dover, 1967.

Michalski, Sergiusz. *The Reformation and the Visual Arts: The Protestant Image Question in Western and Central Europe*. New York: Routledge, 1993.

Michelangelo. *Poems and Letters*. Translated by Anthony Mortimer. London: Penguin, 2007.

Milgate, Wesley. "Dr. Donne's Art Gallery", *Notes and Queries* 194:15 (1949): 318-319.

Mitchell, W. J. T. *Picture Theory*. Chicago: University of Chicago Press, 1994.

Morales, Helen. "Fantasising Phryne: The Psychology and Ethics of Ekphrasis", *The Cambridge Classical Journal* 57 (2011): 71-104.

Muroaka, Isamu. "Donne to Cusanus", *Eigo Seinen (The Rising Generation)* 114 (1968): 216-217.

Nichols, Jennifer L. "Dionysian Negative Theology in Donne's 'A Nocturnall Upon S. Lucies Day'", *Texas Studies in Literature and Language* 53:3 (Fall 2011): 352–367.

O'Connell, Michael. "Milton and the Art of Italy: A Revisionist View", in *Milton in Italy: Contexts, Images, Contradictions*, edited by Mario A. Di Cesare. Binghamton, NY: Medieval and Renaissance Texts and Studies, 1991, pp. 215–236.

O'Connell, Patrick F. "'La Corona': Donne's Ars Poetica Sacra", in *The Eagle and the Dove: Reassessing John Donne*, edited by Claude J. Summers and Ted-Larry Pebworth. Columbia: University of Missouri Press, 1986, pp. 119–130.

Pace, Claire. "'Delineated Lives': Themes and Variations in Seventeenth-Century Poems About Portraits", *Word & Image* 2:1 (1986): 1–17.

Panofsky, Erwin. *Early Netherlandish Painting*. 2 vols. New York: Icon/Harper and Row, 1971.

———. "Die Perspektive Als 'Symbolische Form'", *Vorträge der Bibliothek Warburg 1924–1925* (1927): 258–330.

Parr, Anthony. "John Donne, Travel Writer", *Huntington Library Quarterly* 70:1 (2007): 61–85.

Patrides, C. A. ed. *The Complete English Poems of John Donne*. London: J. M. Dent, 1985.

Patterson, Annabel. "Donne in Shadows: Pictures and Politics", *John Donne Journal* 16 (1997): 1–35.

———. "Donne's Re-Formed *La Corona*", *John Donne Journal* 23 (2004): 69–93.

Paulson, Stephen D. "Luther on the Hidden God", *Word and World* 19:4 (1999): 362–371.

Phillips, John. *The Reformation of Images: Destruction of Art in England, 1535–1660*. Berkeley: University of California Press, 1973.

Piper, David. *The Image of the Poet: British Poets and Their Portraits*. Oxford: Clarendon Press, 1982.

Pollock, John J. "A Mystical Impulse in Donne's Devotional Poetry", *Studia Mystica* 2:2 (1979): 17–24.

Potter, George R. and Evelyn M. Simpson, eds. *The Sermons of John Donne*, 10 vols. Berkeley and Los Angeles: University of California Press, 1953–1962.

Praz, Mario. *The Flaming Heart: Essays on Crashaw, Machiavelli and Other Studies of the Relation between Italian and English Literature from Chaucer to T. S. Eliot*. Gloucester, MA: Peter Smith, 1966.

———. *Mnemosyne: The Parallel between Literature and the Visual Arts*. Princeton: Princeton University Press, 1970.

Preuss, Hans. *Martin Luther Der Künstler*. Güttersloh: C. Bettelsmann, 1931.

Pseudo-Dionysius. *The Complete Works*. Translated by Colm Luibheid. New York: Paulist Press, 1987.

Puttenham, George. *The Arte of English Poesie: Contrived into Three Bookes: The First of Poets and Poesie, the Second of Proportion, the Third of Ornament*. London: Richard Field, 1589.

Réau, Louis. *Iconographie de l'art chrétien*. 3 vols. Paris: Presses Universitaires de France, 1957.

Redpath, Theodore, ed. *The Songs and Sonnets of John Donne*. Second edition. New York: St Martin's Press, 1983.

Rendall, Steven. "The Portrait of the Author", *French Forum* 13:2 (1998): 143–151.

Robbins, Robin, ed. *The Poems of John Donne*. 2 vols. Harlow and New York: Longman, 2008.

Rorem, Paul. "Negative Theologies and the Cross", *Harvard Theological Review* 101:3/4 (2008): 451–464.

Roston, Murray. *The Soul of Wit: A Study of John Donne*. Oxford: Clarendon Press, 1974.

Rugoff, Milton Allan. *Donne's Imagery. A Study in Creative Sources*. New York: Corporate Press, 1939.

Rundell, Katherine. *Super-Infinite: The Transformations of John Donne*. London: Faber and Faber, 2022.

Sahas, Daniel J. *Icon and Logos: Sources in Eighth-Century Iconoclasm*. Toronto: University of Toronto Press, 1986.

Schleiner, Winfried. *The Imagery of John Donne's Sermons*. Providence, RI: Brown University Press, 1970.

Sellin, Paul R. "The Proper Dating of Donne's 'Satyre III'", *Huntington Library Quarterly* 43:4 (1980): 275–312.

Semler, L. E. *The English Mannerist Poets and the Visual Arts*. Madison: Fairleigh Dickinson University Press; London: Associated University Presses, 1998.

Shawcross, John T., ed. *The Complete Poetry of John Donne*. Garden City, NY: Anchor Books, 1967.

Shuger, Deborah. *The Renaissance Bible: Scholarship, Sacrifice, and Subjectivity*. Berkeley: University of California Press, 1994.

Sidney, Philip. *The Countesse of Pembrokes Arcadia, Written by Sir Philip Sidney Knight*. William Ponsonbie, 1598, pp. 519–569.

———. "The Defence of Poesy", in *Sidney's 'The Defence of Poesy' and Selected Renaissance Literary Criticism*, edited by Gavin Alexander. London: Penguin, 2004.

Simpson, Evelyn M. "The Biographical Value of Donne's Sermons", *Review of English Studies* 2:8 (1951): 339–357.

———. *A Study of the Prose Works of John Donne*. Oxford: Clarendon Press, 1924.

Sloane, Mary Cole. *The Visual in Metaphysical Poetry*. Atlantic Highlands, NJ: Humanities Press, 1981.

Sloane, Thomas O. *Donne, Milton, and the End of Humanist Rhetoric*. Berkeley: University of California Press, 1985.

Smith, A. J., ed. *John Donne: The Complete English Poems*. Harmondsworth: Penguin, 1971.

Stampfer, Judah. *John Donne and the Metaphysical Gesture*. New York: Funk and Wagnalls, 1970.

Stanwood, P. G. "Donne's Earliest Sermons and the Penitential Tradition", in *John Donne's Religious Imagination: Essays in Honor of John T. Shawcross*, edited by Raymond-Jean Frontain and Frances M. Malpezzi. Conway, AR: UCA, 1995, pp. 366–379.

Stein, Arnold. *John Donne's Lyrics: The Eloquence of Action*. Minneapolis: University of Minnesota Press, 1962.

Strier, Richard. "John Donne Awry and Squint: The 'Holy Sonnets,' 1608–1610". *Modern Philology* 86:4 (1989): 357–384.

Stringer, Gary A. et al., eds. *The Variorum Edition of the Poetry of John Donne*. Vols 1, 2, 3, 4.1, 6, 7.1, 8. Bloomington and Indianapolis: Indiana University Press, 1995–2017. See also Johnson, above.

Sypher, Wylie. *Four Stages of Renaissance Style: Transformations in Art and Literature 1400–1700*. Garden City, NY: Doubleday, 1955.

Terrill, T. Edward. "A Note on John Donne's Early Reading". *Modern Language Notes* 43:5 (1928): 318–319.

Tuve, Rosemond. *Elizabethan and Metaphysical Imagery: Renaissance Poetic and Twentieth-Century Critics*. Chicago: Chicago University Press, 1947.

Ugolnik, Anthony. "The Libri Carolini: Antecedents of Reformation Iconoclasm", in *Iconoclasm vs. Art and Drama*, edited by Clifford Davidson and Ann Eljenholm Nichols. Kalamazoo: Western Michigan University Press, 1989, pp. 1–32.

Underhill, Evelyn. *Mysticism*. London: Methuen, 1911.

Walsham, Alexandra. "Sacred Topography and Social Memory: Religious Change and the Landscape in Early Modern Britain and Ireland", *Journal of Religious History* 36:1 (2012): 31–51.

Walton, Izaak. *The Lives of Dr. John Donne, Sir Henry Wotton, Mr. Richard Hooker, Mr. George Herbert*. The Fourth Edition. London: Tho. Roycroft for R. Marriot, 1675.

Wendorf, Richard. "Visible Rhetorick: Isaak Walton and Iconic Biography", *Modern Philology* 82:3 (1985): 269–291.

Wiggins, Peter De Sa. "Giovanni Paolo Lomazzo's *Trattato Dell'arte Della Pittura, Scultura, e Architettura* and John Donne's Poetics: 'The Flea' and 'Aire and Angels' as Portrait Miniatures in the Style of Nicholas Hilliard", *Studies in Iconography* 7–8 (1981–82): 269–288.

Wotton, Henry. *The Elements of Architecture*. 1624.

Young, R. V. *Doctrine and Devotion in Seventeenth-Century Poetry: Studies in Donne, Herbert, Crashaw, and Vaughan*. Cambridge: Boydell and Brewer, 2000.

INDEX

Allen, Don Cameron 47n.92
Anderson, David K. 40, 68
Annunciation 19, 80, 83, 86, 88, 90, 94, 96–97
 in Luke's Gospel 84
 paintings of 84–85, 86, 94, 103(fig.3)
 and linear perspective 83–85
Apelles 44
Aphrodite 44–45
apophatic theology 52, 57–60, 61, 62–68, 69, 71, 75, 108–113, 115, 119–120, 121, 122, 133, 160, 162
Arakawa, Mitsuo 55n.11
Arasse, Daniel 84–85, 94
 L'annonciation italienne 84–85
Aston, Margaret 12n.52, 15n.62, 49–50, 88n.31, 108n.3
Augustine 56n.12, 83n.19, 140
Ayres, Philip 40n.69

Baddily, Richard *Life of Dr Thomas Morton* 29
Bald, R. C. 10n.43, 28n.20, 62, 79n.7
baroque 2, 12, 128
Bell, Ilona 41
Bernard of Clairvaux 53, 88, 89, 97
blazon 34–35, 43, 47–48, 59
Bobo, Elizabeth 43n.76
Book of Common Prayer 28
Bridget of Sweden, St 144n.18
Brooke, Christopher 8, 11
Brown, Piers 55n.11
Bryson, John 8n.32, 28, 29, 33n.44
Burton, Robert *Anatomy of Melancholy* 29
Byzantine iconoclastic controversy 86–88, 99

Calvin, Jean 12, 13–14, 70, 87n.30, 123
Campin, Robert, *Annunciation Triptych* (Merode Altarpiece) 80, 103(fig.3)

Carey, John 34, 42, 132, 146
Carr, Robert, Earl of Ancrum 28
Cassirer, Ernst 98–99
Catullus 47
Chambers, Alexander B. 89, 109n.8
Chambers, E. K., *The Poems of John Donne* 33
Cicero 23
circle, as geometrical conceit 94–99
circle, squaring of *see under* Nicholas of Cusa
circumscription of the divine 78, 86–88, 90, 93, 94, 95, 136
Colclough, David 70, 71, 72n.48
Cooper, Tarnya 24n.5, 29
Correll, Barbara 47n.94, 48
Council of Constantinople (CE 754) 86
Counet, Jean-Michel 98n.56
Cowley, Abraham 43–44
Cramner, Thomas 108
Cranach, Lucas 15
Cresswell, Catherine 27–28, 30
Cromwell, Thomas 108
Crowley, Lara 141n.15
crucifix 20, 49, 108, 110–111, 113, 115–116, 122, 125, 130, 135
Crucifixion 18, 20, 61, 67, 77, 83n.20, 90, 96, 99, 107, 116, 118, 121, 124, 127, 130, 132
 and Judgement 124, 125, 128, 129
 paintings of 96, 128, 130
Cunnar, Eugene 55n.11, 81–82, 96

Davies, Stevie 128
della Francesca, Piero, *Annunciation* 84–85
Derrida, Jacques 115
Deus absconditus 115–118, 122
DiPasquale, Theresa 113, 156
Docherty, Thomas 34n.47, 35, 38
Dolce, Ludovico, *Aretino* 44–45

Index

Donne, John
- catholic youth 12, 19
- *Poems* (1633) 23, 79n.6, 117, 141, 147
- *Poems* (1635) 8, 23, 26–27, 147
- portraits of 10, 23, 24–30, 33, 37, 43, 49
 - deathbed portrait 25, 30
 - Lothian portrait 24, 28–30, 32, 33, 36–37, 101(fig. 1)
 - Marshall engraving 8–9, 25–27, 33, 102(fig.2)
- will 28, 30, 79

Donne, John, works of
- "The Canonization" 86
- "La Corona" 2, 19, 77–83, 85–86, 88–94, 95, 96, 97, 99, 100, 107, 135, 136, 140, 146, 150, 158, 159, 160, 161
- "The Crosse" 20, 39n.64, 59, 107–111, 113–115, 119, 120, 122, 124, 125, 133, 136, 160, 161
- "The Dampe" 40–41
- "The Ecstasy" 139
- "Elegy: His Picture" 18, 24, 30–38, 39, 40, 41, 42, 43, 45, 49, 59, 159
- "Elegy: The Comparison" 42–43, 59
- "Elegy: To His Mistress Going to Bed" 154
- *Essays in Divinity* 56n.12, 60, 135
- "The Expostulation" 9, 94, 159
- "First Anniversary: An Anatomy of the World" 6
- "Good friday, Made as I was Rideing westward, that daye" 18, 20, 77, 78n.4, 107, 108, 115–118, 119, 120, 121, 122, 124, 125, 133, 142, 145, 153, 161
- "The Good Morrow" 86
- *Holy Sonnets* 3, 12–13, 20, 135–136, 140, 141, 146, 150, 153, 155, 156, 157, 161, 162
 - "As due by many titles" 147n.26, 153, 155
 - "At the round earth's imagined corners" 17, 20, 147, 148–150
 - "Batter my heart" 3
 - "Father, part of his double interest" 156–157
 - "I am a little world" 153, 154
 - "If poisonous minerals" 147n.26, 154
 - "Oh might these sighs" 154
 - revision of 136, 147, 151–153, 156, 157, 158
 - "Spit in my face" 93n. 44
 - "This is my play's last scene" 147, 149, 151–153
 - "Thou hast made me" 3, 153–154, 155
 - "What if this present were the world's last night?" 2, 16, 20, 39, 97, 107, 124–133, 136, 147, 151, 157, 159
 - "Wilt thou love God?" 153, 154–155
- "A Hymne to Christ" 3, 61–65, 67, 71, 159, 162
- "Image of her whom I love" 40, 41
- "The Legacie" ("Elegie") 24, 40–42
- "A Litany" 81, 114
- "Metempsychosis" 83n. 20
 - epistle to "Metempsychosis" 23, 42
- "Negative Love" 59, 75
- "Phrine" 18, 43–46, 49, 160n.8
- "The Relique" 161–162
- "Resurrection. Imperfect" 136, 141–146, 158
- "Sappho to Philaenis" 18, 24, 43, 45–48, 49, 142
- "Satyre 3" 1, 2, 16–17, 92, 114, 123, 160
- "Satyre 4" 8
- *Sermons* 6, 8, 9, 10, 13–15, 18, 19, 25, 32, 37, 38, 49, 51–54, 56, 57–59, 61–75, 77, 88–90, 95–97, 98n.55, 99, 109, 110, 112, 114, 118, 119–121, 122, 123, 124, 138–140, 143, 145, 146, 149, 151, 153, 154, 155–156, 157, 158, 159, 160, 161
- "The Storme" 8–9, 11, 21
- "The Sun Rising" 142
- "Upon the Annunciation when Good-Friday fell upon the same daye" ("Upon the Annunciation and the Passion") 3, 78n.4, 96–97, 107
- "Upon the translation of the Psalms" 98, 99
- "A Valediction: Forbidding Mourning" 95–96
- "Witchcraft by a Picture" 2, 16, 39, 45

Drummond, William of Hawthornden 28–29

Index

Duffy, Eamon 108n.3
Dürer, Albrecht 8, 73

ekphrasis 2, 4, 16, 31, 27, 37, 51, 80, 81, 92
El Greco 5, 13
Elizabeth I, reign 108
Elizabethan *Injunctions* 13–14
Elsky, Martin 8n.31, 13n.55, 93–94
emblem 3, 28, 61, 62, 64, 67, 97
Essex, Earl of (Robert Devereux) 33
Ettenhuber, Katrin 70n.43, 140n.13
Evett, David 5

Falk, Ruth 141n.15
Farmer, Norman 3, 43, 68, 71
Flynn, Dennis 11n.47, 26, 27, 117–118
Ford, Sean 59–60
Fowler, Alastair 5n.16, 7
Fra Angelico, *Resurrection* 105(fig.5), 143
Friedman, Donald M. 119n.31
Froehlich, Karlfried 60n.27
Frost, Kate 29, 30, 141n.15, 144–146

Gardner, Helen 2, 8n.32, 12–13, 33, 46, 79, 80, 81, 91, 108, 135–136, 147, 152
General Resurrection 136, 138, 139, 140, 141, 143
Genesis (Book of the Bible) 51, 68–70
Gent, Lucy 8n.29, 12, 31, 32n.37, 73n.51
geometrical metaphors 78, 84–85, 95–96, 98, 99
Gill, Richard 132
Gilman, Ernest 1–2, 10, 13, 13, 15, 16–17, 18, 74n.54, 78n.4, 79, 85, 92, 160
Goodyer, Henry, letter to 62
Grierson, Herbert 83n.19
Guibbory, Achsah 43n.76, 118n.31

Hagstrum, Jean H. 3–4, 9–10, 17, 52, 57
Harland, Paul W. 131n.49, 132–133
Harvey, Elizabeth D. 48n.96
Hay, James, Viscount Doncaster, later Earl of Carlisle 11, 53, 62, 63–64, 66, 68, 119
Haydocke, Richard (translator of Lomazzo) *see* Lomazzo, Giovanni Paolo

Heffernan, James A. W. 4n.11, 31n.32, 37n.63
Hegedüs, Kader 41n.73
Hegel, Georg Wilhelm Friedrich, *Lectures on Fine Art* 137, 139, 143
Hester, M. Thomas 152
Hilliard, Nicholas 8–9, 11, 21, 26–27, 33n.45, 73
 The Art of Limning 7, 19, 54
Hollander, John 4n.12
Holstun, James 45n.88, 46
Homer, *Iliad* 37
Homilie against Perill of Idolatrie 74
Hopkins, Jasper 56, 57
Horace, *Ars poetica* 9
Howard, Richard, "Giovanni da Fiesole on the Sublime" 77
Hurley, Ann Hollinshead 2, 7, 8n.31, 9, 11, 18, 19, 26n.12, 33, 34n.48, 35–36, 51n.1, 58, 74
Hutterer, Maille S. 144n.18

iconoclasm 13, 15, 40, 49, 107, 108, 114, 122, 124–125, 130–131, 133
 Byzantine 86–87
 in the Reformation 1, 11, 12, 88, 124–125
idolatry 11, 14, 18, 70, 74, 78, 114, 120, 122, 125–126, 132, 154
Ignatius of Loyola, *Spiritual Exercises* 13, 93, 135
imago Dei 52, 71–72, 74, 75, 110, 122, 133, 153, 155
incarnation 80, 83, 85, 86, 87, 88, 90, 95, 99, 100, 112, 117, 120, 136, 137
 paradox of 19, 78, 81, 84, 85, 88, 90, 99
interart approach 4–5, 7, 12–13, 93

John of Damascus 87–88, 99, 137
Johnson, Jeffrey 15, 62n.29, 64n.36, 68n.40–41, 70
Johnson, Kimberly 82, 84

Karim-Cooper, Farah 43
Karlstadt, Andreas 124, 126
Keynes, Geoffrey, *Bibliography of Dr John Donne* 24n.4
Klawitter, George 19, 78n.4
Knapp, James 39
Kneidel, Greg 82n.17, 156–157

Koerner, Joseph Leo 15, 16, 49,
 114n.19, 124n.35, 126n.40, 127,
 130, 133, 161

Labriola, Albert 79–80
Last Judgement 17–18, 20, 77, 91, 107,
 124–125, 128–131, 133, 135–137,
 140, 141, 146–150, 151, 152n.33,
 153, 158, 162
 paintings of 17, 91, 104(fig.4),
 106(fig.6), 124, 125, 148–149
Lederer, Joseph 3
Lee, Rensselaer W. 9n.35, 42n.74, 44
Legouis, Pierre 57
Lessing, Gotthold Ephraim, *Laocoon* 37
Lewalski, Barbara 3, 108n.5
likeness 18, 23–24, 31, 35, 42–50, 51,
 55, 68–71, 75, 82
linear perspective 19, 82–84
Lomazzo, Giovanni Paolo, *Trattato
 dell'arte della pintura* (*Tracte
 containing the artes of curious
 painting*) 7, 8, 19, 36, 54, 58, 73
Lorenzetti, Ambrogio, *Annunciation* 85
Lothian portrait *see under* Donne, John
Louthan, Doniphan 131n.49
Luther, Martin 56n.12, 87n.30, 108,
 110–113, 114, 116, 118, 121–122,
 124, 128, 129
 and art 15, 114, 123, 124, 126
 *The Babylonian Captivity of the
 Church* 111
 Heidelberg Disputation 116–117
 and the Last Judgement 128–129
 theology of the cross 108, 111–113,
 115, 116, 118, 121–122, 133
 *Wider die himmlischen
 Propheten* 15–16, 122, 124,
 126, 127

MacCulloch, Diarmaid 124–125
mannerism 5–7, 12–13, 93–94, 128
Marino, Giambattista, *Galeria* 57
Marshall, William *see under* Donne, John
Martin, Catherine Gimelli 131n.50
Martin, Michael 55n.11, 56n.12,
 59n.23, 109n.8
Martz, Louis J. 2–3, 12–13, 28n.21, 78,
 80, 123, 131, 135–136, 149, 156
Marvell, Andrew 7n.25, 56
Mary, mother of Jesus *see* Virgin Mary
Mary (reign) 108
Maurer, Margaret 91–92, 95n.49, 117–118

McCaffrey, Philip 35n.41, 45
McGrath, Alister E. *Luther's Theology of
 the Cross* 115n.22, 116–117
McQueen, William A. 108n.5
Michalski, Sergiusz 124n.35
Michelangelo 73, 109
Milgate, Wesley 10–11, 68n.41, 79
Milton, John 11–12
mimesis 49, 70 *see also* likeness
Mitchell, W. J. T. 21, 52n.4
Montemayor, Jorge de, *La Diana* 27
Morales, Helen 44n.82–83
Muroaka, Isamu 55n.11
mystical theology 19, 52, 54, 58, 59, 60,
 61–64, 66, 67, 109, 119–120, 160
 see also apophatic theology

National Portrait Gallery, London 24,
 28n.21, 29, 36–37
negative theology *see* apophatic theology
Nicholas of Cusa 19, 51, 54–57, 59, 61,
 62, 63, 64, 65–67, 68, 69, 75, 95,
 98–99, 120, 121, 154, 157, 160,
 161, 162
 Cribratio Alkorani 56n.12
 De docta ignorantia 56n.12, 98
 De Visione Dei 19, 51, 54–57, 61,
 65–67, 120, 121, 160
 omnivoyant icon 59, 62, 63, 64, 68,
 75, 154, 157, 161, 162
 squaring the circle 98–99
Nichols, Jennifer L. 60n.26

O'Connell, Michael 11–12
O'Connell, Patrick 77, 91n.38, 99
Okamura, Makiko 55n.11
Oliver, Isaac 26
Ovid, *Heroides* 45

Pace, Claire 31n.34, 32n.37, 39, 35n.50,
 39n.66, 43, 44n.81
Panofsky, Edwin 55n.10, 85
Parmigianino 5, 94
Parr, Anthony 62
Passion plays 130
Patterson, Annabel 2, 3, 13, 14, 15, 80,
 81, 86n.26, 89, 92, 94, 96n.52, 159
Paulson, Stephen D. 112n.16
Pelikan, Jaroslav 116–117
Percy, Henry, Earl of
 Northumberland 64, 68n.40
Petrarchan conventions, rejection of 47,
 48, 59

Index

Phillips, John 12n.52, 108n.3
pictorial 3–4, 9, 17, 18, 19, 21, 52, 57, 92, 159, 161
Piper, David 24n.5, 30
Pollock, John J. 62–63
Pontormo 94
portrait 2, 9, 10, 23, 24, 25, 27, 28, 30, 31, 32, 34–35, 38, 42, 43, 44, 45, 47, 49, 52, 82–83
 of Donne *see under* Donne, John
 frontispiece 23, 26–27
 miniatures 8, 33, 35–36
Praxiteles 44
Praz, Mario 4–7, 12, 20, 109
Preuss, Hans 128n.45
Pseudo-Dionysius the Areopagite, *Mystical Theology* 19, 52, 58–60, 62, 64, 68, 108–113, 115, 120, 160
Puttenham, George, *The Arte of English Poesie* 34, 42, 47

Randolph, Thomas 35
Réau, Louis, *Iconographie de l'art chrétien* 84n.21, 143n.17
Rendall, Steven 23n.2
Resurrection 20, 91, 105(fig.5), 136–141, 142, 143, 145, 146 *see also* General Resurrection
Rich, Nathaniel 117
Robbins, Robin 98n.55, 109n.8
Rorem, Paul 111–112
rosary 2, 78–79, 80, 81
Roston, Murray 12–13, 93n.44
Rugoff, Milton 10n.39&41, 52n.2, 54
Rundell, Katherine, *Super-Infinite* 138

Salviati, Francesco 5
Sappho 45–48
Schleiner, Winfried 70n.44, 72
Second Council of Nicaea 87
Sellin, Paul 16
Semler, Liam 7–8, 9n.34, 19, 45, 54, 58
serpentine line (*linea serpentinata*) 6–7, 9, 159
Shakespeare, William 5, 82
Sidney, Philip 3, 27, 98
 Apology for Poetry 9
 Arcadia 27
 Astrophel and Stella 82, 127

Simpson, Evelyn 14, 62n.32
Sloane, Mary Cole 3n.7
Sloane, Thomas O. 132
Smith, A. J. 35n.54, 41n.71, 109n.7
Spenser, Edmund 3
Stampfer, Judah 91n.38
Stanwood, Paul 53n.6
Stein, Arnold 59, 60n.26, 61, 63
Stone, Nicholas 25
Strier, Richard 97n.54
Synod of Dort 16
Sypher, Wylie 4–7, 12, 13, 20, 94

Terrill, Edward 27
Tintoretto 5, 13
Titian 11, 68
Transfiguration 20, 137–139, 141, 143, 145, 158
Tuve, Rosemond 34n.46–47, 38

Underhill, Evelyn 144
ut pictura poesis 9, 142, 161

van Cleve, Joos, *Last Judgement* 106(fig.6), 148
van der Doort, Abraham 11
van der Weyden, Rogier 55n.10
Vasari, Giorgio, *Lives of the Artists* 58
Velázquez, Diego, *Christ on the Cross* 2, 4, 128
Virgin Mary 10, 11, 19, 68, 78, 83–86, 88, 96–97, 107, 125
visual analogue 2, 4, 17, 19, 128

Walsham, Alexandra 15
Walton, Izaak 25–26, 27, 30, 49
Wendorf, Richard 25
Wenhaston Doom 104(fig.4), 125
Wiggins, Peter de Sa 9n.34
Worthington, Thomas, *Rosarie of Our Ladie* 78n.3, 80–81, 92
Wotton, Henry 26, 49
 Elements of Architecture 58

Yong, Bartholomew 27
Young, R. V. 2, 4, 128

Zeitgeist 4, 7, 12 *see also* interart approach
Zwingli, Ulrich 126

Studies in Renaissance Literature

Details of earlier volumes in the series can be found at
www.boydellandbrewer.com

Volume 20: *The Heroines of English Pastoral Romance*
Sue P. Starke

Volume 21: *Staging Islam in England: Drama and Culture, 1640–1685*
Matthew Birchwood

Volume 22: *Early Modern Tragicomedy*
edited by Subha Mukherji and Raphael Lyne

Volume 23: *Spenser's Legal Language: Law and Poetry in Early Modern England*
Andrew Zurcher

Volume 24: *George Gascoigne*
Gillian Austen

Volume 25: *Empire and Nation in Early English Renaissance Literature*
Stewart Mottram

Volume 26: *The English Clown Tradition from the Middle Ages to Shakespeare*
Robert Hornback

Volume 27: *Lord Henry Howard (1540–1614): an Elizabethan Life*
D. C. Andersson

Volume 28: *Marvell's Ambivalence: Religion and the Politics of Imagination in mid-seventeenth century England*
Takashi Yoshinaka

Volume 29: *Renaissance Historical Fiction: Sidney, Deloney, Nashe*
Alex Davis

Volume 30: *The Elizabethan Invention of Anglo-Saxon England: Laurence Nowell, William Lambarde, and the Study of Old English*
Rebecca Brackmann

Volume 31: *Pain and Compassion in Early Modern English Literature and Culture*
Jan Frans van Dijkhuizen

Volume 32: *Wyatt Abroad: Tudor Diplomacy and the Translation of Power*
William T. Rossiter

Volume 33: *Thomas Traherne and Seventeenth-Century Thought*
edited by Elizabeth S. Dodd and Cassandra Gorman

Volume 34: *The Poetry of Kissing in Early Modern Europe:
From the Catullan Revival to Secundus, Shakespeare and the English Cavaliers*
Alex Wong

Volume 35: *George Lauder (1603–1670): Life and Writings*
Alasdair A. MacDonald

Volume 36: *Shakespeare's Ovid and the Spectre of the Medieval*
Lindsay Ann Reid

Volume 37: *Prodigality in Early Modern Drama*
Ezra Horbury

Volume 38: Poly-Olbion: *New Perspectives*
edited by Andrew McRae and Philip Schwyzer

Volume 39: *The Atom in Seventeenth-Century Poetry*
Cassandra Gorman

Volume 40: *Pity and Identity in the Age of Shakespeare*
Toria Johnson

Volume 41: *John Cruso of Norwich and
Anglo-Dutch Literary Identity in the Seventeenth Century*
Christopher Joby

Volume 42: *Localizing Christopher Marlowe: His Life, Plays and Mythology,
1575–1593*
Arata Ide

www.ingramcontent.com/pod-product-compliance
Lightning Source LLC
Chambersburg PA
CBHW052100300426
44117CB00013B/2220